Y
O
G
A

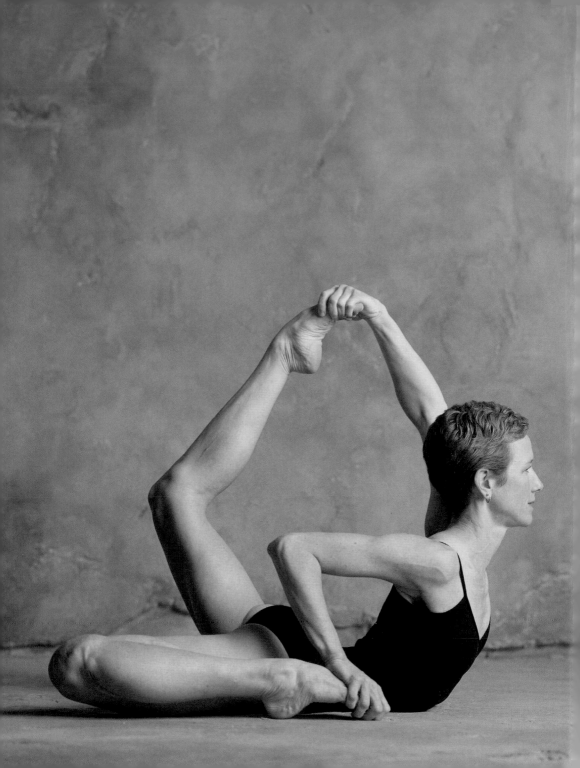

YOGA

Linda Sparrowe

Photography by David Martinez

A YOGA JOURNAL BOOK

UNIVERSE

ACKNOWLEDGMENTS

Special thanks to Hugh Levin, the publisher; Kathryn Arnold, Todd Jones, and Jonathan Wieder of *Yoga Journal*; yoga teacher Catherine de los Santos; Trisha Feuerstein of Yoga Research and Education Center (YREC); Jayanthi of Krishnamacharya Yoga Mandiram; copyeditors Jeanne Ricci and James Keough; photographic assistants Chris Leschinsky, Frank Gaglione, and Kristen Flammer; make-up and hair designers Bernadine Bibiano, Ivan Mendoza, and France DuShane; and Jeff and Lily of Manna Catering in San Francisco.

Our aim is to celebrate the beauty of yoga asanas, the physical postures captured on these pages, and to provide a historical context for yoga philosophy. The book should not, in any way, be construed as an instructional guide, or used as a primer for the reader's own yoga practice. Yoga should be practiced under the guidance of a trained yoga instructor and only with the approval of a physician.

Yoga Journal
2054 University Avenue
Berkley, California 94704
510-841-9200
www.yogajournal.com

Project Manager: Linda Sparrowe
Managing Editor: Jeanne-Marie P. Hudson
Design: Charles J. Ziga, Ziga Design

Published by Universe Publishing
A Division of Rizzoli International Publications, Inc.
300 Park Avenue South
New York, NY 10010
www.rizzoliusa.com

© 2008 Universe Publishing
Photographs copyright © David Martinez Inc.

All rights reserved. No part of this publication may be reproduced, stored in a retrieval system, or transmitted in any form or by any means, electronic, mechanical, photocopying, recording, or otherwise, without prior consent of the publishers.

2008 2009 2010 2011 / 10 9 8 7 6 5 4 3 2 1

Printed in China

ISBN-13: 978-0-7893-9987-8

Library of Congress Catalog Control Number: 2007932823

Contents

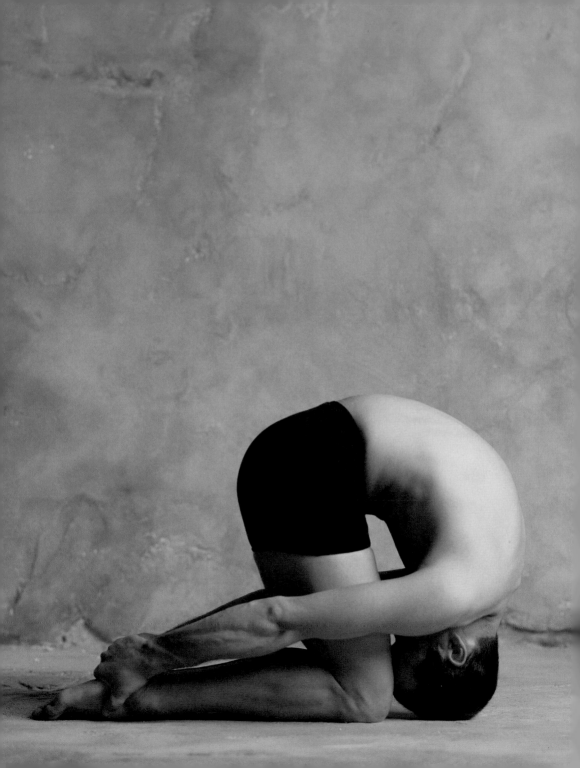

DEDICATION

To Dharma Mittra, the sweet, gentle yoga master, whose famous poster of 908 poses served as the inspiration for this book. Dharma's smile lit up our lives the minute he walked into the studio, and he captivated us all with his ability to do beautiful yoga poses. The depth of his spiritual practice and his delightful sense of humor never let us forget the true essence of the ancient tradition we honor in these pages. Dharma—thank you for everything.

Linda Sparrowe, former managing editor and current contributing editor of *Yoga Journal*, is a long-time yoga practitioner. Her undergraduate and graduate studies at the University of California, Berkeley, focused on Vedic and yoga history and the Sanskrit language. Over the last ten years Linda's articles on yoga, women's health, and complementary medicine have appeared in numerous national magazines. Her most recent books include *A Woman's Book of Yoga and Health: A Lifelong Guide to Wellness*; *Yoga for Healthy Bones*; and *Ancient Healing*, a textbook of traditional healing methods. She currently directs the yoga program for the San Francisco Bay Club and Bay Club Marin.

David Martinez, a well-known San Francisco-based photographer, spent most of high school cutting classes so he could shoot pictures and work in the darkroom. Since that time he has worked for many national magazines as well as advertising agencies, specializing in fashion and portraiture. This is his first book project. Although his photos have graced the covers and pages of *Yoga Journal*, he knew next to nothing about yoga when he started this project. "Yoga is obviously more than just an exercise to these yogis," says David. "They all clearly take care of themselves and speak of learning to realize their true nature. But what has really impressed me is that everyone of them has found a way to take the principles of their yoga practice into the world to help other people."

Yoga Journal magazine has been dedicated to helping people find more balance and meaning in their lives through yoga since its founding in 1975. Millions of Americans have embraced yoga as a contemporary lifestyle that brings them not only health benefits but also self-awareness and inner tranquility. As the voice of yoga today, *Yoga Journal* reflects the myriad ways in which Americans are assimilating this 3,500-year-old mind-body practice and how we are changing it in the process.

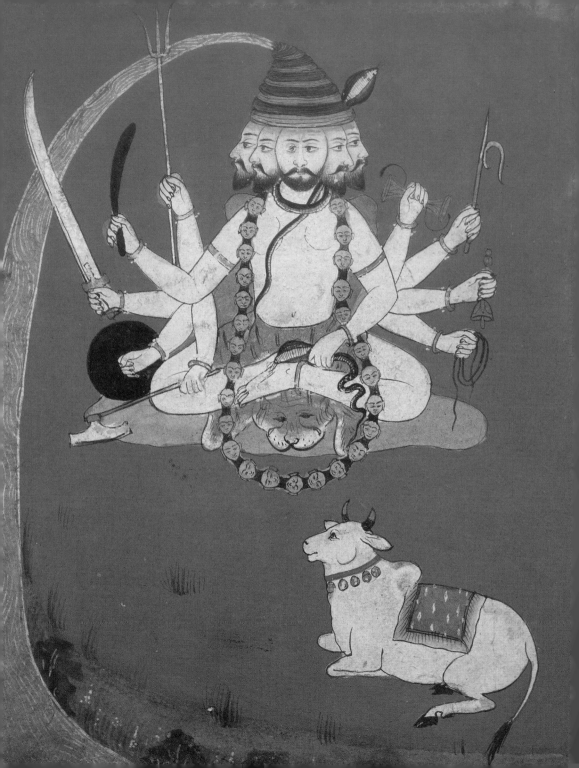

The History of Yoga

Yoga is everywhere these days. Millions of people in cities and towns all over the Western world don workout clothes once, twice, even three times a week and head for their local recreation center, dance studio, YMCA, or yoga studio to stretch, sweat, and breathe their way to leaner, more flexible bodies, stronger muscles, and tighter abdominals. With regular practice, that is what they often achieve, but many find something more as well. Yoga offers these practitioners a path to a calmer mind, a healthier body, and a more open heart. While most are content with regular yoga classes, thousands more visit retreat centers as well to renew their energy and restore their spirits. They come ready to discover a larger purpose and a deeper meaning in their lives. And, although Western society has left an indelible mark on yoga practice and philosophy—especially in the last 50 years—this deeper level of physical and emotional release clearly predates the emergence of yoga in the health clubs of London or at the exclusive spas of Los Angeles.

As anyone who has ever stepped onto a yoga mat can attest, what begins as a physical workout soon creeps into the hearts and the minds of even the least spiritual practitioners. Yoga has the power to change lives, whether those lives play out in corporate boardrooms, small-town living rooms, or in ashrams hidden deep in the Himalayas. It's also true that what we practice today bears little resemblance to yoga's humble beginnings 3,500 years ago. But that's all right. Neither does the yoga practiced 2,000 years ago, 1,500 years ago, or even 150 years ago.

To the casual observer, what happens in yoga studios today may look like just another fitness obsession. Purists may wince and roll their eyes at the sight of bodies swathed in spandex bending and stretching to the Beatles or twisting and moving to Jane Fonda's yoga tapes. Others put a more positive spin on the new yoga. The fact is, they say, yoga adapts itself to fit the age. In its rich and varied history, yoga has always evolved to meet the needs of the culture it serves. While the meaning of its name has remained constant—yoga means yoke, union, or discipline—what gets united or bound together, and how that union is achieved, can change rather radically as the culture and the needs of the practitioners change. In the earliest texts, yoga meant only the action or discipline it took a practitioner to achieve his goal. Today, yoga books define yoga as a system of specific poses, breathing exercises, and behaviors designed to purify, heal, and awaken. In the intervening centuries, the definition of yoga has encompassed activities as diverse as a method of singing devotional songs, intense meditation practices, and a set of austere purification rituals. Wild sex or scholarly study, selfless community service or complete withdrawal from society—which one is yoga? They all are. So is devotion to a guru or god. And practicing nonviolence and compassion—that's yoga too.

Shiva, the God of the yogis, seated in Padmasana (Lotus Pose).

Certain concepts prevail throughout yoga history. The union of opposites—male and female, gods and humans—plays a central role in yoga. What happens in the outside world affects what takes place in the body. That's important, too. Yogis always strive to achieve liberation in some form or another. And they are always interested in discovering their true nature. Above all else, yoga has been and continues to be about the *process* of transformation.

Most of the physical poses (yoga asanas) shown in the pages of this book came into the yoga canon very recently (within the last 120 years or so) and owe their existence as much (if not more) to British gymnastics, martial arts, and wrestling as they do to the yoga tradition itself. Does that somehow make them less than real yoga? Not at all. Two thousand years ago the asana repertoire consisted of a limited number of seated poses; today there are hundreds of postures. Those few seated poses and the myriad right-side-up and upside down asanas practiced today serve the same purpose: to strengthen the body, to bring flexibility not only to the spine, but to the mind, and to calm the nervous system and quiet the mind enough to connect the practitioner more deeply to his or her spiritual center. In other words, the yoga of yesterday and today both work to "yoke" the mind and the body and help the yogi achieve union with his or her own divine nature.

It matters little whether the yogis today practice "authentic" asanas—whatever that might mean. What truly matters is the intention they bring to their practice. For the practitioners in these pages, yoga clearly goes far beyond the physical dimension, although the inherent beauty of every pose comes alive in the model's body. To keep their balance in difficult poses requires a calm mind and the ability to maintain a steady focus. To bend and stretch the way they do necessitates the ability to surrender completely, to release any attachment to the outcome of their actions—in other words to truly practice yoga as its tradition dictates. The depth of commitment and the spiritual connection these yogis have to their practice bind them to a tradition that promises to grow and evolve with each passing generation, even though its seeds were planted so many thousands of years ago.

The physical aspect of yoga captured on these pages—the stretching, bending, twisting, and turning—represents a relatively new development in what is an ancient Indian tradition. Yoga teachers may talk about practicing a certain pose the "traditional" way. But the tradition he or she draws from extends back only about 150 years or so. The physical postures have their roots in a rich heritage, to be sure. It's just that the Downward-Facing Dog and Triangle poses so popular in yoga classes today don't appear in any sacred texts, nor do the ancients deem either pose necessary to reach enlightenment. In fact, the term asana, which we use today to mean a pose or posture, and which includes hundreds of positions to stretch the body and open the mind, originally meant "seat," and referred only to what the yogi actually sat on for meditation and the material that covered it (grass, wood, animal skin, or cloth). Over time, the term asana grew to include the way in which a yogi sat in meditation—usually a cross-legged Lotus position. Only much later in yogic history does the most rudimentary practice of asana (a few more ways to sit, some forward bending, and a couple balancing poses) take its place alongside the yogic disciplines of action, breathing, and meditation, which bring the practitioner closer to final liberation or enlightenment.

Nonetheless, the asanas we practice today rise out of—and retain elements of—an ancient meditation heritage, the beginnings of which date back at least 3,500 years. Deep in the heart of the Indus Valley region a highly developed civilization flourished on the banks of the Ravi and Indus rivers in what is now present-day Pakistan and western India. Two major cities, Harrappa to the north and Mohenjo-Daro to the south, bookend what collectively became known as the Harrappan

culture, which thrived for over a millennium. Archaeologists have unearthed carved images that depict gods and men sitting in the cross-legged Lotus position, many holding tridents (a yogic symbol of transcendence) or surrounded by wild animals. Unfortunately, the Harrappan language remains largely indecipherable, so no one really knows how the people incorporated these yoga positions into their daily lives. It could very well be that cross-legged was the most popular (and comfortable) way to sit. Whether the Harrappans meditated or simply conducted business, cooked, ate, and socialized in that position, we can only surmise.

YOGA AND VEDIC CULTURE

The actual word "yoga" surfaced around 1500 B.C.E., just as the Harrappan civilization began to decline. The Harrappans' rather rapid demise was helped along, some scholars believe, by an invasion of Aryan barbarians. These nomadic invaders had no use for the sophisticated urban civilization the Harrappans had built and took little time destroying it. They brought with them Brahmanism, a complex religious tradition based on sacrifice and ritual that formed the basis of modern-day

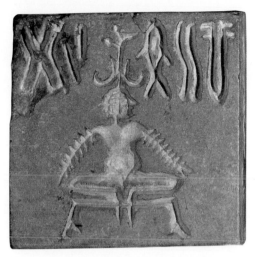

Hinduism, and introduced the concept of yoga. The sacred scriptures of Brahmanism, known as the *Vedas*, contain a mixture of incantations and instructions in both poetry and prose. The first three books, *Rig Veda*, *Sama Veda*, and *Yajur Veda*, were used exclusively by the priestly class of Brahmins; a later, fourth book called *Atharva Veda*

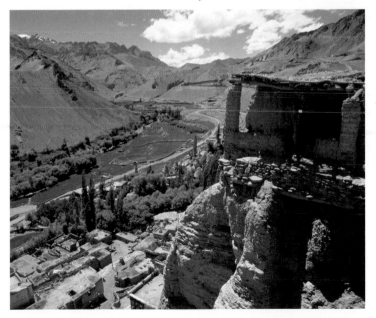

OPPOSITE: *Yoga teachers adjust their students in a typical yoga class.*

TOP: *A steatite seal of a yogi seated in meditation, from the Mohenjo-Daro region of ancient India, ca. 1500 B.C.E.*

LEFT: *Ruins of the Lamayuru monastery tower above the town of Ladaku in the Indus Valley region of modern-day Pakistan.*

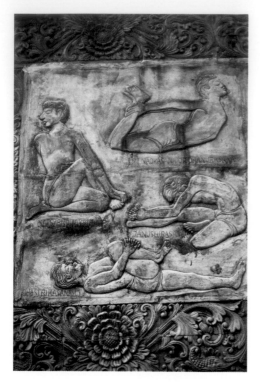

notes longer—if they practiced what they called pranayama, a type of breath control.

This, then, is the very beginning of yoga as we know it, the first mention of a physical action as part of a discipline or practice. Roughly 800 years will pass before history yields more information on yoga's development.

PRECLASSICAL YOGA

Little more than a noun and a nascent discipline in the *Vedas*, yoga played a more prominent role in the *Upanishads*, the sacred revelations of ancient Hinduism. The earliest of these teachings date back to at least 800 to 500 B.C.E. The word *Upanishads* combines the verb "shad," which means to sit, with "upa" meaning near, and "ni" meaning down, which suggests that the only way a student could learn the truths hidden in these revelations was to sit at the foot of his guru or teacher. The *Upanishads* contained little that we would call yoga asana practice. Instead, yoga referred in a more general way to a discipline used or path taken to achieve liberation from suffering. Two yoga disciplines in particular gained prominence during this time: *karma yoga*, the path of action or ritual, and *jnana yoga*, the path of knowledge or intense study of scripture. Both paths led to liberation or enlightenment.

The secret teachings of the *Upanishads* differ in important ways from their Vedic parent texts. The *Vedas* taught the fine art of sacrifice—external offerings to the gods in exchange for a peaceful and fruitful life. This form of karma yoga included specific rituals and sacrifices humans had to perform in order to appease the gods and be free from suffering. The *Upanishads* also espoused sacrifice as a means to liberation, but chose an internal, more mystical expression of that sacrifice. Gurus taught that the Self or ego (not an animal or crops) must be sacrificed in order to attain liberation. The means to do that, these revelations showed, came not through action or ritual, but through knowledge and wisdom (jnana yoga).

The *Upanishads*, as a whole, concentrated on these basic truths:

• Your true essence (the Self with a capital "S") is the same as the essence of the universe, or brahman. That essence—what we might think of as the soul—is called *Atman*.

provided householders with spells and incantations for everyday living.

Scholars have a hard time pinpointing the inception of the *Vedas*, but they generally agree that the scriptures date back at least 3,500 years. The word yoga has its first mention in the *Rig Veda*, the oldest of the sacred texts. This Vedic book, a collection of hymns or mantras, defines yoga as "yoking" or "discipline," but offers no accompanying systematic practice. The term yoga turns up again in the *Atharva Veda*, most particularly in the fifteenth book (*Vratya Kanda*). Again it refers only to a means of harnessing or yoking. But this time it's the breath that needs controlling. The *Vratya Kanda* introduces a group of men, the *vratyas*, quite possibly fertility priests, who worshipped Rudra, the god of the wind. Considered horrible outcasts by traditional Brahmins, these vratyas composed and performed songs and melodies. They found they could sing their songs a lot better—and probably hold the

• Everyone is subject to birth, death, and rebirth.

• Your actions in this lifetime determine the nature of your rebirth (the doctrine of karma). This understanding of karma says that if you perform good deeds throughout your life, you'll be reborn into the womb of a woman from a high caste; if you do evil, you're likely to find yourself in the lowly womb of a pig, or a dog, or, perhaps worse, an outcast.

• You can reverse the effects of bad karma through specific spiritual practices (i.e., internal sacrifices) like meditation and renunciation. Renunciation allows you to offer up the fruits of your actions and to renounce any actions fueled by desire or passion. In much later *Upanishads*, yoga became known as the path of renunciation (*samnyasa*).

One of the earliest *Upanishads* to teach specific yoga meditation practices was the *Maitrayaniya Upanishad* from the second or third century B.C.E. This *Upanishad* defined yoga as a means of binding the breath and the mind using the syllable Om. According to its author, "The oneness of the breath and mind, and likewise of the senses, and the relinquishment of all conditions of existence—this is designated as yoga." The *Maitrayaniya* took the concept of yoga a step further by presenting an actual method or discipline for joining or yoking the universal brahman with the Atman within all beings. This six-fold yoga path includes controlling the breath (*pranayama*), withdrawing the senses (*pratyahara*), meditation (*dhyana*), concentration (*dharana*), contemplation (*tarka*), and absorption (*samadhi*). Elements of this six-fold path expanded somewhat, and would resurface in the second century C.E., in Patanjali's *Yoga Sutra*.

The vibrational power of sound, as exemplified in the primordial word Om, came to signify the inner meaning of a yogi's actions, and speech enabled the yogi to express that meaning. Today, as in the days of the *Upanishads*, the guru's words impart wisdom to his students and, for the more

OPPOSITE: *Relief sculpture from a Hindu temple in Sumatra depicts yogis performing asanas.*

LEFT: *A sample of Sanskrit devanagari script from the* Nirvanaprakarama, *or* Exposition of Greeting.

devotionally adept, chanting the name of a god or goddess remains a powerful vehicle for transformation.

THE *BHAGAVAD GITA*

The most famous—and most beloved—of all yoga texts, the *Bhagavad Gita* ("The Lord's Song") has its roots in the mystical, revelatory literature of the *Upanishads*. No one knows for sure how old this scripture is—it quite possibly dates from the third century B.C.E.—but we do know that it provides the most comprehensive description of yoga at that time. Later folded into the canon of the *Mahabharata*, India's well-known epic tale, the

RIGHT: *The Sanskrit symbol for Om, the primordial syllable exemplifying the vibrational power of sound.*

OPPOSITE: *A scene from the* Mahabharata, *India's epic tale of moral teachings and ethical lore.*

Gita brought together moral teachings and mystical lore as Lord Krishna instructed his pupil Arjuna on the ways of the world. While the *Maitrayaniya Upanishad* outlined a six-fold path to liberation, the *Gita* advocated a three-pronged approach: karma yoga, the path of service; jnana yoga, the path of wisdom or knowledge; and *bhakti yoga*, the path of devotion.

In the *Bhagavad Gita,* jnana yoga signified meditation, or the path of wisdom, much as it did in the *Upanishads.* Using this type of yoga, a practitioner would try to discriminate between real and unreal, in an attempt to separate the Self from the non-Self. Karma yoga of the *Gita* was still

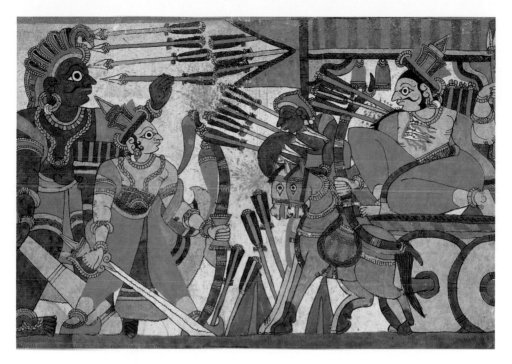

a yogi's path of action, what Krishna called Arjuna's *sva-dharma*. As a warrior, Arjuna's obligation (his dharma) is to fight against the forces of evil, no matter what. And if he were to decide he doesn't like fighting, could he sell his wares in the marketplace instead? He can't, Krishna tells him. He's not a member of the merchant class, and he has no right to perform someone else's duties. In fact, doing one's duty poorly accumulates better karma than doing someone else's well. What if Arjuna knows the battle he's engaged in is wrong? It doesn't matter, says Krishna. The outcome of the battle makes no difference; it's Arjuna's duty to fight no matter what. He must practice what the *Gita* called *buddhi yoga*.

Buddhi yoga, the *Bhagavad Gita*'s melding of karma (action) and jnana (knowledge) yoga principles, taught that the yogi must never be attached to the outcome of his actions. What mattered was not whether Arjuna won or lost in battle, only that he perform his duty (his sva-dharma) and then offer up the fruits of his actions

to Krishna, his Lord. In this way, Arjuna's sva-dharma became a form of internal sacrifice.

The *Gita* dedicated most of its later chapters to bhakti yoga, the path of devotion, most particularly devotion to Krishna himself. While a yogi could achieve liberation through what the *Gita* called "disinterested action," he attained an even higher state of awakening by worshipping Krishna.

THE CHANGING YOGIC WORLD VIEW

The concept of universal consciousness, or brahman, developed out of the metaphysical teachings of the *Upanishads*. Yoga has lots of names for it: Atman, the transcendental Self, the Divine, *isvara*, *purusha*, pure awareness, the seer, the witness, and the knower are but a few of the more popular ones. At this point in preclassical yoga, everything resided within this consciousness and nothing existed outside of it. It was both the seer and the seen, and even the act of seeing. Purusha, the *Upanishads* taught, was all-knowing, pure, male, and infinite. Some schools of yoga and

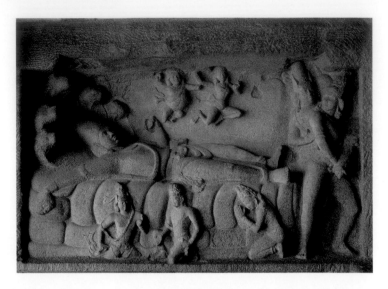

Supported by the snake Shesha, the god Vishnu dreams the universe into existence. Mahisamardini Cave, Tamil Nadu, India, 7th century C.E.

Hindu philosophy taught that this universal consciousness manifested itself in everything, beginning with the grossest, most visible realm of the five *bhutas* (air, fire, water, earth, and ether) and moving into the subtlest realm of the soul or Atman.

Toward the middle of the preclassical period, a rather radical metaphysical school called *Samkhya* surfaced. Although not a school of yogic thought, per se, this parallel tradition—which existed anywhere between 400 and 200 B.C.E. and owed its teachings to an obscure sage named Kapila—developed the basis for a more modern yogic world view. What made Samkhya so radical? Certainly not its tenet that yogis must renounce the world in order to transcend it and be relieved of their suffering. The concept of samnyasa (renunciation) is as ancient as the earliest *Upanishads*. By the time Samkhya elevated this well-established concept, mainstream yoga philosophy felt that renunciation alone was not enough. Yogis had to practice karma yoga (the path of action) and jnana yoga (knowledge or meditation) to achieve true liberation. Samkhya became radical when it taught that the visible world was *not* a manifestation of the Divine. According to Kapila, nature and, in fact, all of creation was separate and distinct from the universal consciousness, although the manifest

world could be illuminated by purusha. Suffering, according to the Samkhya tradition, occurred when the yogi became attached to things that were not the Self, and when he mistakenly identified those things with pure consciousness (purusha). Although this dualistic, rather heretical teaching failed the test of time, the Samkhya tradition created a sophisticated cosmology that explains the difference between the seer (purusha) and that which is seen. Subsequent schools of yoga rejected the Samkhyan's dualistic view of suffering, but borrowed its larger world view, which goes something like this:

There are two separate forms of reality or existence—purusha (the pure, transcendental spirit, which is male) and prakriti (matter or nature, which is female). Purusha is all-knowing, without beginning and without end. It has no characteristics and is completely immobile. It simply exists as pure consciousness. It is the seer. Prakriti, on the other hand, is in constant motion, creative, active, distinct, but unconscious. She is all that is seen. She has, in fact, created everything in the universe by manifesting herself in three ways: *sattva*, *rajas*, and *tamas*. These three manifestations of her nature are called *gunas*. They exist simultaneously, but in varying degrees of prominence, in everything in the cosmos.

Prakriti dynamically creates these phenomena; purusha passively illuminates them.

- **Sattva** is the guna of the mind and the cognitive senses (eyes, ears, nose, tongue, and skin). The mind coordinates all biological and psychic activities and the cognitive senses keep us connected to the external world.

- **Rajas** is the guna of gross motor responses and physical experience. When this guna predominates, the senses of yearning—the voice, hands, feet, anus, and genitals—become active. Rajas makes physical experience possible, and controls the activity of the body.

- **Tamas** is the guna of darkness and inertia. When this guna predominates, the five subtle elements become active—these are the potential of sight, sound, smell, taste, and touch, which give rise to the structure of existence.

In the early Samkhya system, the gunas were neutral manifestations of prakriti; only later did they become aligned with certain qualities. The *Bhagavad Gita* also taught that the gunas came from nature, but believed that their existence bound humans to a particular body. Sattva, for example, denoted goodness and pure essence. The *Bhagavad Gita* taught that a sattvic nature was illuminating and "immaculate." The downside of having a sattvic nature was that a yogi could too easily become attached to the joyful feelings it produced. Being rajasic, in the *Gita*, meant he was bound by and attached to action. Rajas energy is dynamic, passionate. Later *Upanishads* translated rajas to mean greed, lustfulness, desire, possessiveness, passion, and clinging to material goods. Tamas became known as an obstacle that would bind a yogi to a life of sloth, heedlessness, and despondency. Its energy is heavy, slow, and thick. These gunas appear later on in Patanjali's *Yoga Sutra*.

Samkyhan philosophers believed that the only way out of this erroneous attachment to objects and desires was for the yogi to renounce the world completely. Through renunciation, the yogi could experience universal consciousness (purusha) and foreswear the natural world.

An illustration from the Bhagavata-Purana, *an 8th-century scripture from the Bhagavat sect of Krishna worshippers, exemplifies bhakti yoga.*

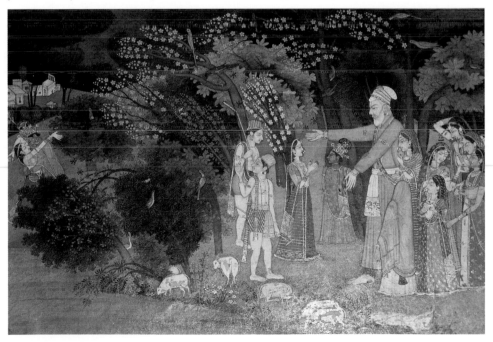

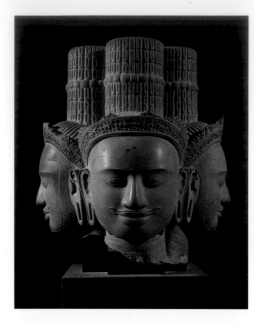

CLASSICAL YOGA
Patanjali's *Yoga Sutra*

The most famous proponent of the Samkhya world view was an enigmatic philosopher/writer known only as Patanjali. Nearly every yoga teacher today is familiar with his treatise, the *Yoga Sutra*, which is considered to be the first systematic presentation of yoga, and reveres its author as the father of modern yoga. Actually, no one really knows who Patanjali was, although speculation varies widely. Was he a simple grammarian, a teacher of Samkhya philosophy, or an incarnation of Shesha, the thousand-headed ruler of serpents? Whoever else he was and whatever else he did, Patanjali clearly succeeded in codifying the concepts of an ancient, oral tradition. His collection of 195 sutras (aphorisms or "terse statements") compiled most probably in the second century C.E., provides the first practical treatise on daily living, beginning with how to conduct oneself in society and culminating in the act of final liberation or enlightenment. Because Patanjali believed one could attain final liberation only with the help of a guru, these aphorisms are not really a self-help guide. They exist to assist the guru in his teachings.

Like the followers of Samkhya before him, Patanjali embraced a dualistic view of existence. On the one hand, he taught, there is purusha, the all-present, all-knowing ethereal consciousness, made up of countless Atmans, who watch as the cosmos unfolds before them. Male, formless and unmanifest, Purusha attaches to nothing; immobile yet pervasive, he simply sees all and knows all. Prakriti, on the other hand, is nature incarnate. Female, visible, and dynamic, prakriti constantly moves, creating and changing as she goes. She is all that is manifest in the world. Existing only to serve purusha, prakriti is unconscious and insentient. Nature exists, according to Patanjali and the Samkhyan philosophers, through a complex interplay among the three gunas—sattva, rajas, and tamas—which are visible aspects of her character. Much like in the *Bhagavad Gita,* Patanjali aligned these gunas with specific characteristics in humans. When the element sattva presents itself, according to this philosophy, the energy is light, clear, and joyous; a predominance of rajas produces passionate feelings, desire, and even greed, as one becomes attached to worldly goods; when tamas gets the upper hand, it brings energy that is slow, heavy, and thick, and can bind a person to a life of sloth and despondency.

Like the Samkhya philosophers, Patanjali believed suffering resulted when humans become attached to external phenomena, when they hold on to the fruits of their actions or when their desires (all the shoulds, wants, and needs in life) pull them away from their connection to a higher consciousness. Patanjali thought that conflict among the three gunas, each vying for dominance, was at the heart of human suffering. Sattva may bring feelings of joyfulness, he reasoned, but being attached to those feelings is no better than holding on to the greed of rajas or being stuck in the despondency of tamas. Much like the *Bhagavad Gita*—and diametrically opposed to the renunciation espoused in Samkhya—Patanjali wrote that only hard work (karma yoga) and deep meditation (jnana yoga) could relieve human suffering and lead to liberation. In fact, only through strict adherence to his eight-limbed path of yoga (*ashtanga yoga*) could a yogi tame the gunas and bring them back into balance, as they existed in primordial nature.

Ultimately, said Patanjali, by releasing attachments to the natural world, a yogi could allow the transcendental quality of purusha to shine through his true Self.

Although yogis eventually rejected Patanjali's dualism entirely, they continued to use and expand upon his eight-limbed yoga path. This combination of practices still serves as a blueprint for living in the world and as a means of attaining enlightenment, although modern-day teachers no longer believe students must master the limbs in succession.

THE EIGHT-LIMBED PATH OF YOGA

Patanjali readily understood that attaining enlightenment—or freeing oneself from suffering—was no easy task. The second chapter of his *Yoga Sutra* offers a systematic approach that

OPPOSITE: *Late 9th-century sculpture depicting the three heads of god: Brahma, Vishnu, and Shiva.*

BELOW: *A relief from Gumbat, in the Gandhara style of the 1st and 2nd century* C.E., *depicts Brahma and Indra, two Hindu gods, inviting the Buddha to preach.*

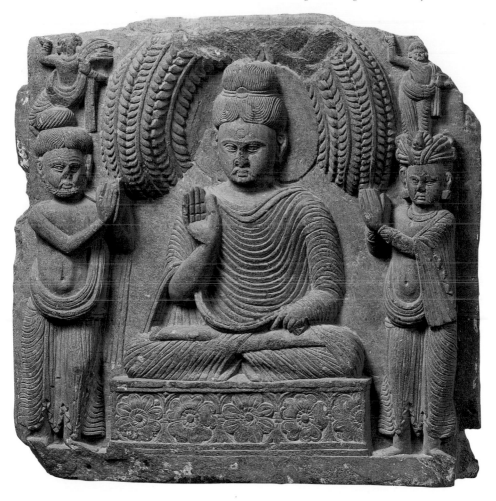

A yogi seated in Ardha Padmasana (Half Lotus) prepares for meditation.

couples the concept of *ahimsa* (nonviolence) with present-moment attention and service (karma yoga). Patanjali began by giving prescriptions for getting along in society and then turned increasingly toward ever deeper internal phenomena. Learn to control your actions, Patanjali taught, and then can you begin to steady your body and your breathing. Once your body and breathing are still, he said, you move to quell the chattering (vritti) of your mind (chitta). Only with a quiet mind can you master *ekagraha*, or single pointedness, and ultimately reach final liberation (samadhi). The eight limbs Patanjali set forth include the yamas (restraints), niyamas (disciplines), asana (physical practice), pranayama (breath control), pratyahara (withdrawal of the senses), dharana (concentration), dhyana (meditation), and samadhi (liberation).

The Yamas

The yamas most closely resemble the five Buddhist precepts and the "Thou Shalt Nots" of the Ten Commandments, and they serve as the foundation of all ethical behavior. Separately and collectively, these ethical constructs (literally, in Sanskrit, restraints) teach a single lesson: Do no harm. Patanjali wrote that a yogi could hope to purify the body or control the mind only by first learning to live in society as a happy, functional individual. The *Yoga Sutra* identifies five distinct yamas, all of which a yogi must master before he (all yogis in Patanjali's time were male) could move further along the yogic path: *ahimsa* (nonviolence), *satya* (truthfulness), *asetya* (non-stealing), *brahmacharya* (abstinence), and *aparigraha* (non-covetousness). Later texts list additional yamas, such as steadfastness, patience, sympathy, moral integrity, dispassion, and devotion to the guru.

Ahimsa, or nonviolence, means more than just turning the other cheek or refusing to eat meat or join the army. Practicing nonviolence means replacing destructive actions and words with positive, constructive ones, trading violence and hatred for love. Known in Buddhism as right speech or compassionate action, and in the Bible as the Golden Rule, ahimsa, pure and simple, means do no harm. Martin Luther King, Jr., Mahatma Gandhi, and His Holiness the Dalai Lama exemplify the power of ahimsa. Becoming acutely

combines ascetic practices to strengthen the body with austere meditation techniques to control the mind. He said that daily living bombards humans with constant chatter, or mental fluctuations he called *chittavritti*. Listening to these fluctuations gives rise to ignorance, a feeling of separateness, attachment to objects and outcomes, and profound sorrow. The only way to control these fluctuations is to adhere to a rigorous yoga practice. For Patanjali, of course, a rigorous yoga practice meant more than simply going to class everyday, learning to breathe properly, or even sitting in meditation every morning and evening. But he saw no need to renounce the world or join a monastery, either.

The eight-limbed path of the *Yoga Sutra* challenges yogis to live in the world without becoming attached to the objects of the world; it

aware of one's actions, thoughts, and intentions in the present moment takes diligence and courage, and it's no accident that this is the first precept a yogi must master. Patanjali asked a yogi to first become mindful of his actions (and their repercussions) in the world and take a stand against the violent actions of others. Next, he said, a yogi must learn to control his thoughts, taking care to harbor no ill will or hatred toward others. After that, he must seek to control the intentions behind his thoughts and actions as he interacts with others. Finally, he must practice nonviolence toward himself, observing with compassion and gentle humor his successes and his setbacks on the yogic path, and take responsibility for his own behavior.

Satya, or truthfulness, also means do no harm. Again, beginning with actions in the visible world, to practice satya (literally, actively speaking the universal truth) entails speaking with intention, telling the truth as best one can. A yogi must also seek his inner truth, coming to a deeper understanding of his own integrity and cultivating self-awareness. Living one's truth—expressing it in every thought, word, and deed—cleanses the body and the mind and replaces darkness and evil with purity and light.

Asetya, or nonstealing, closely resembles the Judeo-Christian Commandments "Thou shalt not steal" and "Thou shalt not covet thy neighbors' goods." As long as a yogi lives in the world, Patanjali admonished, he must take nothing that belongs to someone else. The *Yoga Sutra* makes no distinction between actions and thoughts. Desiring or coveting someone else's ideas or possessions and wishing with all one's heart to own them are the same for Patanjali as stealing them outright. Violating someone's trust is a further act of stealing. A yogi can steal from himself, as well, by denying himself opportunities to realize his true nature or by failing to act when he should. Patanjali taught that practicing asetya allows a yogi to live in the present moment and, most importantly, be comfortable with what he has and who he is.

Brahmacharya, or abstinence, in Patanjali's time meant celibacy or sexual continence.

Literally translated as the act of walking with God, brahmacharya later came to include devotion to God or a higher truth or even to one's guru. Giving up sex for most ancient yogis meant transmuting that energy into a purer, more devotional kind. The energy derived from such self-restraint brought them a clear mind, increased vitality, and a renewed determination to use this physical energy wisely and compassionately.

Aparigraha, or nongreed, is, on the surface, an easy stricture to explain: Becoming attached to material goods, Patanjali warned, creates suffering. Externally, wanting what one doesn't or can't have moves one further away from realizing one's true Self. This applies to spiritual goals as well as objects. Practicing aparigraha keeps a yogi anchored in the present moment, less interested in becoming and more focused on being.

The Niyamas

Once a yogi learned to restrain his impulses and avoid harmful actions and thoughts, the next step on Patanjali's eight-limbed path was to concentrate on positive actions and attitudes, disciplines that promoted freedom from suffering and a deeper connection with the outside world. Patanjali taught that the niyamas, much like in the yamas, applied on a gross, physical, in-the-world level as well as on much subtler mind and spiritual planes. These niyamas, or observances, are the "Thou Shalts" of the eight-limbed path and include: *saucha* (cleanliness), *santosa* (contentment), *tapas* (austerity), *svadhyaya* (study of the Self), and *isvara pranidhana* (surrender or devotion to God). Although it is not the case today, yogis in Patanjali's time had to adhere to this code of conduct before they could go to the next step, which is asana practice.

Saucha, or cleanliness, obviously denotes more than bathing daily and performing good hygiene. While honoring the body was seen as important, even in Patanjali's time, a yogi's thoughts, words, and deeds had to be as clean as his teeth, hair, and nails. On a physical, worldly level, practicing saucha means a yogi must take care of his body by eating clean, sattvic foods, exercising, and staying away from all forms of corruption. Saucha also translates as purity, which speaks of intention—

the thought behind the deed—as well as action. Thinking pure thoughts, acting out of compassion instead of greed or selfishness, is to observe saucha. Saucha practice was one more way Patanjali demonstrated nonattachment to the outcome of human actions. Practicing loving-kindness toward friends, family, and even enemies is also to understand saucha.

Santosa, or contentment, is the quintessential "present moment" observance and a critical step to cultivating nonattachment to external possessions. For some yogis, this niyama gives them permission to renounce the world and head off to the forests or caves to meditate and attain liberation from suffering. Patanjali appears to have purposely placed santosa here—as a daily observance—to challenge a yogi to live in the world without becoming attached to it.

Events happen all around him—some joyous, some horrendous. A yogi must remain content within himself in the face of all he experiences. Much like the Buddhist principle of detachment, santosa challenges yogis to feel the happiness or experience the pain in the world, but not become that joy or that pain. The true source of contentment lies within.

Tapas, or austerity, in Sanskrit, means heat and comes from the root word "tap," which means, to burn. In Patanjali's time, a yogi who perfected tapas gained mastery over extremes—feeling neither hot nor cold, pleasure nor pain. On a more subtle level, practicing tapas allowed the yogi to remove impurities from both the body and the mind. Tapas later evolved to include the intense internal focus a yogi needs to cultivate constancy in his practice and in his daily life.

Svadhyaya, or self-study, for Patanjali included attention to the body, mind, intellect, and ego. This niyama, he said, would take the yogi a step closer to uniting with the universal consciousness. For the yogis of the classical era, svadhyaya was part and parcel of the study of the *Yoga Sutra* and the intense one-on-one study with their gurus. More than just memorization and recitation, svadhyaya approached meditation and helped the students gain more control over their actions, thoughts, and emotions. Svadhyaya later meant

the yogi must be constantly vigilant in his attempts to practice yoga, beginning with the yamas and the niyamas. He must always be mindful of his responsibilities to himself and to the world around him.

Isvara pranidhana, or devotion to God, literally meant giving up to the Lord. Patanjali's *Yoga Sutra* did not actually envision a creator-god figure; more likely Patanjali's isvara referred to a meditation vehicle, an object of the yogi's concentration, which existed to assist the yogi in attaining liberation. In later times, isvara grew to encompass a particular deity, the Lord with a capital L, and today can indeed relate to a personal god, to a higher power, or to a universal presence. Once again, Patanjali's work implies present-moment focus. If a yogi becomes attached to the fruits of his actions, his focus moves into the future or stays stuck in the past. He must give up trying to control the outcome of his actions even as he continues to act with a clear purpose and a pure heart.

Asanas
The third limb of Patanjali's yogic path is asana practice. According to Patanjali, by taking control of the physical body through asanas, the yogi will gain the strength necessary to endure the rigors of meditation practice. By the time he reaches this limb, a yogi must have successfully mastered the yamas and niyamas, and brought present-moment awareness to the world around him. He must understand how to act from kindness and compassion without becoming attached to the outcome of those actions. Now, said Patanjali, it's time for the yogi to bring that same mindfulness to his own body and mind.

Patanjali didn't talk much about specific postures; he spent even less time explaining how to get into or out of them (all of that comes much later in yogic history). He did say that each pose should be steady and comfortable; that a yogi should concentrate on proper alignment and good posture; that he should work to hold the positions for longer and longer periods of time without effort and without fatigue; and that his mind should remain calm and clear. To perfect a pose for classical yogis meant to find stillness in the movement, to quiet the body in order to begin to

tame chittavritti, the constant fluctuations of the mind. By remaining steady in the physical pose, a yogi learned to observe his thoughts and to understand which ones to act on and, because they cause suffering, which ones to let go. Of course, the more effortless an asana practice became, the more the yogi could move his attention away from the body to focus on the mind and the senses.

Pranayama

The fourth step on the eight-limbed path, pranayama, trains the yogi to control the breath. Pranayama begins to shift the yogi's awareness from the outside world to his inner essence, from the body to the mind and toward the Self. The yamas and niyamas concentrate on actions in the world, teaching love and service to the world; asana focuses on strengthening and honoring the physical body, and now pranayama moves to harness the breath, teaching a yogi how to find peace within.

The word pranayama combines the root "prana," meaning vital energy or life force, with "ayama," meaning extension or expansion, or, as some translators say, with "yama," meaning restraint or control. In other words, pranayama (the control, expansion and extension of the life force) harnesses the vital energy and consciously moves it through the body's subtlest channels.

Although many modern yoga teachers offer pranayama techniques in their beginning yoga classes, Patanjali's *Yoga Sutra* specifically stated that a yogi must bring his body under control before he can hope to master the senses or learn to direct

Yoga master Krishnamacharya demonstrating pranayama, the control and extension of the breath.

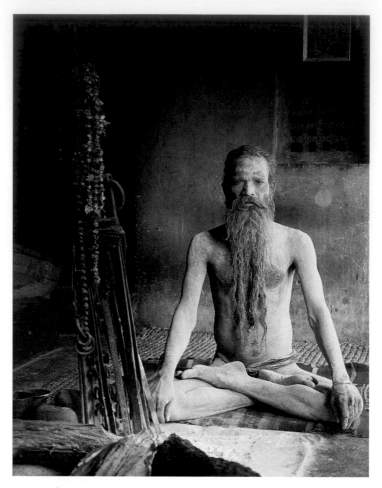

Seated in Padmasana (Full Lotus), this yogi practices pratyahara, the withdrawal of the senses.

the breath. Of course, Patanjali hardly required expertise in all the postures currently associated with yoga before learning pranayama; he merely stressed the ability to sit with *dhriti* and *sukha*—steadiness and ease—and to be present without having to focus on the body's needs.

As with his asana step, Patanjali offered little in the way of specific pranayama techniques, except to say that the movement of breath in, through, and out of the body must be precise. He encouraged the yogi first to learn the simple act of breathing before perfecting the three movements of pranayama: prolonged inhalation,

deep exhalation, and prolonged, steady retention of the breath. Prolonged inhalation (*puraka*) takes air into the nostrils, from whence it travels through the lungs and heart and enters into the area around the navel as prana. *Recaka*, or deep exhalation, moves the prana from the navel area, pushing it upward into the heart and lungs and out through the nostrils. *Kumbhaka*, or breath retention, comes twice in the sequence—first after inhaling the breath and second after exhaling (sometimes called suspension).

Pranayama in the *Yoga Sutra* gives the yoga student an additional lesson in being present

in the moment. Focusing on the breath makes it difficult to think about anything else. By controlling and retaining the breath, the yogi can quiet the chittavritti and move toward final liberation.

Pratyahara

The practice of pratyahara, the fifth step in Patanjali's eight-limbed path, challenges the yogi to withdraw the senses from the objects of desire, to take power over what he sees, hears, smells, tastes, and touches, so that external stimuli can no longer control his thoughts or his actions. By drawing the senses inward, Patanjali believed the yogi could separate himself from the goings on around him, and yet remain keenly aware of everything.

Asana and pranayama steady the body and quiet the mind by removing physical and mental distractions, according to Patanjali. Once this happens, a yogi can move on to more subtle practices that involve deeper levels of consciousness. Pratyahara meant withdrawal even before the *Yoga Sutra*. But Patanjali's writings do not imply physically removing oneself from society, trading house and home for forest and cave. Pratyahara in the *Yoga Sutra* more closely resembles the Buddhist concept of detached compassion, the idea that one must be present in the world, indeed must participate even more fully in the world, without becoming attached to what goes on.

Patanjali's pratyahara refined the notion embodied in the yamas and niyamas—that a yogi must act from kindness and compassion without being attached to the outcome, whether those actions are internal or external. Ironically, to withdraw in preclassical yoga did not mean to stop paying attention; it required very close attention. Pratyahara primarily centered on withdrawal from attachment, not from participation. During pranayama practice, Patanjali said, a yogi learns to control his breathing and to use it to calm the senses and the mind. In pratyahara, he must learn to control the mind, moving closer to complete present-moment mindfulness—the art of staying present without judgment and without need to change or control the outcome. It is the joy of beholding the Divine within and without.

Dharana

Once a yogi brought his body and senses under control through pranayama and pratyahara he was ready to strengthen the practice of paying attention through dharana or intense concentration. Patanjali taught that performing dharana literally meant binding the consciousness to a single point (*ekagraha*). In the *Yoga Sutra* any point will do—the navel, the space between the eyebrows, a flower, an image of a guru, or even a sound or phrase like the universal Om. Focusing attention on this single point not only keeps the mind from wandering, preclassical yogis learned, it controls the activities of the senses—the eyes, ears, nose, mouth, and skin—as well. This step of the eight-limbed path was prerequisite for learning dhyana (meditation) and attaining final liberation (samadhi).

Dhyana

While practicing dharana teaches control of the mind by concentrating on a single point, dhyana goes much deeper. Through meditation (dhyana) a yogi experiences a deep and prolonged sense of connection with the universal consciousness. Patanjali permitted the use of props—Sanskrit sounds, images of a guru, even charts or maps—as long as they weren't sexually stimulating or otherwise distracting. The experience of dhyana is one of release, expansion, and tranquility. It is the release of all sense of attachment, whether physical, mental, emotional, or spiritual; expanded awareness of the interconnectedness of all things; and an abiding state of blissful tranquility that is indifferent to joy as well as to sorrow and totally absorbed in the moment. As the mind, ego, senses, intellect, body, and breath all lose their separate identities, Patanjali reminded students, a yogi moves toward seeing the universal consciousness, or achieving samadhi.

Samadhi

True liberation, or samadhi, in Patanjali's eight-limbed yoga path, brings together the knower, the act of knowing, and that which is known. For Patanjali, there were no distinctions, no oppositions, and no self-awareness. Samadhi is the state of total absorption, of exquisite balance, the state in which a yogi becomes one with the single point (*ekagraha*) of his meditation (*samprajnata*

samadhi) and in which he ultimately transcends the self, completely obliterating any distinction between subject and object (*asamprajnata samadhi*). Although achieving samadhi is a lifetime endeavor, it can also happen in a blink of an eye. Patanjali taught that everyone is capable of true liberation; that even in a single moment each of us can experience wholeness and realize in our hearts and souls what it means to be one with the universal consciousness.

Of course, many obstacles (*antaraya*) stand in the way of achieving true liberation. Patanjali picked nine in particular: sickness, laziness, self-doubt, inattention, over-indulgence, inability to concentrate, lack of perseverance, false knowledge, and lack of mental effort. Succumbing to any of these roadblocks, he said, would bring pain and suffering to the body, shortness of breath, and depression or even despair.

Patanjali's Kriya Yoga

Although he is best known as the chronicler of the eight-limbed yoga path, Patanjali also presented a version of *kriya yoga*, the path of transmutative action (i.e., the act of changing into a higher form) in his *Yoga Sutra*. Kriya yoga can best be described as a form of internal karma yoga. That is, by perfecting the niyamas or self-disciplines of Patanjali's eight-limbed path, particularly tapas (austerity), svadhyaya (self-study), and isvara pranidhana (devotion to the Lord), a yogi erases *samskara* (subliminal activators) from his subconscious. Samskara are like karma scars that result from good or bad behavior. They are indelible memories, imprinted on the subconscious, that propel the conscious mind to act; they are what dictate a person's birth, life experiences, and death. These activators cause the constant chatter or fluctuations in the mind that separate a person from purusha and make it impossible for him to experience it. An individual has good kinds of samskara and bad kinds, according to the *Yoga Sutra*. The bad kind keep the conscious mind actively seeking experience outside itself, regardless of whether that experience is pleasurable or painful. The good kind stop the conscious mind from seeking and attaching itself to external objects and senses. The resultant cessation (*nirodhah*) of vritti (fluctuations) and samskara brings true liberation.

THE POST-CLASSICAL ERA OF YOGA

Patanjali's *Yoga Sutra* defined yoga practice in the early part of the first millennium, and his eight-limbed path became a central aspect of the yoga systems that followed. The *Yoga Sutra,* however, was firmly rooted in the dualism of Samkhya philosophy, a school of thought that existed alongside the nondualistic Vedic and *Gita* traditions without ever supplanting them. Putting a precise date on the decline of classical yoga, as represented by Patanjali, and the subsequent start of the post-classical period is impossible, because the boundaries separating schools of yogic thought were remarkably fluid. Certain concepts and tenets from Patanjali and the early *Upanishads* continue unchanged or only slightly modified throughout the post-classical period as part of what might be called mainstream yoga. Upstart schools such as tantra or hatha yoga, which took exception to or radically departed from many of these older tenets, expanded the practice of yoga in often radical ways. The one thing both mainstream and new-age post-classical philosophers had in common was their rejection of Patanjali's dualistic world view. That marked the close of one era and the beginning of a new one.

Understanding the concepts of duality (*dvaita*) and nonduality (*advaita*) is no easy task, especially since they seem to have a lot in common. Both schools of thought believed in a universal consciousness that is formless, omnipresent, and immortal. Judeo-Christians call this the soul; for Patanjali it was purusha, and the nondualistic tradition of Advaita Vedanta called it Atman or Self. Although this Atman resides in each one of us, he (purusha may be formless, but he's still considered to be male) cannot be understood by the senses—he can't be seen, heard, smelled, touched, or tasted. Both schools understood that humans suffer when they become disconnected from this higher Self, and both believed that liberation comes when humans realize their true, transcendental Self.

For the dualist in preclassical and classical yoga, this suffering occurred when someone held onto and became subsumed by everything that was not the Self—in other words, when he came to believe that all he did, all his relationships, actions, feelings, thoughts, or motives made up his true Self. A person could free himself from suffering

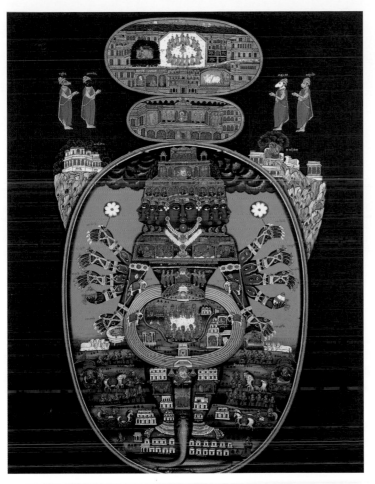

An early 20th-century depiction of Krishna in cosmic form.

only when he let go of his attachments to such things and realized—not with the intellect, but with the heart—that the transcendental Self resided within and that the Self was the ultimate reality. For the nondualist in pre- and post-classical yoga, suffering began when an individual tried to make a distinction between Self and no-Self; when he failed to understand that he was a small part of something much larger than himself; when he forgot that everything he did, all that he sensed, was simply a manifestation of the transcendental Atman or purusha. A nondualist released himself from suffering when he came to understand that

his Self was not separate, but an integral part of the transcendental Self or Atman. Today, it might be easy to understand the difference between these philosophies if we paraphrase Shakespeare. For the dualist, "all the world's a stage" and the play prakriti (nature, primordial matter) puts on is for the benefit of purusha (universal consciousness, transcendental Self). The story is make-believe; the parts the actors play are not the same as the lives they lead; and the roles they take on are separate from who they really are. Obviously, to mistake the action on stage for real life would be confusing at best; knowing that the actor who

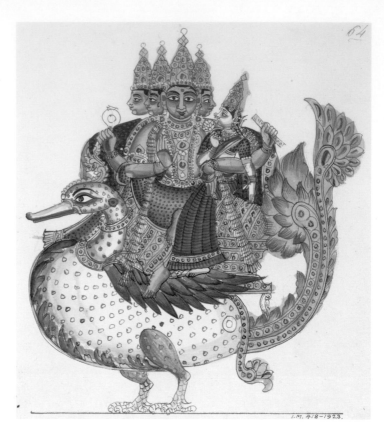

Five-headed Brahma, the creator god, with Saraswati, his Shakti or life force, on the back of Vahana, the Cosmic Goose.

plays Hamlet is in fact *not* Hamlet makes a world of difference.

The world's stage, for the nondualist, looks quite different. The play, while different than real life, is not separate from it. The play can't exist without the actors, who are real people, but playacting is only one aspect of who the actors are. The actors are real people; the roles they play, the script, the music are all contained within real life. Anyone who views the play as its own reality, separate from everything else, will get terribly confused.

It's somewhat easier to see the Divine in the mundane when you take the nondualistic view of reality, because the Divine is everywhere and in everything. When Atman or purusha is separate, how can anyone glimpse its luminous nature in everyday life? Patanjali never really answered that

question, but later commentators explained that by practicing yoga (the eight-limbed path), the yogi attains the highest level of existence. At this point prakriti becomes so transparent and illuminating (sattvic) that purusha, the transcendental Self, shines through and reveals himself. The path toward true liberation lies in experiencing (not just believing) the universe as one. This combination of jnana yoga (yoga of wisdom and knowledge) and karma yoga (yoga of taking action) is similar to the ideas espoused in the *Bhagavad Gita*.

The History of Tantra Yoga

Tantra emerged early in the post-classical period, around the fourth century C.E., but didn't reach its full flowering until 500 to 600 years later. This school represents a rather radical departure for

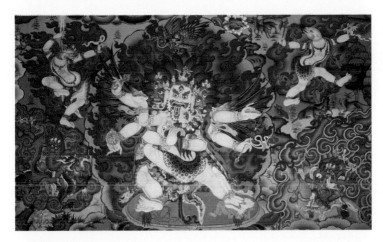

This powerful tantric diety comes from the Buddhist tantra tradition, shown here holding a thunderbolt, a chakra, and a dagger, all symbols of protection.

yoga philosophy. In what could only have been understood as heresy, tantra rejected the *Vedas* (the most sacred texts of Hinduism since at least 1500 B.C.E.) as irrelevant. It refuted the notion that liberation could be attained only through rigorous asceticism and meditation, and it dismissed the Samkhyan precept that a yogi must renounce the world in order to free himself from it. Tantra also eschewed karma yoga (the path of action or service), choosing instead to focus on devotion (bhakti), most particularly worship of the Goddess.

In teaching about the causes of suffering and the path to liberation, tantra shares common ground with its ancestors. Like the nondualistic authors of the early *Upanishads*, tantric yogis believed that human suffering comes from the illusion of opposites, from the mistaken notion that the Self is somehow separate from the objects it desires. Being good nondualists, *tantrikas* (tantric yogis) see all possible sets of opposites, all dualities (good and evil, hot and cold, hard and soft, male and female) contained within the universal consciousness. The only way a yogi can liberate himself from suffering, according to tantra, is to unite all the opposites or dualities in his own body. Like Patanjali, tantrikas believe in the need to have a strong, pure physical body. While Patanjali may have acknowledged the need to strengthen and purify the body, he ultimately believed that the body was defiled and that a truly liberated yogi would shun the company of others

for fear of becoming contaminated. Tantrika, on the other hand, celebrated the physical body, which they considered to be a sacred temple of the Divine, as a means to conquer death. The body became the vehicle for attaining liberation. In tantric yoga, the universal consciousness, which earlier philosophers called purusha, became Shiva and resided within the body. The principle of nature or creation, called prakriti in earlier yogic thought, became *shakti* and lived at the base of the spine. The ultimate unity — the male energy of Shiva with the feminine principle shakti — took place internally and led to final liberation or samadhi. Unlike the more traditional nondualists, however, tantrikas believed that the whole world was not an illusion, but a manifestation of the Divine and that all experience brought the practitioner closer to his or her own divinity.

Most Westerners equate tantra with kinky sex practices, and in one particular school of tantra uniting the male energy of Shiva with the feminine principle of shakti actually does lead to unusual sexual positions and wild orgiastic practices. The *vamamarga*, or left-handed path of tantra, employed traditionally forbidden pleasures, including sexual intercourse, to achieve samadhi. After all, they reasoned, how can an individual know what to transcend if he doesn't experience it first? The more conservative, right-handed tantrikas, on the other hand, weren't quite so literal. In fact vamamarga practices horrified them. They considered these practices dangerous,

and preferred more symbolic means of uniting male and female energies. The right-handed tantrikas relied on arduous practices of asana, pranayama, mudras, and bandhas to awaken the female energy (shakti), draw it up through the body, and unite it with the male Shiva at the crown of the head. Both types of tantra respected women far more than their yogic predecessors and most of their contemporaries, and revered the feminine deity (Shakti) as the necessary, active energy that made liberation possible.

Not everything in tantra broke with yogic tradition. Before a yogi could even begin tantric practices, he had to adhere strictly to the yamas and niyamas (ethical standards and moral disciplines) and the asanas and pranayamas as outlined in Patanjali's eight-limbed path in the *Yoga Sutra*. From there, the adept learned to concentrate (pratyahara) on a single point (ekagraha); for a tantrika, this point was an icon of a deity. Once he mastered pratyahara, he was ready to study visualization, which included feeling the deity's presence and summoning the sacred force of the deity in order to experience its divinity.

Similarly, tantra's use of mantras (sacred sounds) is as old as the *Rig Veda*, but tantrikas employed these sounds in a very different way. Each letter of the mantra (given to the student by his guru) corresponded to a place in the body and each place in the body represented a force in the universe. By chanting the mantra, the yogi could awaken the body and its corresponding universal forces. In order to practice this form of mantra meditation, the body must be pure and strong and the mind clear and alert.

Tantric yogis liked to use visual aids, such as mandalas, in their meditations. Generally made of wood, paper, or cloth, tantric mandalas were drawings of circles and geometric designs. Regardless of how simple or complex these drawings were, they always contained a seed or *bindu* at the center, which represented the union of the cosmos and the mind; concentric circles, which represented the various levels of existence; and a square "fence" around the circles, with open gates, to protect the sacred space. Ultimately, by meditating and visualizing, the tantrika entered into the mandala and realized that the unity of all things resided in him and that there was no separation between him and the Divine.

Hatha Yoga

Hatha yoga, out of which came the physical postures the Western world now embraces, first appeared in the ninth or tenth century. Despite its rather detailed and complex philosophic underpinnings, it was little more than a small and somewhat radical sect during the post-classical period. In fact, among some Hindus of the period, hatha yoga had the reputation of being nothing short of heretical in its focus on the physical and in its fascination with magical powers. Hatha yoga's principles arose from tantra, and incorporated elements of Buddhism, alchemy, and *Shaivism* (worship of the transcendental Shiva).

Like tantrikas, hatha yogis believed that creating polarities (male vs. female, hot vs. cold, happy vs. sad) caused suffering and brought about disease, delusion, and pain. The very name hatha yoga, a combination of "ha," meaning sun, and "tha," meaning moon, denotes the union of opposites. Hatha also means a force or determined effort, and yoga, of course, translates as yoke or joining together. Therefore, hatha yoga implies that it takes a lot of strength, discipline, and effort to unify opposing forces and to bring together the body and the mind. The biggest obstacles to practice for the hatha yogi include greed, hatred, delusion, egoism, and attachment.

Interested less in the sexual union of opposites than tantrikas, hatha yogis strove to transform the physical body into the subtle, divine body and thereby attain enlightenment. The transformed body was said to be impervious to disease, void of any defects, eternally youthful, and the bearer of paranormal, magical powers. Before hatha yoga students could even hope to accomplish such transformation, however, they had to learn an intricate physiology of the body, including the muscles, organs, chakras (energy channels), and tissues, and the gods that govern each. Hatha yogis also had to perform intense purification rituals before they could begin asana and pranayama practices. As with all yoga practice at the time, yoga students received instruction from their gurus.

Even though hatha yoga remained a somewhat marginal sect during the post-classical period, it produced an impressive number of treatises and prescriptive manuals. The first and primary text was written by a yogi named Goraksha, the person

The Role of the Guru

The idea of a guru, a spiritual teacher, is as old as the *Vedas* themselves. Much of yogic teaching was shrouded in secrecy, and the only way to secure the teachings—and understand them—was to sit at the feet of one's teacher, who had learned the tradition from his own teacher. *Guru* is a Sanskrit word meaning dark ("gu") and light ("ru"), and implies someone who takes a student out of the darkness and into the light. The guru's job is to remove the veil of ignorance, to open his student's eyes to what is real, and to awaken the powers within him. Although achieving final liberation is ultimately a solo endeavor, the ancient texts warn that students need the light of their teacher to lead them there. The guru, after all, has already realized his true nature, the transcendental Self, and the student must treat him with utmost reverence and respect. Yoga gurus still exist today, transmitting *shaktipat* (blessings or psychospiritual energy) to their disciples.

A disciple washes the feet of his guru.

most often deemed the father of hatha yoga. Like most early gurus, Goraksha was a rather elusive figure. Quite possibly a member of the weaver caste in the Punjab, he probably lived in the ninth or tenth century C.E., although later hatha yoga texts also place him in the twelfth or thirteenth century. Goraksha founded the Natha sect of yogis and was considered by some to be a miracle worker, saint, and revered teacher. His earliest writing, the *Siddha Siddhanta Paddhati*, introduces several important elements of hatha yoga, including the idea that the physical body is only one level of embodiment. There are five others, moving from the grossest (*garbha* or physical) body to the subtlest (*para* or transcendental) body. He also delineates nine energy channels or chakras, three signs or *lakshya* (literally, visions), and 16 props or *adhara*, upon which a yogi focuses attention (the ankle, the thumb, the thighs, the navel, etc.).

Svatmarama Yogin, who called himself a disciple of Goraksha (even though he came a few centuries later), wrote a second treatise, the *Hatha Yoga Pradipika*, probably during the mid-fourteenth century. This text describes sixteen postures, most of which are variations of Padmasana (the cross-legged Lotus pose), several purification rituals, eight pranayama techniques (primarily to retain the breath), and ten seals (mudras) with specific *bandhas*, or locks to constrict the flow of prana or life force. As Svatmarama explained, before the mind can even hope to control the senses, the breath must neutralize the mind. Steady, rhythmic breathing calms the mind, freeing it from external distractions; a calm mind in turn reins in the senses. Although decidedly nondualistic in nature, Svatmarama's six-limbed yoga path was exclusively for the attainment of samadhi through the practice of *raja yoga* (the yoga of Patanjali).

The *Gheranda Samhita*, a late-seventeenth-century manual based on the *Hatha Yoga Pradipika*, offers seven niyamas, or disciplines necessary for yoga practice: cleanliness, firmness, stability, constancy, lightness, perception, and nondefilement. The manual's author, the sage Gheranda, prescribes 32 asanas and 25 mudras. He also outlines an intricate purification system. But despite this emphasis on the physical body, Gheranda believed that a yogi attains liberation or ecstasy ultimately through the kindness of his guru.

Perhaps the most comprehensive—and the most democratic—treatise on hatha yoga, the *Shiva Samhita* may have been written toward the end of the post-classical period, as late as the early eighteenth century. It emphasizes that even a common householder (a common *male* householder, that is) can practice yoga and reap its benefits—a concept that would have startled earlier proponents of yoga. The *Shiva Samhita* outlines the intricacies of esoteric physiology, names 84 different asanas—the most wide-ranging list to date—and describes five specific types of prana (or life force), providing explicit techniques to regulate them. Unfortunately, only four of the asanas are described in detail. Just like all hatha yoga philosophy, the *Shiva Samhita* postulates that performing asanas will cure a yogi of all diseases and bestow upon him magical, superhuman powers.

Hatha Yoga Physiology

From its earliest incarnation in Goraksha's *Siddha Siddhanta Paddhati*, hatha yoga delineated an abstruse physiology that moved far beyond what Westerners would describe as scientific anatomy. Successive hatha yoga texts refined and expanded Goraksha's anatomy in an effort to describe how yoga transforms the physical body. Besides being able to identify the muscles, bones, flesh, blood, veins, organs, and nerves of the physical body, a student of hatha yoga had to understand the elements of the subtle body—the nadis (ethereal channels through which prana circulates), the chakras or psychoenergetic centers, which loosely correspond to the neuroendocrine system, and the bhutas, the five elements of nature inherent within the body itself.

Much like the healers in Vedic times, hatha yogis believed that the body mirrors the universe. That is, everything in the physical body is a microcosm of everything found outside the body in the natural world. For example, the five elements of nature—air, fire, water, earth, and space (or ether)—are present in the body. Air (*vata*) manifests as breath and movement in the body; fire (*agni*) as digestive fire or heat; water (*ap*) as urine, semen, blood, perspiration, and saliva; and Earth (*prithivi*) as the densest part of the body—the bones, muscles, and skin. Ether (*akasha*) represents the subtlest, most luminous "inner space."

The Five Aspects of Prana

Prana—life force, vital energy, spirit, or cosmic breath—is more than just the air we inhale and exhale every day. As far back as the *Vedas*, priests, scholars, and yogis alike dissected prana into at least five different aspects.

Prana **or ascending breath** resides in the heart. Associated with the color red and the fiery energy of the sun, this prana is light and energizing. Distinct from the universal life force also called prana, the individualized prana comes up through the *pingala nadi* (one of the primary channels of life force) on the right side of the spine, and governs the chest, torso, and stomach. It controls respiration (both the inhalation and the exhalation) as well as cardiovascular health.

Apana **or descending breath** governs the lower half of the body, most particularly the digestive tract and the reproductive organs. Considered calming and centering, apana is associated with the moon and connected to the exhalation. When brought together in the belly with prana and *agni* (the digestive fire), apana is said to awaken the *kundalini* power.

Vyana **or the diffuse breath** circulates life force through the body, most particularly in the joints, eyes, ears, and throat, and supports the inhalation of prana and the exhalation of apana. Some texts say that vyana activates speech.

Udana **or the up-breath** also circulates life force, concentrating on the joints, limbs, and digestive tract. According to Patanjali, the effects of udana include the supernormal power of levitation.

Samana **or the breath of food** pervades all limbs and governs the bodily functions of digestion and elimination. It is responsible for distributing food throughout the body and providing nourishment. Early texts place it at the heart; hatha yoga texts say it resides at the navel.

As a yogi controls the flow of prana through his body, he is ultimately able to release his mind and move toward oneness with the Universal Consciousness.

Agni, ancient God of Fire, becomes internalized as heat or digestive fire in the body.

By meditating on the body as a microcosm of the universe, hatha yogis believed they could more easily understand the interconnectedness of everything. By transcending the body, the yogi transcends the universe. For a hatha yogi, the spine is the same as the mythical Mount Meru at the center of the earth, where the gods reside; the yogi's arms and legs are no different than the continents of the world; his eyes are the sun and the moon; his toes, knees, and thighs are the seven hells; his head the heavens; and the soles of his feet give solace to the tortoise that holds the universe on his back.

The Five Sheaths
Hatha yogis saw the physical body as one aspect of an individual, one layer through which the transcendental Self can express itself. In an intricate view of the human body, hatha yogis identified five different sheaths or *koshas*, all vibrating at different frequencies. These interdependent, interpenetrating layers provide a glimpse of what Westerners today know as the body-mind-spirit connection. The anatomical layer, the *annamaya* kosha or sheath composed of food, comprises the physical body, which includes skin, muscles, and bones, and the five gross elements (bhutas)—earth, water, fire, air, and ether. When a yogi practices asanas, he is working with the annamaya kosha. The next layer, the *pranamaya* kosha (the sheath composed of life force) exists on a slightly deeper level and represents the physiological body, which includes the circulatory, respiratory, excretory, digestive, nervous, glandular, and reproductive systems. Pranayama practice touches this kosha. Deeper still, the *manomaya* kosha (the sheath composed of the mind) is the mental or psychological body and includes the emotions as well as the mind. Meditation reaches this layer. The *vijnanamaya* kosha (sheath composed of awareness) represents the intellectual body. The serious study of scripture (*jnana marga*) awakens this sheath. And at the deepest level, the *anandamaya* kosha (the bliss sheath) represents the spiritual body, which encompasses the transcendental Self.

When a yogi performs asanas, pranayama, or any meditation (dhyana), all the koshas reap the benefits of his actions. Which is to say, what he does for or to his body ultimately affects his mind and his spirit. For example, meditation relieves the stress muscles and joints feel (annamaya kosha), which in turn quiets the sympathetic nervous system (pranamaya kosha), which calms the emotions (manomaya kosha), which quiets the mind, allowing the yogi to see more clearly (vijnanamaya kosha), which puts him in closer touch with his divine Self (anandamaya kosha).

Hatha yoga defines the mind a little differently than Westerners, dividing it into the lower mind (*manas*) and the higher mind (*buddhi*). Manas is that aspect of consciousness that takes its cues from the senses—it remembers, perceives, desires, doubts, feels, and experiences. Its tendency is to jump around a lot and get stuck worrying about external stimuli. It needs yoga, particularly pranayama, to control it, to "yoke" its energy. This lower mind bears no relation to intelligence, however. Buddhi mind governs intelligence, that higher form of discernment yogis call wisdom. Practitioners of yoga learn to control the lower mind and awaken the buddhi mind.

The Nadis

On a base level, the *nadis* correspond to the veins and arteries that carry blood to and transport waste products out of the body. On a more esoteric level, the nadis represent subtle channels that circulate prana or life force throughout the body. In order for a yogi to stay healthy, obviously his arteries and veins must remain clear and open for the blood to flow freely; in order to release the mind and ultimately connect with the higher Self, the subtle channels (particularly those within the central axis or spinal column) must remain pure, allowing prana to flow unimpeded. According to hatha yoga physiology, these two types of pathways interconnect. Blocked or clogged arteries impede the free-flow of prana just as impure or coiled chakras and nadis affect physical and emotional well-being. Someone once suggested looking at the spine as a garden hose. If the hose has kinks in it, the water can't flow freely from the spigot to the nozzle. If the body's channels (whether the arteries or the nadis) are blocked or imbalanced, prana can't flow unimpeded either.

In hatha yoga, the yogi's spinal column — the central axis of his body — controls everything. Like Mount Meru, hatha yoga texts taught, this spine is fixed and immutable. Within the spine exist several layers of nadis, which circulate prana. The most important of those layers is the *sushumna* nadi, which transports the prana from the base of the spine up through the crown of the head.

To the right of the sushumna nadi sits the pingala nadi. Beginning at the base of the central axis, it ends in the right nostril. The pingala nadi's nature is heating and expansive, like the sun's energy, and moves the life force through the body. Closest physiologically to the sympathetic nervous system, this nadi energizes the body and invigorates the whole system. It is said to regulate respiratory and cardiovascular functions.

The *ida* nadi — the channel of comfort — sits to the left of the sushumna nadi. Beginning just above the sex organs, this channel terminates at the left nostril and governs the lower half of the body, from the navel to the feet. Physiologically akin to the parasympathetic nervous system, the ida nadi relaxes and restores equilibrium to the body. Governing the exhalation, or the suspension of the breath after the exhalation, this subtle channel cools the body and, like the energy of the moon, is considered feminine and calming. According to the *Shiva Samhita*, *amrita*, the nectar of immortality flows through this channel, nourishing the whole body.

A hatha yogi's goal is to collect the prana, which the ida and pingala nadis circulate throughout the body, and direct it to the sushumna nadi. Once in the spinal column, the prana, amplified and fueled by yoga-agni (the fire of yoga), ignites the kundalini Shakti and forces her up through the sushumna channel to the crown of the head where she will unite with Shiva, the universal consciousness.

The Chakras

Subtler still than the nadis, the chakras reside deep within the sushumna nadi in what's called the *brahma* nadi, a channel no thicker than one one-thousandth of a hair's width. In these wheels or rings of coiled energy, the subtle body meets the physical. The word chakra itself means wheel, and the chakras are often depicted in paintings and mandalas as lotus flowers. Besides referring to the seven energy loci in the subtle body, the word can also refer to a diagrammatic tool a guru would use to determine the appropriate mantra for his student's meditation practice, or the circle or wheel around which male and female initiates of left-handed, sexual tantra sit with their guru.

Many Western scholars equate the seven chakras with the neuroendocrine (glandular) system in the body; others believe they correlate with the body's organs. Actually the chakras can best be understood in a more metaphysical sense. Located all along the spine, and only coincidentally near the thyroid, the heart, and the reproductive organs, the chakras take in and hold, coiled within them, the cosmic energy necessary for all life. Only through intense yoga and pranayama practice can a yogi awaken each chakra and begin to activate the divine energy it contains, which the nadis then circulate through the body. At each chakra center, emotions rooted in that locus awaken and transform as well. In other words, each chakra has a physical, emotional, and spiritual component.

For a hatha yogi, these chakras serve as a kind of internal map, a visual aid, as it were, to help meditate on the body. Each chakra, seen as a lotus blossom with a set number of petals, has its own

ruling god or goddess, as well as a particular color, and a unique *bija* mantra, or seed syllable from the Sanskrit alphabet. Each chakra corresponds to one of the five gross elements as well—earth, wind, fire, water, and ether or space. The first or spiritually lowest chakra is located at the base of the spine; the seventh chakra, the *sahasrara* chakra, transcends the physical body and resides just beyond the crown of the head.

Muladhara **Chakra (The Root Wheel).**
Situated at the base of the spine or the opening of the anus, this is the first, most basic chakra. Its element is earth, its color crimson, and its bija mantra *lam*. Its sense is the sense of smell, its organ of action is the feet, and Dakini is the goddess who governs its energy. The base of the spine, the legs, feet, and large intestine are associated with this chakra. Yogis who meditate on the muladhara chakra, ancient texts promise, are able to jump like a frog and ultimately to levitate. The sushumna nadi rises out of this root chakra and the kundalini shakti—the serpent power of the divine goddess—lies coiled deep within it.

Svadishthana **Chakra (The Self-Based Wheel).**
The second chakra is associated with the element water and the color orange. Governed by the god Vishnu and the goddess Rakini, the center of the svadishthana lotus is the navel. Its sense organ is taste, its organs of action are the hands, and its bija mantra is the syllable *vam*. Not surprisingly, the svadishthana chakra, situated in the genital area, embodies fertility. It has as its symbols a crocodile-like sea monster and a shiny, coral inward-facing phallus. The reproductive organs, hips, sacrum, lower back, bladder, and kidneys are associated with this channel. Yogis who meditate on the second chakra often attract the opposite sex, which brings them even more challenges.

Manipura **Chakra (The Wheel of the Jeweled City).**
Located deep within the solar plexus, the manipura ring houses the emotions, particularly fear, anger, hatred, and shame, and is connected to the breath. The god Rudra and the four-armed goddess Lakini govern this center, the bija mantra of which is ram. Its color yellow, and its gross element fire. Its sense is the sense of

sight, and its organ of action is the gastrointestinal tract, where it governs digestion and metabolism. Yogis who meditate on this chakra are said to gain freedom from pain and disease, enjoy a deep sense of calm, and acquire the power to make gold, medicinal remedies, and locate hidden treasures. In other words, they attain a certain level of magical powers.

Anahata **Chakra (The Wheel of the Unstruck Sound).**
One of the more powerful chakras, the anahata sits at the center of the heart, which since Vedic times has held a venerable place in a yogi's practice. This is the spot where the physical nature of existence (prakriti or shakti) present in the lower chakras connects with the divine essence (purusha or Shiva), present in the upper three chakras. Governed by Pinakin and the three-eyed goddess Kakini, the anahata chakra is home of the individual self and the seat of the transcendental Self. Its color is green, its sound *yam*; its gross element is air, its sense is touch, and its organ of action is the penis. The anahata chakra is associated with the heart and the lungs and governs emotions such as hope, anxiety, doubt, remorse, and egoism. Yogis who meditate on the anahata chakra attain special powers of clairvoyance and clairaudience, and develop compassion and a deepening sense of the spiritual.

Vishuddha **Chakra (The Pure Wheel).**
Situated in the throat, the vishuddha chakra is considered the great doorway to liberation, the seat of intellectual awareness. Governed by the goddess Shakini, its gross elements are sound and ether, its color a smoky purple, and its sense hearing. According to tantra, this pure wheel is connected to the spiritual body. Its organ of action is the mouth, and its sound is *ham*. According to the *Shiva Samhita*, yogis who meditate on the vishuddha chakra (sometimes called the *jalandhara-pitha*) acquire immediate understanding of the ancient texts (the *Vedas*) and all the secrets they contain. In other words, they experience and immediately understand the subtle vibrations beneath the sounds that create the universe.

Ajna **Chakra (The Command Wheel).**
Located between the two eyes and just above them at eyebrow level, the ajna chakra corresponds to

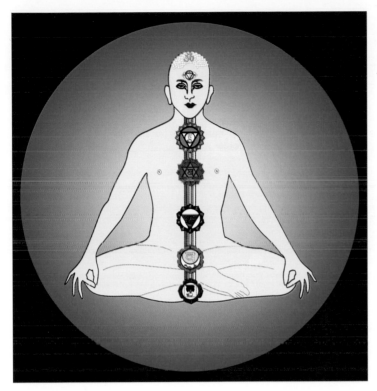

the third eye and is often dubbed the guru chakra, because the student receives knowledge telepathically from his guru through the third eye. It has no gross element, but its color is a deep indigo, its sense is the sense of cognition, its organ of action is *yoni* (the female genitalia), and its sound is the primordial Om. Governed by Parama-Shiva and the goddess Hakini, the ajna chakra presides over the realm of understanding and the power of concentration. Hatha yoga explains that a balanced ajna chakra brings an abiding sense of humanity and spirituality; the yogi receives psychic powers, including the power of telepathic communication, the ability to see the future in his dreams and visions.

Sahasrara Chakra (The Thousand-Spoked Wheel).

Generally thought to reside just above the crown of the head, the sahasrara chakra signals the final destination for the kundalini serpent, which begins its journey at the base of the spine in the root chakra muladhara and culminates here in the union of Shiva (the male energy) and Shakti (the feminine). Home to universal consciousness (purusha in the days of old), the great emptiness (*sunyata*), and the *parama* bija (the ultimate seed point), this thousand-petal lotus represents pure consciousness and encompasses all colors, all sounds, all senses, and all organs of action—in essence, all functions of the mind and the body. Associated with the highest functions of the mind, the sahasrara chakra is more than just thinking clearly. It contains the thought within the thought, the action preceding the action. Its wisdom comes from thinking with the heart and can only be experienced with an open heart.

Purification Rituals

A hatha yogi's guru taught him to prepare and purify his body before beginning the deep

The Seven Modern Chakras

Modern-day Kundalini Yoga practitioners believe life issues contribute to chakra imbalances, which, in turn, cause physical, emotional, and spiritual pain (or dis-ease). They see the even-numbered chakras as decidedly feminine—promoting feelings, vision, and the ability to love unconditionally—and the odd-numbered ones as masculine—assertive, decisive, and being out in the world. When the chakras are out of balance, these practitioners often recommend specific asana and pranayama techniques to bring the subtle channels back into balance.

1. The muladhara chakra, when balanced, brings a sense of physical and emotional groundedness, the ability to stand on your own two feet. Patient, calm, and confident people enjoy balance in this area. People who feel flighty, edgy, or too much in their heads, suffer from a root chakra deficiency, according to modern-day teachers; those who are greedy, possessive, or who use food excessively to help them feel better have an overactive muladhara chakra.

2. Svadishthana chakra balance invites movement—physical, emotional, and sensual—into your life. If you have the ability to go with the flow, accept things as they unfold, see the beauty (and the tragedy) in the world, delight in your sensuality and sexuality, you have a balanced second chakra. If you feel rigid, unable to take time away from your Type A workaholic habits, resist change, and have trouble connecting with your feelings, you probably suffer from svadishthana chakra deficiency. On the other hand, if you feel out of control or have no sexual or emotional boundaries, your second chakra has gotten a bit out of hand.

3. Manipura chakra balance is synonymous with the ability to transform, take risks, be warm yet confident and assertive. Poor third chakra energy results in digestive problems, even eating disorders, and poor self-esteem. An overactive manipura chakra fosters the obsessive-compulsive drive toward perfectionism, the inability to let go, and hot emotions such as jealousy, greed, and hatred.

4. Anahata chakra health enables you to love unconditionally, bringing joy, openness, and compassion to the world around you while, at the same time, allowing the divine spirit to shine within you. A closed, recoiled anahata chakra literally zaps the life force from your body and your spirit. Physically, your chest collapses, your shoulders round, and your breathing becomes labored. Emotionally, you feel stuck in your head, cut off from your feelings, and estranged from your body. Suspicion, shyness, and self-centeredness may result, as well as asthma, frequent colds, and other lung problems. An over-exuberant anahata chakra may bring feelings of possessiveness or jealousy and physical symptoms like high blood pressure or erratic heart beats.

5. Vishuddha chakra is the vehicle for hearing and speaking your inner truth. A deficient fifth chakra brings about physical ailments like neck and shoulder pains, jaw stiffness, hypothyroidism, and frequent sore throats. Emotional challenges include fear of speaking in public. Excessive vishuddha chakra energy causes you to talk too much without listening, stutter, or be inarticulate. Physically, an overactive thyroid can indicate an overactive fifth chakra.

6. Ajna chakra deficiency causes pride and desire to predominate and may (literally and figuratively) harm the yogi's ability to see clearly. Excessive ajna chakra energy may bring headaches, dizziness, and hallucinations, causing the yogi to feel distracted and unable to concentrate.

7. Sahasrara chakra balance brings clarity to the mind and cultivates insight and the ability to see one's own divine nature. An overly active seventh chakra keeps the yogi attached to spiritual endeavors, separating rather than uniting the body, mind, and spirit. A sluggish sahasrara chakra brings skepticism, lack of confidence, and a deep sense of apathy.

OPPOSITE: *Eleventh-century sculpture of Shiva Nataraja, Lord of the Dance.*

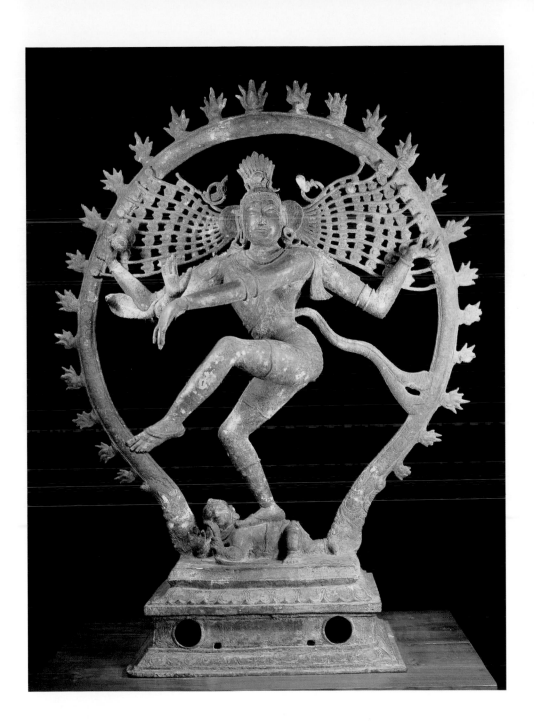

meditative practice required to access the chakras and unleash their coiled energy. The *Gheranda Samhita* outlines several of these rituals, called *shodhana* (literally, practices), which range from simple everyday tasks like cleaning the teeth and ears to extreme purification rites such as removing and washing the prolapsed intestines (not something modern-day physicians would recommend). The yogi also must perform nadi shodhana, purification rituals (mostly specific pranayama techniques involving alternate breathing) designed to keep the channels of life force open and clean so that prana can flow freely. Before he can begin nadi shodhana, the yogi must cleanse and purify his body. The most common purifications, many of which are still performed by serious yogis, included the *dhautis*, the *bastis*, the *netis*, *nauli*, *trataka*, and *kapala bhati*.

The dhautis involved internal, dental, and rectal cleansing, as well as purifying the heart. Dhautis were as simple as belching or passing gas and as challenging as pushing the navel back toward the spine 100 times to stimulate the digestive fires or

The linga, or phallus, is the symbol of Lord Shiva.

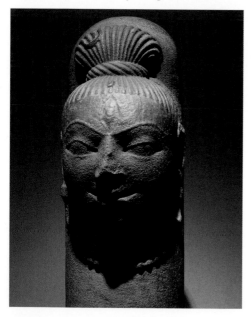

using a turmeric stalk to cleanse the rectal cavity. Purifying the heart, a rather intense practice, included ritual vomiting and again probing with a turmeric stalk—in this case placing it down the throat and slowly withdrawing it to remove excess bile and phlegm. An even more unappetizing practice had the yogi swallowing a long, thick piece of cloth and then pulling it out again after it had remained in his system a while. Hatha yogis swore this custom reduced fever, cured stomach ailments, and even got rid of skin diseases.

The bastis involved dry or wet enemas and were believed to cure urinary and digestive disorders. The dry enemas had the yogi sit in a forward-bend position and contract and dilate his sphincter muscles as he bore down on his intestines. A wet enema called for the same activity while squatting in water.

Netis were ritual nasal and sinus cleansings yogis performed using a nine-inch-long piece of thread. Practitioners inserted the thread into one nostril at a time and pulled it out through the mouth. Intended to clear out the sinus cavities, this routine was also said to improve a yogi's vision.

Nauli, also known as *lauliki* (rolling), involved rounding the shoulders, pressing the navel back toward the spine, and then rotating the main stomach muscle (the *rectus abdominus*). This was said to balance and quiet the digestive system.

Trataka purified the eyes. A yogi performed this ritual by sitting in lotus position and staring intently at an object just in front of his feet. He fixed his gaze on the object for as long as he could, without blinking, until his eyes began to water profusely.

Kapala bhati, while purporting to control hunger, thirst, and sleep, actually cleanses the nasal passages and helps cure sinus problems. This ritual involved a three-step process. First the yogi breathed in through one nostril and exhaled through the other. Then he inhaled water through one nostril and expeled it from his mouth. Finally, the yogi took water into his mouth, held his breath as long as he could, and then expelled the water through his nose, making a loud "sheet" sound.

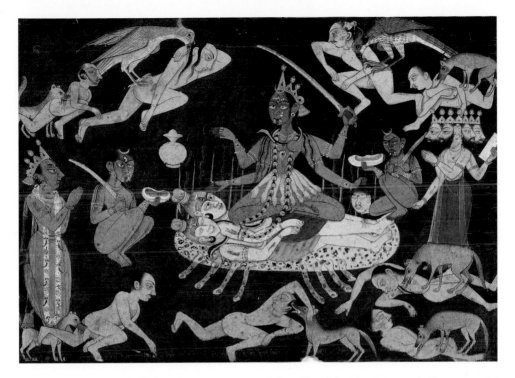

Awakening the Kundalini Serpent

Once a yogi had opened the nadis and purified his body, he was ready to embark on the yogic path to self-realization. As spelled out in tantric and hatha yoga texts, this journey involved asana and pranayama practice, as well as learning mudras and creating bandhas or locks, which control the flow of energy to the chakras and particular parts of the body. To achieve self-realization, a yogi must awaken his divine nature, which can only happen if everything in his yoga practice works in concert. Asanas and pranayama awaken the chakras. The chakras, in turn, activate the nadis, an action that causes the chakras to vibrate. The energy generated from the chakras then flows up through the nadis and circulates in the body. As each chakra uncoils, emotions rooted there arise and transform into divine energy.

In tantra or hatha yoga, the concepts of universal consciousness (purusha) and primordial matter or nature (prakriti) become internalized. In the nondualistic, preclassical yoga that came

Kali, goddess of destruction, sits astride Shiva surrounded by attendants and corpses.

before them, all matter (prakriti) was merely a manifestation of the universal consciousness (purusha). Prakriti was the feminine principle of creation, dynamic energy, the visible dimension of the invisible purusha. Purusha was the male: eternal, immutable, and immeasurable, and completely incapable of creating anything. Prakriti, on the other hand, could create but had no consciousness, no purpose without purusha. Once the yogi realized that no distinction existed between the two, he could release himself from despair, disease, and delusion.

Tantra yoga (and hatha yoga after it) saw Shiva as the masculine universal consciousness (purusha), and Shakti (his consort) replaced prakriti, the feminine aspect of creation. According to these schools, within the yogi's body, Shakti is the kundalini serpent, which lies asleep at the base of the spine, blocking the door to final

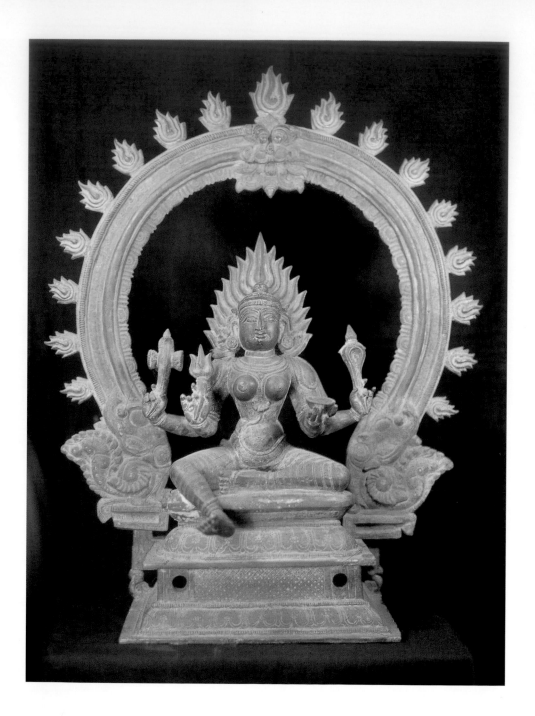

The most common bandhas in hatha yoga are the *mula* bandha (root lock), the *uddiyana* bandha (upward lock), and the *jalandhara* bandha (Jalandhara's lock), all of which are practiced today. The mula bandha contracts the anal muscles and presses the navel back against the spine. This combined movement forces the apana or downward-moving breath upward. The apana and prana (upward-moving breath) then combine to unite with the *nada* and bindu (inner sound and transcendental sound). What that really means is that through intense pranayama practice and meditative concentration, the yogi learns to control (and quiet) his breathing so he can hear the inner sounds (nada) of the body and eventually transcend even the nada to realize the bindu (the sound within the sound, or the transcendental sound of the absolute), which exists just above the heart.

The uddiyana bandha is another technique used to push the life force up the central channel of the body, from the lower abdominals toward the crown of the head. The yogi sits up tall, with his heels pressed against his anus, and presses the abdomen (above and below the navel) back against the spine as he exhales.

The jalandhara bandha technique contracts the throat by using a "chin lock," a method still employed in many modern-day asanas. The yogi inhales, and at the top of the inhalation, presses his chin down onto his chest. Besides curing any throat ailments, jalandhara bandha is said to prevent the nectar of immortality (amrita) from flowing downward into the rest of the body.

THE *YOGA UPANISHADS*

Despite their overriding popularity in the West today, both tantra and hatha yoga were considered radical departures from mainstream yoga, which was far more widespread and popular throughout the post-classical period. This more conservative strain of yoga incorporated much of preclassical yogic thought as well as Patanjali's eight-limbed yoga path, without, of course, his dualistic world view. Roughly two-thirds of the way through the post-classical period, a group of 21 secret teachings called the *Yoga Upanishads* surfaced. Most likely written between the fourteenth and fifteenth centuries C.E., these sacred texts elaborated on particular practices of yoga,

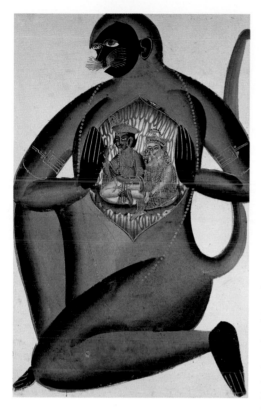

Hanuman, the monkey god, opens his chest to reveal the union of male and female (Rama and Sita) within his own heart.

recruit a female partner who will allow him to ejaculate his semen into her vagina, mixing his fluids with hers. He then forcibly sucks the mixture back out of her body and into his. Although this practice cannot be that beneficial for the female volunteer, it is said to enable the yogi to unite all opposites within his own body. Perfecting this pose, according to the *Hatha Yoga Pradipika*, allows the yogi to disregard the niyamas, the principles of self-discipline.

The vajrolimudra most commonly practiced today is akin to the one described in the *Gheranda Samhita*, which is a balancing pose. The yogi simply sits down, places his palms on the floor and lifts his legs up toward his head.

liberation. The goal of tantra yoga is to forcibly awaken Shakti so she will rise up through the sushumna channel to the sahasrara chakra at the crown of the head and unite with Shiva. This union represents the reunion of all opposites, the combination of physical sexuality and mental and spiritual transcendence, and final liberation (samadhi) from the cycle of birth, death, and rebirth. The path to samadhi lies in joining the sexuality of the body with the spirit of the Divine within the human form to produce a state of transcendence and indescribable bliss.

The action that awakens the kundalini serpent comes from prana or life force, which the yogi brings into his body through specific pranayama practices. The body must be strong and pure, the mind open and clear for the yogi to survive such an awakening; thus making asanas a critical element in a yogi's training. Through asana and pranayama, the yogi opens the pingala, ida, and sushumna channels and prepares himself for the flow of kundalini energy. Once the yogi begins to awaken that energy, however, he must learn how to control it through the practice of mudras (seals) and bandhas (locks), which prevent the energy from moving too fast or entering a particular channel of the body. Advanced practitioners learn to close off the ida and pingala nadis, forcing Shakti to surge straight up the sushumna nadi to the crown of the head.

The practice of mudras and bandhas remained highly secretive, being handed down orally from gurus to only their most advanced adepts. Although the *HathaYoga Pradipika* pronounced them a divine means of liberation and insisted that they produce both curative and magical results, a closer look at some of the instructions reveals that these practices were not for the faint of heart. Here are some examples of *paramudras*, practices that combine mudras, asanas, and pranayama. The last two fall into the "don't-try-this-at-home" category.

Mahamudra, the Great Seal, is the most common of the paramudras. To perform mahamudra, a yogi sits up tall, with both legs stretched out in front of him. He bends his left leg and presses his left foot into the right groin, near the perineum, forming a 90-degree angle to the right leg. Stretching his arms forward, he hooks his big toe with his thumbs and forefingers. He then contracts his throat by pressing his chin tightly against the top of his chest. As he inhales he pulls the abdomen back toward the spine and up toward the diaphragm. Closing off all orifices of the body (eyes, ears, mouth, and nose), he concentrates on a single point between his eyebrows, holding his breath the whole time. According to the *HathaYoga Pradipika*, perfecting mahamudra relieves the yogi of indigestion, consumption, leprosies, and an enlarged spleen. Today yoga therapists also believe it relieves digestive and reproductive disorders and tones the abdominal organs, the kidneys, and the adrenal glands.

Khecharimudra, which means air-moving seal, takes a good deal of preparation before a yogi can master it. For one thing, the student must first cut out the connecting tissue of his tongue, massage his tongue with milk or butter, and soften it enough so that it can stretch up and out of his mouth, reaching the point between his eyebrows. This alone can take six months. Then he needs to get his soft palate out of the way by hooking a piece of metal onto the palate ridge and pulling it forward. At long last—perhaps several months later—he can then draw his tongue back into his mouth, down his gullet, and block the nasal passages that open into the mouth, all the while reciting mantras from his guru and concentrating his gaze between his eyebrows. The medicinal benefits supposedly outweigh the difficulty of the preparation, because the khecharimudra blocks the flow of semen, prevents fainting, hunger, thirst, laziness, old age, and even death; plus it protects the yogi against venomous snakebites.

Vajrolimudra, the thunderbolt seal, also takes a lot of preparation time to accomplish and needs a willing female volunteer. This is how it works: the yogi takes months to cleanse and strengthen his penis and make it as hard as a thunderbolt. Using what is aptly called a phallus lock (*medhra* bandha), the yogi practices keeping his penis rigid for longer and longer periods of time. Before he tries the real vajrolimudra, he practices by sucking cow's milk up into the penile shaft and releasing it back into a bronze vessel. Now he is ready to

OPPOSITE: *A bronze sculpture of Kali from 15th-century India.*

including a few asanas and some of the pranayama and mudras Western practitioners know today. Their emphasis, decidedly nondualistic in flavor, remained focused on the proper way to achieve liberation. Instructions on how to recite the sound Om show up in several of these texts; others demonstrate an elaborate means of breath control (pranayama); still others teach the student how to use inner sound (*hamsa*) to transport the self toward liberation.

One of the *Yoga Upanishads*, *Tejo Bindu Upanishad*, grafts seven new limbs onto Patanjali's eight-limbed yoga path. To the precepts and disciplines (yamas and niyamas), asana, pranayama, withdrawal (pratyahara), intense concentration (dharana), meditation (dhyana), and liberation (samadhi) of the *Yoga Sutra*, the *Tejo Bindu* adds mula bandha (root locks), equilibrium, steadiness of vision, *tyaga* (abandonment), *mauna* (silence), *desha* (place), and *kala* (time). In a similar vein, other *Upanishads* offer additional yamas, niyamas, and asanas, provide bhutas or elements upon which to concentrate in pratyahara, and outline new methods to control the breath. The *Tri Shikhi Brahmana Upanishad* actually mentions 17 different asanas and details practices for purifying the channels (nadis) of the inner body, and for proper breath control (pranayama).

Much like Patanjali, the authors of the *Yoga Upanishads* saw many obstacles to practice, which could prevent a yogi from achieving samadhi. One text (the *Yoga Tattva Upanishad*) lists laziness, boastfulness, and sexual fantasies as impediments to liberation. It deems keeping bad company and becoming attached to the fruits of one's practice (i.e., enjoying the magical powers one attains) equally bad. The author of the *Tejo Bindu Upanishad* concurs, but can't help adding excessive sweating, absentmindedness, stupor, and being distracted to the list.

YOGA COMES WEST

The American brand of yoga we love today focuses primarily on the physical poses called asanas and is thus clearly an offshoot of hatha yoga, even though jnana yoga (the path of knowledge) and the raja yoga of Patanjali's *Yoga Sutra* were the first to gain currency in the West. Like Indian yogis, the first Westerners to encounter yoga were more interested in—and fascinated by—methods and

practices that took them out of their bodies, transcending the physical to put them in closer touch with the absolute. According to yoga scholar Georg Feuerstein, the Western love affair with all things Eastern began in the third century B.C.E., once Alexander the Great's conquests opened up

Eleventh-century sculpture of Shiva as the Great Teacher.

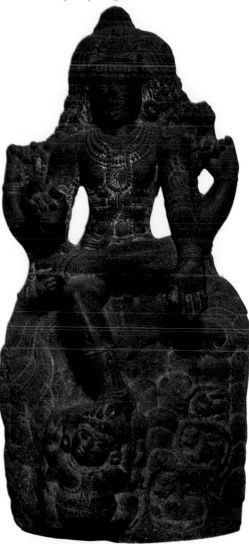

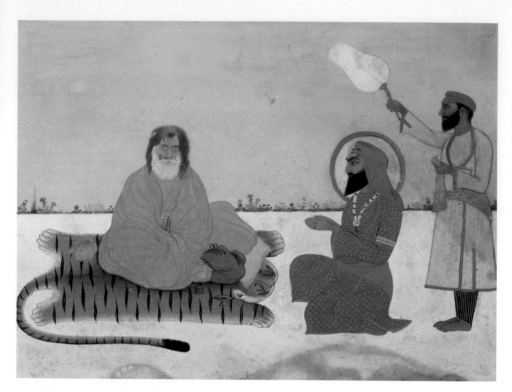

Schools and Branches
of Yogic Thought

Many Western practitioners equate hatha yoga with a particular style of yoga, when in fact the term merely refers to the physical aspect of yoga practice. As far back as the *Yoga Upanishads,* several schools of yoga practice distinguished themselves. *Mantra yoga,* beneficial for even the most beginning (i.e., dull-witted or distracted) student, relied on chanting mantras, or sacred sounds from the Sanskrit alphabet, to achieve enlightenment. *Laya yoga,* a more intermediate practice, used mudras, pranayama, and meditation on the body to achieve control over the senses, longevity, and ultimately liberation. Hatha yoga, a group of physical practices, was geared toward preparing the body for the higher spiritual path of raja yoga, the yoga of Patanjali, which included the eight-limbed path to enlightenment.

These schools of yogic practice are different from the branches of yoga found throughout history, such as jnana, karma, bhakti, raja, and tantra yoga. Each of these five branches represents a particular approach to life and ultimately, to liberation from suffering.

Jnana yoga dates back as far as the *Upanishads* and the *Bhagavad Gita.* It is the yoga of the mind, the path of the sage. Some believe this type of yoga, with its concentration on the scriptures, offers the most direct, albeit the most difficult, path to enlightenment. Western traditions have their own

jnana yogis, such as the Jesuit priests of Catholicism and the scholars of the Kabala in Judaism.

Karma yoga, equally as ancient, made its debut in the *Vedas* themselves. The Vedic philosophers believed that only through action could humans ever hope to appease the gods—which they had to do in order to survive. The discussions between Krishna and Arjuna in the *Bhagavad Gita* provide the most comprehensive example of karma yoga, the path of service and action. This age-old understanding serves as the basis of the karma yoga philosophy we know today, that is, our efforts (how we act in the world and how we perform our duties) create a future, free of suffering for ourselves and for others. Hospice workers, social workers, and those who volunteer in soup kitchens, after-school care, or any other service-oriented program practice karma yoga.

Bhakti yoga is the path of devotion, the belief that by putting your faith in god (Krishna in the *Bhagavad Gita*) you attain ultimate liberation. Again, Krishna's discussions with Arjuna in the *Bhagavad Gita* exemplify this path. The *Gita* says liberation can happen without devotion, by practicing detachment, that is, being in the world but not attached to it. But the liberation available through devotion to Krishna is a superior kind. By "awakening in the divine person of Krishna" the yogi attains suprapersonal liberation. Western practitioners can see plenty of bhakti yogis in their history. Ammachi, a sweet, round-faced South Indian called the "hugging saint," is said to be an incarnation of the Divine Mother; she receives thousands of eager devotees wherever she goes. Mahatma Gandhi, Martin Luther King, Jr., and Mother Theresa are three prime examples of yogis who combined the fiery devotion of a bhakti yogi with the dedication to service of a karma yogi.

Raja yoga denotes the path of meditation, and places Patanjali's eight-limbed path of the *Yoga Sutra* at the center of its practice. Strict adherence to the yamas and niyamas is as important to raja yogis as the steps leading to deeper meditation—asana, pranayama, pratyahara, dharana, dhyana, and ultimately samadhi. Hatha yoga makes its entrance here. It provides the way to gain control over the body. If you lack physical control, you won't be able to control the mind or the senses, which is a critical step on the path toward enlightenment.

Tantra yoga, the path of ritual, elicits the biggest reaction from the uninitiated. Most Westerners equate tantra yoga with kinky sex practices, which include impossible positions and multiple partners. The truth is this branch of yoga practice, the most esoteric and secretive of all, simply sees the sacred in the mundane. It celebrates the human body and seeks to unite all dualities within one's own body. Unlike raja yogis, who believed that the restraint of consciousness (stopping the fluctuations of the mind) was the way to achieve samadhi (liberation), tantra yogis said that one must control the cosmic energy (prana or life force) within the body in order to awaken to the Divine.

OPPOSITE: *A student, sitting at the feet of his guru, practices bhakti yoga, the path of devotion (ca. 1800 C.E.).*

BELOW: *Twelfth-century sandstone relief of three-headed teacher (Trimurti) practicing raja yoga.*

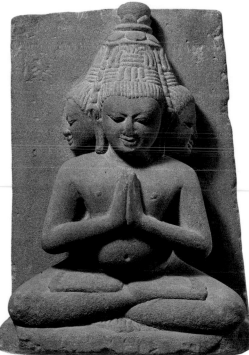

Persia and India. Even before that, Plato and Aristotle paid homage to Eastern philosophy in their writings.

Nearly 50 years before yoga landed on American shores, a group of Englishmen formed the Asiatic Society of Bengal (in Calcutta) and took it upon themselves to study all things Indian. Their research and translations included essays on the *Vedas*, yoga, and the poetry of Shankara (800 C.E.). Society member Sir Charles Wilkins published the first English-language translation of the *Bhagavad Gita* in 1785, his colleague Sir William Jones weighed in with his own translations of the *Isha Upanishad* and a collection of hymns from the *Vedas*, and Henry Thomas Colebrooke wrote essays on the *Vedas* and on yoga, most particularly the *Samkhya Karika*, Ishvara Krishna's commentary on Samkhya.

The contemplative paths of yoga also resonated with a group of American intellectuals and self-described transcendentalists that included Henry David Thoreau and Ralph Waldo Emerson and that drew inspiration from the *Bhagavad Gita*. Fifty years later, Madame Blavatsky, a Russian immigrant, occultist, and student of ancient India, established the Theosophical Society in New York City and in Europe. Her writings, most particularly *Isis Unveiled* (1877) and *The Secret Doctrine* (1888), captivated her audience with the secrets of the ancient *Vedas*.

By 1893 Americans were sufficiently smitten by yoga exotica to embrace Swami Vivekananda, the first Indian spiritual teacher (and perhaps the first East Indian) they had ever seen. Vivekananda spoke passionately about raja yoga at the first Parliament of World Religions held that year in Chicago, and the crowd went wild. He lectured extensively for another two years before moving on to European cities and then returning to India. When he came back to the United States in 1899, he set up the New York Vedanta Society, a still-thriving community dedicated to four branches of yoga practice: bhakti (devotion), karma (service), jnana (knowledge), and raja (the eight-limbed path of Patanjali's *Yoga Sutra*).

About the same time, the Germans discovered the beauty of the Sanskrit language and the mystery of the *Vedas*. Although several scholars of the Romantic era welcomed the rich literature of India, Max Müller, comparative religions pioneer,

most influenced Vedic scholarship and helped birth the flurry of European translations of ancient Indian texts that continued throughout the nineteenth and into the twentieth century. Among the greatest of these was the work of Johann Wilhelm Hauer, who, according to Feuerstein, was the first to study the vast history of the *Vedas*. He produced a translation of Patanjali's *Yoga Sutra* as well. Of course the English and the Germans weren't the only Europeans to gravitate toward yoga research. Feuerstein mentions Poul Tuxen, a Dutch scholar, who wrote a history of the yoga tradition in 1911. Twenty years later, Swedish researcher Sigurd Lindquist published two books on yoga, focusing on its psychological aspects, and by the 1940s, the Frenchman Jean Filliozat had added his translations of several works, and Italian scholar Giulio Cesare Evola his own writings on tantra yoga.

Yoga asanas gained a little more prominence in America around the turn of the twentieth century when hatha yoga adherents began to look more seriously at the physical benefits of their practice. Back in India, partly in an attempt to shore up hatha yoga's sagging popularity, Paramahansa Madhavadasaji encouraged local scientists and medical doctors to explore the physiological aspects of asana practice. One of his students, Kuvalayananda, established the first institute devoted solely to such exploration—the Kaivalyadhama Ashram and Research Institute in Pune, India. Madhavadasaji sent another of his adepts, Yogendra Mastamani, to the United States to set up the first American branch of the institute. Mastamani's connections with the Eclectic Physicians and Benedict Lust, the founder of naturopathy, gave yoga a foothold in the burgeoning holistic medicine practice of the day.

Up through the mid-1920s, Americans embraced a steady stream of Indian swamis coming to the West. But then in 1924, the federal government imposed a quota on Indian immigration. No longer able to bring their gurus stateside, Americans traveled to India to find them. Paul Brunton, a former writer and editor, discovered one of yoga's greatest teachers, Ramana Maharshi, and wrote *A Search in Secret*

OPPOSITE: *Seventeenth-century painting of a yogi in Goraksasana (Cowherd Pose).*

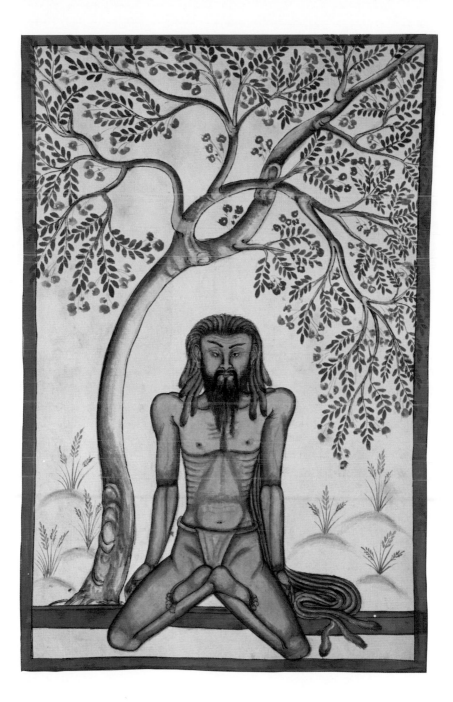

India in 1934, to introduce him to the world. Brunton went on to become one of the most prolific yoga chroniclers of his time.

J. Krishnamurti, an Indian philosopher, drew huge numbers of followers, beginning in the early 1930s and culminating at his death in 1986. For many baby boomers (as well as their parents), Krishnamurti epitomized the beauty and wisdom of jnana yoga, about which he so eloquently spoke, and his life and teachings influenced thousands of educators, philosophers, and laypeople. Besides embracing the spiritual side of yoga, Krishnamurti became an enthusiastic student of yoga asanas, spending many summers in Gstaad, Switzerland, with yoga master B.K.S. Iyengar and, later, with yogi T.K.V. Desikachar.

In 1947, Theos Bernard, another passionate student who studied in India for many years, wrote *Hatha Yoga: The Report of a Personal Experience*, one of the first guidebooks to yoga asanas. Indra Devi, after studying with yoga master T. Krishnamacharya in India, wrote how-to manuals and had scores of Americans bending and stretching to her guru's yoga. In 1950, Richard Hittleman, a spiritual disciple of Ramana Maharshi, began teaching the physical aspects of hatha yoga in New York City. By 1961, thanks to the power of television, Americans everywhere were learning a non-religious, decidedly unspiritual form of yoga exercise. The teacher was the same Hittleman, who hoped to convince these new converts that yoga meditation and philosophy could forever change their lives. His books, including *The Twenty-Eight-Day Yoga Plan,* sold millions of copies and put hatha yoga on the American map. Ten years later, yoga teacher Lilias Folan consummated America's love of this gentle physical form of yoga in her PBS-TV series "Stretching with Lilias." Her openhearted, energetic manner convinced millions more that anyone could and should practice yoga. Today she has produced 11 yoga videos, which have sold more than 700,000 copies, and she continues to teach and lead workshops all over the world.

While America's World War II generation moved and stretched to the yoga of Richard and Lilias, the postwar baby boomers there and abroad yearned for a more spiritual awakening. These young college-age kids turned on and tuned in to Eastern spirituality in general and yoga principles in particular through *Autobiography of a Yogi*, by Paramahansa Yogananda. Although written in 1946, this introduction to the power of yoga spoke to a generation of young people in the 1960s and '70s who wanted more spiritual and transcendental experiences than they could get in their local churches or synagogues. Many of these seekers incorporated asanas into their yoga practice, but their primary goal was enlightenment, not perfect alignment in Downward-Facing Dog. Many of these same novices embraced the teachings of another bhakti yogi, Maharishi Mahesh Yogi, whose Transcendental Meditation enticed everyone from college freshmen to the Beatles, with its offer of experiences even more awesome than drug-enhanced trips.

Richard Alpert, a Harvard professor fired for his psychedelic experiments, found that a spiritual lifestyle could be even more powerful and life affirming than all his past acid-trips. He left for India in the late '60s and returned to America as Ram Dass, adept of Neem Karoli Baba. His book, *Be Here Now*, opened the eyes and hearts of many thousands of Western students. Ashrams and spiritual communities burgeoned during the '60s and '70s, and while some taught aspects of yoga asana and pranayama, the other paths—bhakti, jnana, and karma yoga—prevailed.

A Modern Spin on an Ancient Tradition

So how did yoga become the bending, stretching, twisting discipline we see today in yoga rooms and recreation centers around the world? How did the yoga canon expand from fewer than 100 postures—most of them variations on the seated lotus pose (Padmasana)—to more than a thousand, and come to include inversions, backbends, arm balances, and twists named after animals, gods, and myriad shapes? How did the ancient yogi's need to strengthen and purify his body translate to a current obsession with flat abdominals, toned biceps, and the latest in workout wear? Ironically enough, three Indian swamis in the early part of the twentieth century inadvertently fed this modern fascination with physical prowess by independently studying and expanding the hatha yoga repertoire and presenting it not only to the uninitiated layman, but to women as well. Swami Kuvalayananda

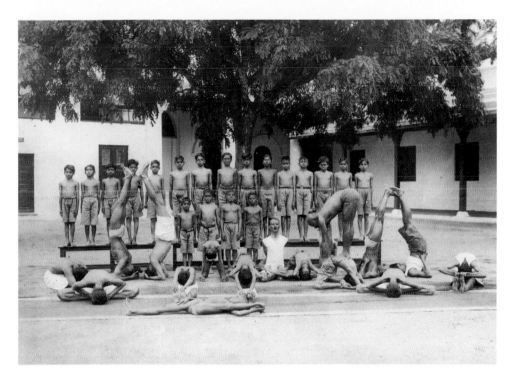

focused primarily on the health benefits of
practicing yoga, Swami Sivananda in Rishikesh and
T. Krishnamacharya of Mysore concentrated on
developing a richer, more varied system of asanas
and pranayama techniques. Most scholars would
agree that the hatha yoga Westerners enjoy today
developed out of the work of these men.

Swami Sivananda Saraswati. Swami
Sivananda, born Kuppuswami in 1887 in South
India, grew up to become a medical doctor of
some renown, more often than not serving
patients too poor to pay for his services. As the
story goes, Dr. Kuppuswami cured a wandering
monk (*samnyasin*) who taught him the mysteries of
yoga and Vedanta. The teachings fascinated and
inspired the doctor, and off he went in search of a
guru. His travels took him to North India where
he settled in the town of Rishikesh. After ten years
of intense study and with a new name, Swami
Sivananda Saraswati developed a system of yoga
sadhana (practice) that synthesized karma, jnana,

*Krishnamacharya teaches his students at Sanskrit
College in Mysore, India, ca. 1930s.*

and bhakti yoga. Corresponding to the hand, the
head, and the heart, this system asks its students to
understand the concept of universal consciousness
as follows: Serve the Self through karma yoga;
behold the Self through wisdom or jnana yoga; and
love the Self through bhakti yoga. Integrating these
three yoga paths, according to Sivananda, touches
upon all the challenges that a human faces in daily
life, and leads to final liberation from suffering.
Sivananda also includes a gentle approach to hatha
yoga to keep the body healthy, and meditation to
quiet the mind.

In 1958, Swami Sivananda gave his student,
Visnu-devananda, the task of bringing his
teachings to the West. Swami Vishnu-devananda
set up the Sivananda Yoga Vedanta Centers in
Montreal, Canada, which have since expanded to
include five more ashrams in North America and
India. Visnu-devananda and his followers teach

Yoga master Tirumalai Krishnamacharya.

and incorporate asanas, pranayama, deep relaxation, and meditation.

T. Krishnamacharya. The man who deserves the most credit for creating, or at least influencing, the type of physical yoga that Americans, Western Europeans, and many Asians embrace today actually never set foot on Western soil. Sometime in the early 1930s, this young Indian man, Tirumalai Krishnamacharya, took it upon himself to champion the beauty and the benefits of yoga asana, lifting it up from relative obscurity and placing it alongside its bhakti, karma, and jnana yoga siblings. (In a biography, Krishnamacharya says asana practice was so little known in India that he had to go all the way to Tibet to find a guru to teach him.) Of course, like all serious yogis, his training began with Patanjali's *Yoga Sutra,* not with the study of postures; but then, he was only five years old when his father began teaching him in 1893.

No one really knows Krishnamacharya's true yoga journey, not even his family. Indeed his life remains shrouded in a fog of myth, fable, fact, and contradictory memories. Whatever the historical details, Krishnamacharya has become the undisputed father of modern-day hatha yoga. Since much of the Indian spiritual tradition has been handed down from guru to student for millennia, it's understandable that hatha yogis who teach the physical postures would want a similarly unbroken lineage. Unfortunately, no such lineage appears to exist. Whether it came from the *Yogarahasya,* an ancient text forever lost that appeared to Krishnamacharya in a dream, or from a palm-leaf manuscript called the *Yoga Korunta,* which was supposedly devoured by ants, or from an ingenious and dynamic blend of asana, pranayama, Indian wrestling, and British gymnastics techniques, Krishnamacharya's yoga represents a uniquely twentieth-century incarnation of a rich and ever-evolving tradition, the underlying tenets of which have wavered little since the time of the ancient *Upanishads.* We benefit from his knowledge every time we step onto a yoga mat in an Ashtanga, Iyengar, Bikram, or Viniyoga class (or just about any hybrid of them).

One old yoga text does appear to have influenced Krishnamacharya. The *Sritattvanidhi* has fairly recently emerged from the private library of

Sivananda's five-point method of practice—proper exercise (asana), breathing (pranayama), deep relaxation (savasana), a vegetarian diet, positive thinking, and meditation (dhyana). A Sivananda class always begins and ends with mantra chanting (laya yoga) and prayer.

Swami Satchidananda, perhaps the most renowned follower of Swami Sivananda's yoga Vedanta, arrived in the United States in 1966 at the behest of the artist Peter Max, and delivered the opening speech at Woodstock, where thousands of eager rock 'n' rollers chanted their first Om. He wasted no time establishing the Integral Yoga Institute, now headquartered in Buckingham, Virginia, which today serves more than 40 branches worldwide. A student of Satchidananda's Integral Yoga system learns to be easeful, peaceful, and useful—that is, to cultivate ease in the body, peace in the heart, and usefulness in life. The classes Satchidananda and his institute offer, much like his teacher before him, have a gentle, meditative quality to them

Yoga master Pattabhi Jois.

friend as well. As Indra Devi, she introduced yoga to the Soviet Union and, in 1947, arrived in Hollywood where she taught such celebrities as Gloria Swanson, Greta Garbo, Marilyn Monroe, and Robert Ryan. Mataji, as her followers affectionately call her, culled a gentler system of yoga from her studies with Krishnamacharya. Her Sai Yoga is not a vinyasa flow. She still uses the breath to move within the pose and between poses, but her characteristic trademark is more devotional in flavor. She adds chanting and meditation or prayer during each class and offers a central asana on which to focus. Mataji, now 104 years old, stopped teaching fairly recently, but she still sees students at any one of her six yoga schools in Buenos Aires, Argentina. She continues to be a powerful presence in the yoga world. She has trained literally hundreds of teachers through her four year, college-level course of study.

B.K.S. Iyengar did not have an easy time being Krishnamacharya's disciple, although he continues to revere his guru. Unlike Pattabhi Jois and Indra Devi, Iyengar didn't exactly seek out Krishnamacharya as a teacher, nor does he look back on his student days with much affection. Iyengar grew up in Krishnamacharya's household as his brother-in-law—a scrawny, sickly child who, by all odds, had very little chance of ever becoming a yogi. Instead, his duties were relegated to tending the gardens and performing the chores Krishnamacharya assigned to him. When Krishnamacharya's star pupil vanished from the household only days before an important asana demonstration, Krishnamacharya had no choice but to teach this puny pupil in hopes he would rise to the occasion. And rise he did—Iyengar not only performed very difficult asanas admirably at the demonstration, but he went on to assist Krishnamacharya in his classes and other demonstrations throughout the area. His brief tenure with this "harsh taskmaster" ended when Krishnamacharya asked him to take over a women-only class in the northern province of Karnataka Pradesh—not exactly a plum assignment—which Iyengar agreed to do. From that point on he remained, happily it seems, hundreds of miles away from his guru.

Partly because of this distance, Iyengar had to explore Krishnamacharya's poses on his own. He

students jump from one pose to the next as a way of linking a variety of asanas together. Just like in the practice of yoga in Patanjali's *Yoga Sutra,* combining the physical poses with attention to the breath brings the modern-day ashtangi steadiness and ease in the body, increased awareness in the mind, and more openness in the heart.

Indra Devi. In keeping with the long-standing yoga tradition of teaching only the initiated, Krishnamacharya never thought to include women or foreigners in his classes. Unfortunately for him, the Mysore royal family insisted that he teach a dear friend of the court, Zhenia Lubunskaia, known today as Indra Devi, who was both a woman and a Latvian. Reluctantly, Krishnamacharya agreed. He figured he would just need to push her beyond her capabilities and break her resolve, and then she'd go away. But Lubunskaia persisted, and eventually she not only became an accomplished yoga teacher, but a good

the Maharaja of Mysore, India, where Krishnamacharya lived and taught. This treatise, which hails from the early nineteenth century, offers the first manual devoted entirely to the physical aspect of yoga. You'll find no breathing techniques, no bandhas or mudras to perform, no chakras to open, and no cleansing rituals to enact. With its 122 postures illustrated and named, the *Sritattvanidhi* expands the repertoire to include poses we've all grown to love—handstands, arm balances, ashtangi foot-behind-the-head poses, and even rope hangings—and could very well be the proof yogis are looking for that a well-developed asana practice flourished prior to the twentieth century. That well-developed practice, however, incorporated much more than just traditional asanas. According to Norman Sjoman, Sanskrit scholar and author of *The Yoga Tradition of the Mysore Palace* (Adhinav, 1999), the *Sritattvanidhi* appears to have borrowed heavily from an assorted array of gymnastics moves, wrestling exercises, push-ups, and rope tricks, as well as yoga asanas. Sjoman says this eclecticism inspired and informed Krishnamacharya's teaching.

Krishnamacharya's work began in earnest in the 1930s when he received the financial backing of the Maharaja of Mysore, whose own ill health drew him to yoga. Krishnamacharya set up classes in a gymnasium at the Sanskrit College with the goal of introducing the power of yoga to as many students as possible. Like so many of today's yoga students, however, Krishnamacharya's students— mostly able-bodied, athletic, young men—were more interested in building strength and fitness and performing near impossible feats than in any spiritual dimensions of practice. So Krishna- macharya created sequences that focused on athleticism by incorporating the power of the breath and the element of meditative gaze (*drishti*) in a dynamic flow of poses called *vinyasa*, using all the props and disciplines at his disposal. To keep his students challenged and focused, Krishnamacharya developed increasingly more difficult sequences, allowing his students to progress to the next level only after they had mastered the first one.

Once he had developed and perfected his sequences, Krishnamacharya took his show on the road. He and his students demonstrated yoga asanas to appreciative audiences all over India.

Understanding that his audience came from diverse backgrounds, Krishnamacharya tailored his yoga message to all beliefs and lifestyles, much as Western yoga teachers do today.

Three of Krishnamacharya's most famous pupils emerged from his years in Mysore— Pattabhi Jois, who went on to develop the school of Ashtanga vinyasa yoga, Indra Devi who became known as the "First Lady of Yoga" in America, and B.K.S. Iyengar, who created his own unique brand of asana practice, which is known for its attention to body alignment and for its extensive use of props.

Pattabhi Jois, who still teaches and practices in Mysore, was just a young boy when he met Krishnamacharya at one of his yoga demonstra- tions. Jois studied with Krishnamacharya for several years before leaving for college. Guru and student reunited in Mysore at the Sanskrit College, and Jois became a faithful follower of Krishnamacharya's methods. Jois credits his teacher with perfecting the Ashtanga vinyasa system, a tradition that he says draws inspiration from the classics—the *Yoga Sutra*, the *Bhagavad Gita*, and the *Hatha Yoga Pradipika*—as well as from modern Western disciplines. This rigorous system of asana flow (vinyasa)—perhaps the most physically demanding sadhana in the West— resonates with Western practitioners who "go for the burn." At least initially, many embrace Ashtanga's emphasis on strength, flexibility, and stamina, and pay little attention to its other benefits. Just as Krishnamacharya did in Mysore, Pattabhi Jois and his disciples continue to teach a set sequence of poses (linked by the breath), the purpose of which is to create tapas, or heat in the body, in order to cleanse and purify. Many teachers in the United States and Europe, who receive inspiration and teachings from Pattabhi Jois, travel frequently to India for further study with him. Although very few teachers receive actual certification from Jois, many of them reap the benefits of his legacy. Ashtanga style classes vary from first-series, the beginning level, which focuses on forward bends, to second, third, or fourth-series classes, which offer increasingly more difficult backbends, standing poses, twists, and arm balances. All classes include a vinyasa of Sun Salutations (Surya Namaskar), in which

used his own body as his laboratory, concentrating on precision and internal and external alignment, as he tried to figure out what effects a pose had on the internal organs as well as the skeletal system. Once Iyengar clearly understood the way an asana worked, he would then modify it to fit his students' bodies and health concerns. Just as Krishnamacharya adapted his sequences to the competitive nature of his able-bodied young athletes, Iyengar customized the poses, and even offered props for his less flexible, older clientele. And, as the aged and infirmed among them began seeking help for their maladies, Iyengar rose to the challenge, creating healing, therapeutic sequences.

This emphasis on the physical body became a signature of Iyengar Yoga, and Iyengar's intuitive, almost uncanny ability to heal through asana practice has become legendary. He views the body as a finely tuned, highly sensitive instrument whose vibrations, he says, "express the harmony or dissonance within it." Asanas, he believes, help the body create or re-create its innate harmony. When performed correctly, asana practice synchronizes the rhythms of the body's physical, physiological, psychological, and spiritual components. Unlike Krishnamacharya, Pattabhi Jois, and Indra Devi, Iyengar waits until the practitioner has mastered asanas before incorporating pranayama into his method. Nor does he link the poses together in the same way. He chooses poses that work together, but his concern is how they achieve balance within the body rather than how they link together. Iyengar continues to teach, along with his daughter Geeta and son Prasant, at his center in Pune, India. His followers have spread Iyengar Yoga all over the planet, creating the most well-known style in the world. Even those who teach other methods often credit the Iyengar method with instilling in them an understanding of the body, the architecture of the poses, and the means to modify asanas when necessary.

Each of Krishnamacharya's star pupils took from him important, but very different lessons. Pattabhi Jois received the vinyasa teachings and went on to spread the word, almost verbatim; Indra Devi gravitated toward his style of sequencing and enhanced those teachings with a more developed sense of devotion and meditation; and Iyengar learned the power of adapting and improvising to meet the needs of his students, a

Yoga master B.K.S. Iyengar.

practice he continues today. But a fourth disciple experienced Krishnamacharya's teachings in a much different way. Krishnamacharya was older, more patient, and had continued to evolve his understanding of yoga asanas when his son T.K.V. Desikachar began to express interest in learning.

T.K.V. Desikachar. By the time Desikachar asked his father to teach him, Krishnamacharya's own work had changed, in much the same way as Iyengar's had. Yoga was no longer reserved only for the select few who were strong and flexible enough to withstand its challenges, or spiritually attuned enough to understand them. To survive as a teacher, Krishnamacharya found he had to open his doors to all kinds of students, including those with physical limitations and even non-Hindus. And then he needed to figure out how to teach

ABOVE: *Yoga master T.K.V. Desikachar.*

OPPOSITE: *Yoga master Indra Devi.*

them. Working one-on-one, Krishnamacharya devised specific practices for each student. Sometimes he varied the pose sequence, or the length and frequency of the breath; other times he modified or simplified the poses to achieve particular goals. As the student reached those benchmarks, Krishnamacharya would alter his or her "prescription" to enable the student to grow further in the practice and to introduce the spiritual aspects of the tradition. This technique laid the groundwork for Desikachar's own interpretation of Krishnamacharya's work, which he called Viniyoga.

Desikachar was already a grown man, having finished college with an engineering degree, when he decided to devote his life to studying yoga. Apparently he saw his father—the ever-proper Brahmin—hug a woman who had come to thank him for curing her insomnia. Whether Desikachar was more shocked by the woman's response or intrigued by his father's ability to heal her, he

knew he wanted to learn more. Krishnamacharya's response to his son's change of heart echoed his reaction to Indra Devi and Iyengar's desire to learn—it annoyed him more than it pleased him. To test Desikachar's resolve, his father began his lessons at 3:30 a.m. seven days a week. He agreed to focus only on asanas and pranayama since Desikachar disavowed any interest in God. Desikachar continued his yoga studies for 28 years, finally understanding, and incorporating, yoga's inherent spiritual dimension.

While he was teaching his son, Krishnamacharya continued to refine his system and developed it into an individualized program of asana, pranayama, and devotional chanting. He created programs for the young, the middle aged, and the elderly. Your youth, Krishnamacharya reasoned, is the time to strengthen your muscles and enhance your flexibility through increasingly challenging yoga sequences; as you mature into your career and family years, your yoga should keep you healthy and stress-free. In your later years, as your focus becomes more internal and your thoughts turn to God, your yoga should have a more spiritual dimension.

Desikachar has devoted his life to spreading Krishnamacharya's message of yoga to the West and increasing its connection to science and medicine. Like Iyengar, Desikachar's Viniyoga concentrates on tailoring the yoga sequences to the needs of the individual, and, like Pattabhi Jois, he emphasizes the power of the breath. However, Viniyoga's focus lies somewhere between Iyengar's precision and Pattabhi Jois's vigorous movements. A Viniyoga class is slower than Ashtanga, though it coordinates the breath with the movement. Like Iyengar Yoga, it is known for its therapeutic applications, though Viniyoga concentrates less on alignment and more on varying the length and tempo of the inhalations and exhalations. Although not yet as popular in the United States as Iyengar and Ashtanga Yoga, Viniyoga has touched the lives of countless practitioners all over the world.

Other Styles of Yoga. Several other yoga styles at least indirectly owe their allegiance to Krishnamacharya's legacy. The increasingly popular Bikram Yoga, created by Bikram Choudhury, the self-proclaimed "Yogi to the Stars," incorporates two pranayama techniques and

24 asanas, including backbends, standing poses, one-legged balances, and twists. A 100-degree, humid room—the signature trademark of Bikram Yoga—makes this style particularly challenging. Kripalu Yoga, originally developed by Amrit Desai, a disciple of Indian master Kripalvananda, a Kundalini yogi, shares its asana repertoire, breath work, and flowing style with Krishnamacharya's vinyasa system. Kripalu encourages its students to discover their own strengths and weaknesses and to "play with their edges," coming into and out of the poses as they need to. Once students become more advanced and learn to hold poses longer and longer, Kripalu Yoga encourages them to allow the poses to arise spontaneously as they work with their life force (prana) and create their own, unique practice.

Yogi Bhajan, a Sikh who immigrated to the United States in the 1960s, broke with tradition and introduced Kundalini Yoga to the masses. His type of Kundalini Yoga combines asana with breath work, chanting, and meditation to awaken the Divine energy coiled at the base of the spine. His Healthy, Happy, Holy Organization (3HO), established in 1969 and headquartered in New Mexico, focuses on karma yoga (the path of service to the community) as much as on education, a vegetarian lifestyle, and the therapeutic applications of yoga and ayurveda. Students who study Kundalini Yoga learn specific pranayama techniques designed to clear the nadis and energize the system.

Vanda Scaravelli, creator of the Scaravelli Method, discovered yoga rather late in life, after the sudden death of her husband. At 45 years of age, she plunged headlong into daily classes with Iyengar, who taught her for many years, and later with T. K. V. Desikachar who introduced the power

Even this California license plate reminds us that yoga is everywhere.

of the breath. Her method of yoga, which she taught in Italy until she was well into her 80s, teaches the power of gravity and the freedom of the breath in asana. The popularity of her book, *Awakening the Spine*, and the hundreds of students currently trained in the Scaravelli method have allowed her style of yoga to live on in Europe, Canada, and America.

The Western Love Affair with Yoga Asanas

In keeping with the Western penchant of adapting anything that comes its way, many teachers have incorporated bits and pieces of various practice styles to create yoga hybrids that speak to Western students of all ages, sizes, and shapes regardless of their particular religious or spiritual bent. In this ever-expanding smorgasbord of Western yoga, you can pick and choose from a dizzying array of techniques. Although yoga purists may decry this movement as the bastardization of an ancient tradition, in truth Westerners are merely following in Krishnamacharya and Iyengar's footsteps. They are creating yoga that works for them. And they are benefiting from the evolution of an ancient custom that has never shied away from new ideas or new methods to achieve its goal.

This Western-style facelift is most apparent in yoga's evolution from a male-oriented practice to a feminine-inspired healing tradition. As recently as 60 years ago, very few women could find yoga teachers with whom to study; yoga belonged to men. Today, buoyed primarily by the work of B.K.S. Iyengar's daughter Geeta, a whole generation of female teachers has midwifed a

discipline that encourages women to discover and speak their truth. Whether that truth manifests as a connection to the goddess within or simply as a realization that women's bodies are beautiful just the way they are, millions of women now use yoga to connect with themselves on a much deeper level. Thanks to Geeta Iyengar and a host of teachers throughout the world, women now practice restorative yoga—a series of modified and supported poses—to bring a sense of calm and clarity to their otherwise hectic lives. And they can use yoga to better understand and honor their cycles, modifying their practices to provide what their bodies and minds need at any given time. By practicing a more feminine flavor of yoga, women can now experience the stages of their lives more mindfully, with grace and good health.

Despite all these innovations, yoga continues to mean to yoke or unite, and it still can be a powerful vehicle for spiritual transformation. A few millennia ago, yoga practice involved action (karma yoga), knowledge or meditation (jnana yoga), and devotion (bhakti yoga). Later, when people became obsessed with the body and intent on exploring its connection to the spirit, yoga found the means, through tantra and hatha paths, to bring awareness to such experiences. Today a serious yogi is likely to combine several paths in order to achieve liberation. Karma yoga now means selfless service in the community as well as performing your duties as a father, mother, son, daughter, sibling, and coworker with mindful attention. Jnana yoga practice encompasses study and meditation, and an abiding commitment to the scriptures. And many yogis turn their hearts and minds to a particular religious or spiritual path. Whether they practice the religion of their parents or feel drawn to Eastern spirituality, bhakti yoga, the path of devotion, informs their quest.

Liberation (samadhi) refers less to enlightenment these days and more to freedom from suffering. More people turn to yoga to alleviate pain than for any other reason. And yoga teaches us that in order to relieve our physical pain, we must also free our minds from suffering and open up our hearts. On a physical level, yoga asanas relieve the backaches, headaches, menstrual discomfort, and strained ligaments a student may suffer. Yoga has poses to correct postural defects

and bring flexibility to the spine. On a deeper level, yoga also balances the neuroendocrine system, calming the nerves and relieving the psychological pain of depression, anxiety, and grief. Deeper still, a consistent yoga practice of asana and pranayama helps open the psychoenergetic channels yogis call chakras and activate the nadis, which circulate life-sustaining prana throughout the body. The cosmic energy of prana releases pent-up emotions and brings joy and calm to the body and the mind. The yogi then realizes her own divinity, and that realization releases her from suffering. The union of the individual self (*jivatman*) with the universal Self or consciousness (now called *paramatma*) has come to mean integration, a yoking of the body with the mind, senses, intellect, and higher Self, and the union of the yogi's higher Self with the world around her.

For some practitioners, a weekly yoga class to improve their bodies gives them all they want. Just as they did thousands of years ago, yoga asanas strengthen the body, make it more flexible, and build up its stamina. In those days, asanas helped prepare the yogi for the rigors of meditation practice; today yoga may prepare the practitioner's body for the rigors of basketball, skiing, or ballet, or repair it from the rigors of twenty-first-century life.

The problem with coming to yoga solely to get stronger and look better is that you can become fixated on the physical image you're creating and forget the true meaning of yoga. Having the leanest, buffest body, being the most flexible in the class, or even being able to do 108 backbends in 15 minutes becomes more important than cultivating an open mind and heart. If that happens, you can at least take heart in knowing you're in good company. Texts as far back as the *Bhagavad Gita* warn students not to become attached to the fruits of their labor, and fifteenth-century hatha yoga texts admonish yogis about becoming enamored with the magical powers they receive from their practice.

Fortunately, yoga touches much more than the physical body, no matter what intention you bring to your practice. Today's yoga asanas still affect the five sheaths or koshas described in ancient yoga physiology—the physical body, the physiological body, the emotional body, the intellectual body,

and the bliss or spiritual body. Even if students practice yoga purely for its physical benefits, doing the postures over and over again can have a magical effect outside of yoga class. Students may find that the strength, flexibility, and stamina they learn in class extend beyond the perimeter of their yoga mats. Physically, they may feel stronger and find themselves standing taller and straighter. Emotionally, they discover they now have the strength to get through difficult times at work or at home. Physically and emotionally, they gain flexibility. They can touch their toes. And they can bring more openness and attention to their relationships. They have the stamina to stay focused and present in their everyday lives.

A Hatha Yoga Class

A typical hatha yoga class—whether it's Iyengar-inspired, Ashtanga, Bikram, or Kripalu, or any combination of style—gives students a way to experience the union of opposites within their own bodies by teaching a sequence of asanas and the breathing associated with them. Beginning with the inhalation and exhalation, a student learns the yogic concept of expansion and contraction (*brhmana* and *langhana*). On an inhalation, brhmana (the expanding aspect of prana) creates heat and light in the body. This action invigorates the whole body. A student experiences brhmana simply by standing still and breathing or by doing backbends and standing poses. Langhana is the opposite action—it cools the body down with dark, pacifying energy. This contracting, introverted aspect of prana helps bring a sense of calm to the body. Forward bends and some twisting poses activate langhana. The breath in yoga becomes the bridge between the body and the mind, the means to steady the body, enliven the mind, and open the heart.

The structure of a Western yoga class also demonstrates brhmana and langhana. For every pose, there is a counterpose. Backbends beget forward bends; twists always happen on both sides; many classes have you right side up and then upside down. Passive poses like seated forward bends follow more active standing poses. Brhmana and langhana concepts apply to individual poses as well. The dynamic way of moving into and out of each pose is expansive; the stillness experienced within the pose is contracting. Subtler still, there is

movement within the stillness of the pose—in the breath and in the musculature, and the spine continues to extend whether you are getting in and out of, or holding the pose.

Performing Asanas

Yoga practice has always begun at the grossest level—the body—and progressively included the mind, the senses, the intellect, and the spirit. B.K.S. Iyengar approaches yoga asana practice in much the same way. He teaches that asana practice must begin by achieving physical stability in the pose, a perfect blend of movement and resistance. Once a student masters the pose, she in effect has control over the body. Now she can practice on a deeper level. As her body moves into, out of, and within the pose, she engages her mind and becomes aware of how the movement affects her muscles, her bones, her joints, and her skin. Her mind then moves her body to connect with the intellect. There is no distinction now between her body and her mind. She is now aware of how the movement affects her on an even subtler level— in her tissues and her cells. She now understands on an emotional level the resistance she feels and the freedom she gains.

Standing poses, for example, offer physical as well as more visceral benefits. These asanas strengthen the leg muscles and joints and extend the spine. Many of them open up the hip joints and bring increased mobility to the back muscles as well as to the feet and knees. On a deeper level, these poses provide elasticity to the arteries in the legs, which increases blood circulation to the lower extremities. Emotionally, standing poses teach students what it's like to feel grounded, connected to the earth, and yet move with grace and ease.

Inversions, on the other hand, literally turn everything upside down. Physically, they increase blood flow to the brain, heart, and lungs. On a deeper level, yogis believe inversions balance the endocrine system and contribute to good reproductive and digestive health. Mentally and emotionally, these poses quell anxiety and yet energize the mind.

Backbends awaken the whole body and bring more flexibility to the spine. Energetically, backbends stimulate the central nervous system and relieve exhaustion and depression. Forward bends, on the other hand, pacify and restore. Physically, they strengthen the paraspinal muscles and release the hamstrings. On a deeper level, they balance the central nervous system, lower blood pressure, and calm the mind.

Beyond Asana Practice

Even though asana practice enjoys much more attention now than at any time in yoga's rich and varied history, doing yoga poses and breathing along with them is only part of the journey toward self-awareness. Every yoga teacher who sat, balanced, inverted, or bent backwards in these photographs agreed that asana practice was only one piece of the puzzle, albeit an important one. More than a few admitted that they were initially drawn to yoga to improve their bodies. Some were former dancers with injuries, or athletes with torn ligaments or bad backs. A few sought yoga to heal emotional scars and psychic pain. Others began at the feet of a guru and learned asana along with pranayama, chanting, and meditation. Ultimately, it didn't matter why they started yoga. Every single one of them said yoga brought them to a deeper, more spiritual place in their lives— something they hadn't really anticipated. That deeper spiritual place, of course, means something different for each one. For one woman, yoga opened her heart to her community, and she felt a strong sense of responsibility to teach. Others felt a strong desire to spread the true meaning of yoga as far and wide as possible. Others still preferred to devote themselves to a meditation practice or their gurus.

Whatever their paths, each one of these modern yogis, much like their ancient forebears, sees yoga as a powerful means of transformation. Because the body and the universe are inextricably linked in yoga, transforming the body and the mind of a single practitioner can have a powerful effect on his or her surroundings. Patanjali reminds us that yoga is as much about how we act toward others as it is about strengthening our bodies or quieting our minds. Yoga unites or yokes us not only to the Divine within, but to the world without; asana is, after all, the seat that keeps us grounded in reality and linked to our roots in Earth.

OPPOSITE: *A 20th-century sadhu, or holy man, practices Vrksasana (Tree Pose) in Varanasi, India.*

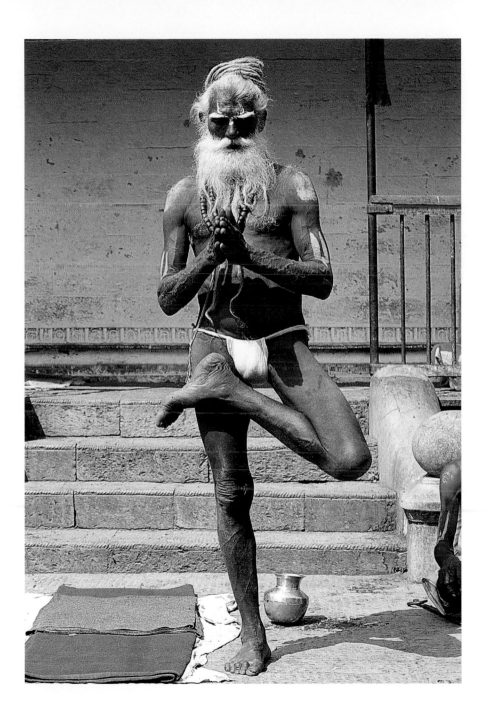

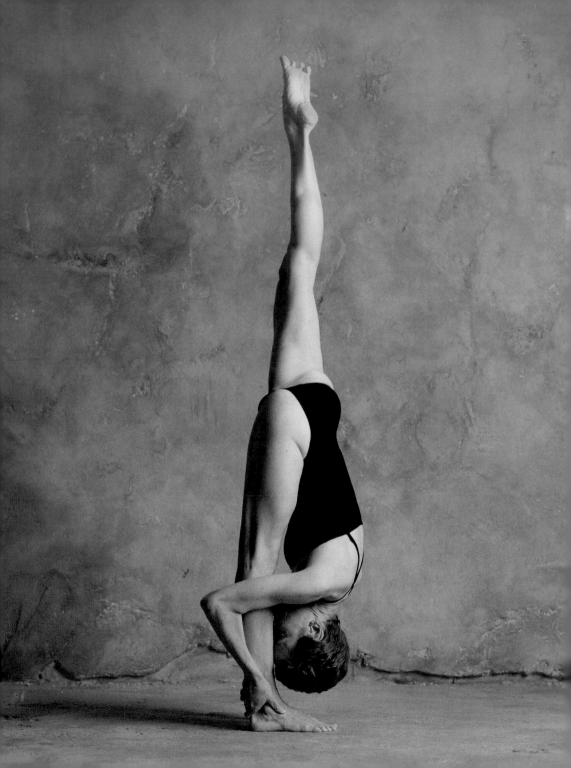

Y O G A

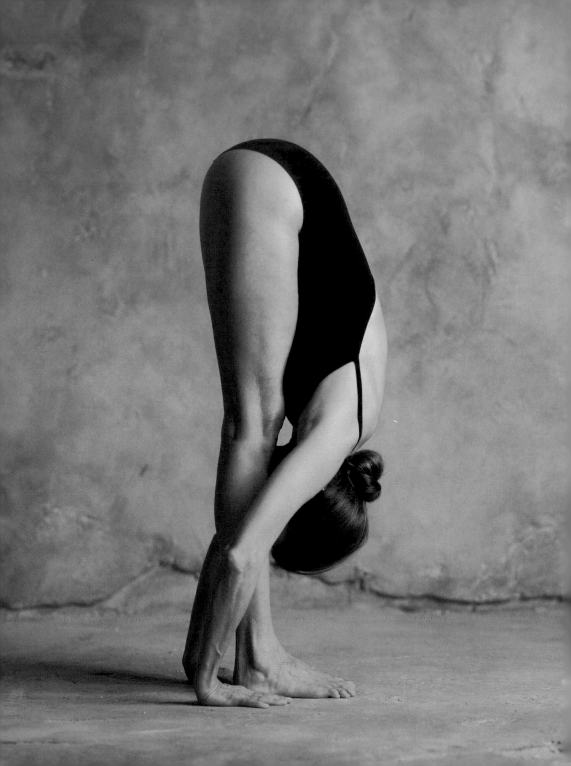

Salute to the Sun

Without beginning or ending,
your original wisdom has been
shining forever, like the sun.
To know whether or not this is true,
look inside your own mind.

—Padmasambhava *(eighth century)*

Surya Namaskar
Salute to the Sun

Salute to the Sun

Surya Namaskar—yoga's salute to the sun—awakens and warms the whole body, preparing it for asana practice. Although there are easily one hundred different Surya Namaskar combinations, every one of them moves the body through its entire range of motion, linking the poses together on the wave of the breath. Encapsulating the true beauty of a complete yoga workout, this sequence strikes the perfect balance between strength and flexibility, contraction and expansion, movement and stillness as the body goes from upside down to right side up, moving forward and back and from side to side.

Tadasana Namaskar
MOUNTAIN POSE WITH
HANDS IN PRAYER

Uttanasana
STANDING FORWARD BEND WITH
CONCAVE BACK (VAR.)

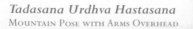

Tadasana Urdhva Hastasana
Mountain Pose with Arms Overhead

Urdhva Mukha Svanasana
UPWARD-FACING DOG

Surya Namaskar 5
LUNGE

Uttanasana
STANDING FORWARD BEND

Surya Namaskar 6
PLANK POSE

Chaturanga Dandasana
FOUR-LIMBED STAFF POSE

Surya Namaskar 10
LUNGE

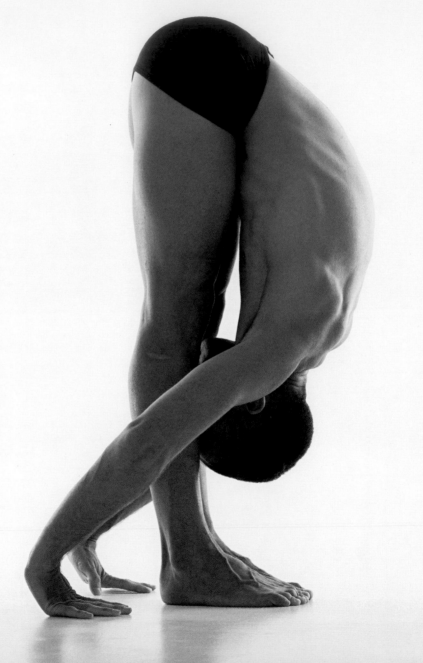

Uttanasana
STANDING FORWARD BEND

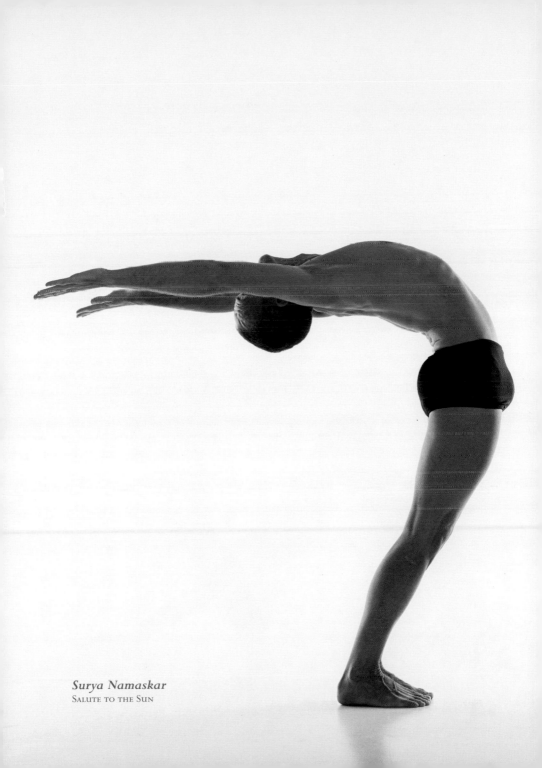

Surya Namaskar
SALUTE TO THE SUN

Adho Mukha Svanasana
DOWNWARD-FACING DOG

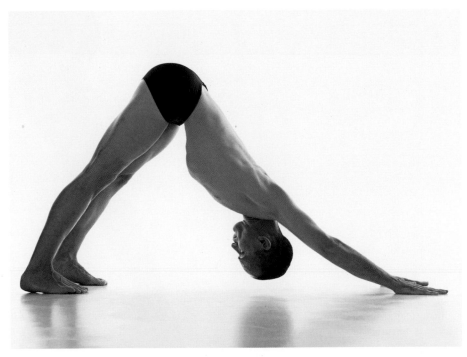

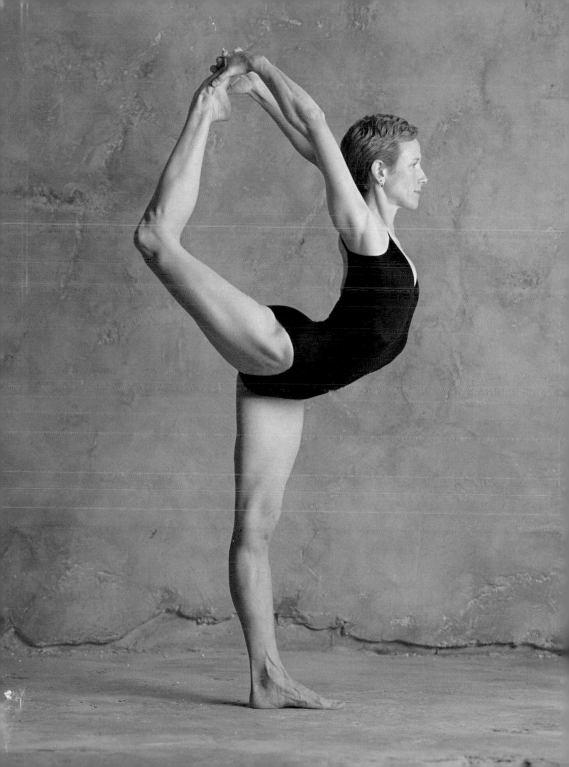

Tadasana Samasthiti
MOUNTAIN POSE

Standing Poses

Standing Poses connect us to the ground we walk on, Earth who supports us. Standing poses give us the foundation upon which to build our practice and the combination of balance, strength, and flexibility we need to live our lives. With our feet planted firmly on the ground, we are free to rise up or bend to meet the challenges of daily life. Physiologically, standing postures strengthen the leg muscles and joints, keep the spine flexible and long, open the heart, and increase blood circulation to the lower extremities.

Standing Poses

Be strong then, and enter into
 your own body;
There you have a solid place for your feet.
Think about it carefully!
Don't go off somewhere else!
Kabir says this: Just throw away all
 thoughts of imaginary things,
 and stand firm in that which you are.

—Kabir

Natarajasana
Lord of the Dance Pose

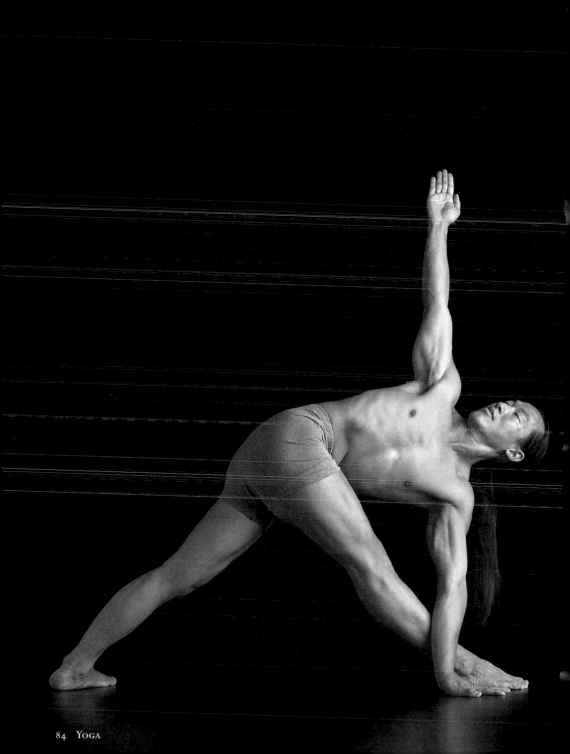

Utthita Trikonasana
EXTENDED TRIANGLE POSE

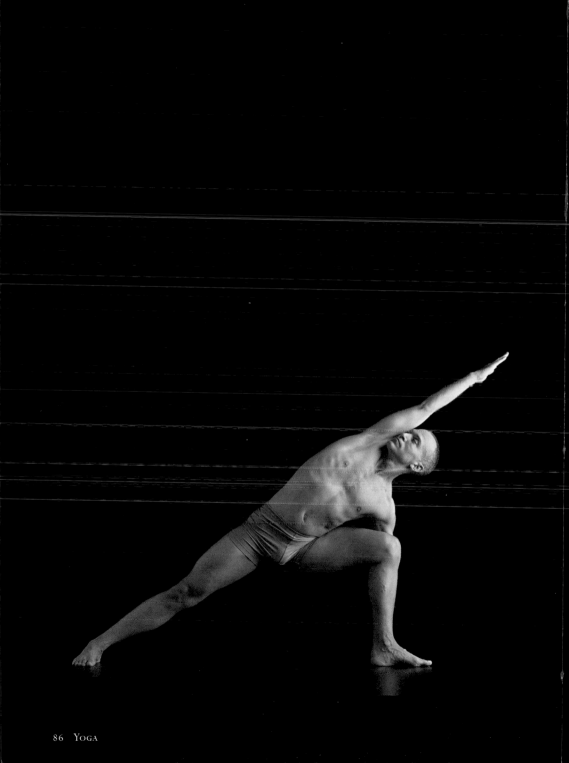

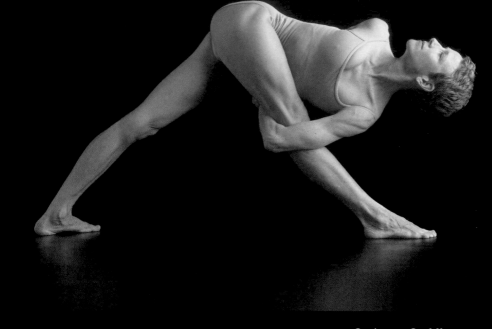

***Parivrtta Baddha
Trikonasana***
REVOLVED BOUND TRIANGLE POSE

Parivrtta Trikonasana
REVOLVED TRIANGLE

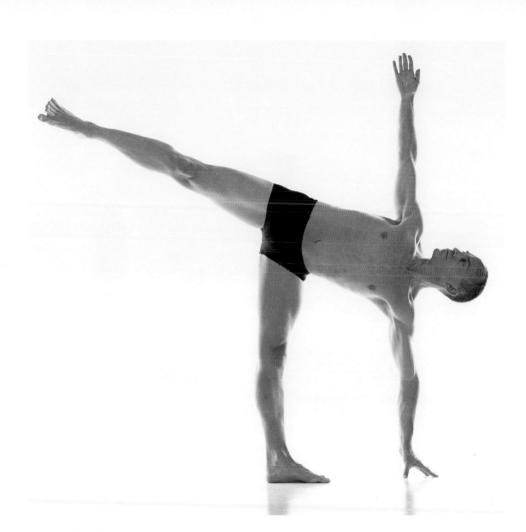

Ardha Chandrasana
HALF MOON POSE

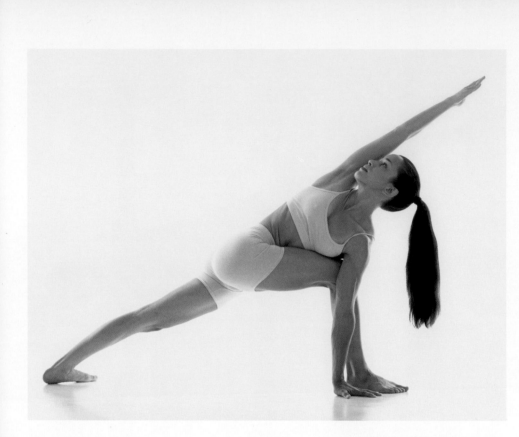

Parivrtta Parsvakonasana
REVOLVED SIDE ANGLE POSE

Utthita Parsvakonasana
EXTENDED SIDE ANGLE POSE

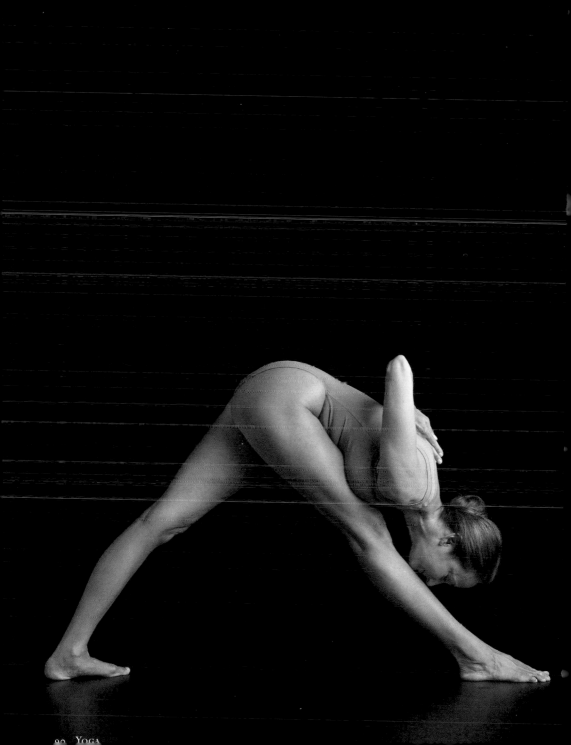

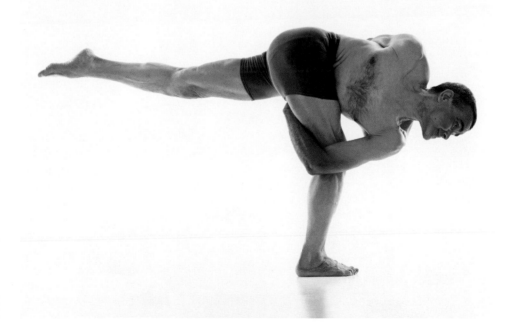

Parivrtta Baddha Ardha Chandrasana
Revolved Bound Half Moon Pose

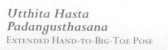

***Utthita Hasta
Padangusthasana***
Extended Hand-to-Big-Toe Pose

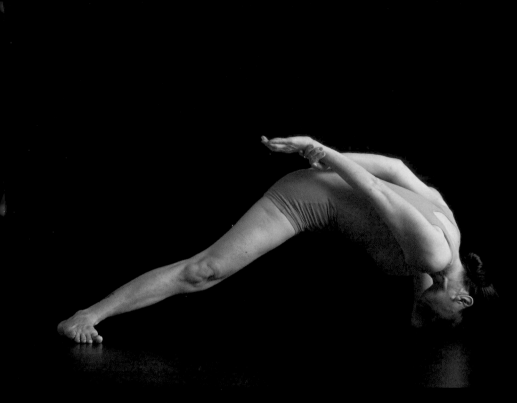

Virabhadrasana
WARRIOR POSE (VAR.)

Parsvottanasana
SIDE STRETCH POSE

Utthita Hasta
Padangusthasana
EXTENDED HAND-TO-BIG-TOE POSE

**Utthita Hasta
Padangusthasana**
EXTENDED HAND-TO-BIG-TOE POSE

Durvasanana
STANDING FOOT-BEHIND-
THE-HEAD POSE

Utthita Hasta
Padangusthasana
EXTENDED HAND-TO-BIG-TOE POSE

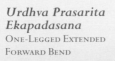

Urdhva Prasarita
Ekapadasana
ONE-LEGGED EXTENDED
FORWARD BEND

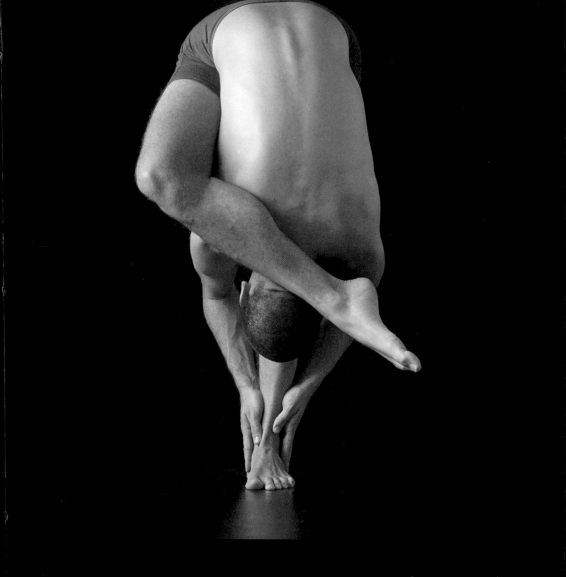

Tadasana Urdhva Hastasana
MOUNTAIN POSE WITH ARMS OVERHEAD

Virabhadrasana I
PREPARATION FOR WARRIOR I

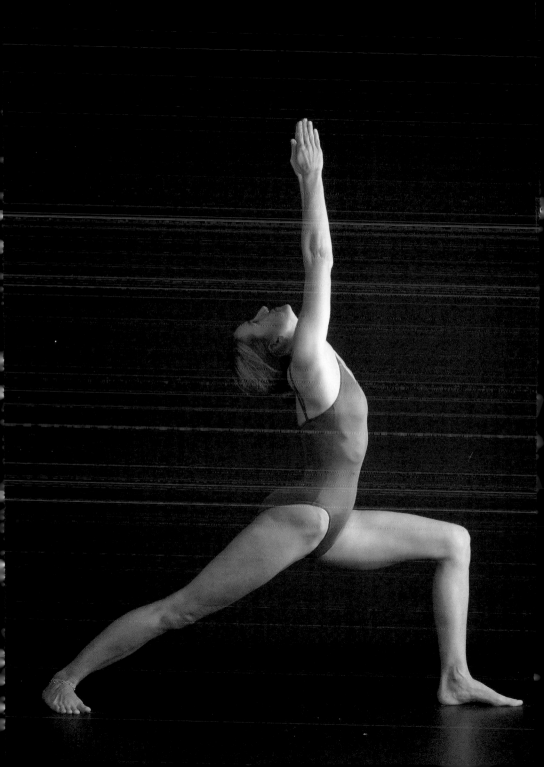

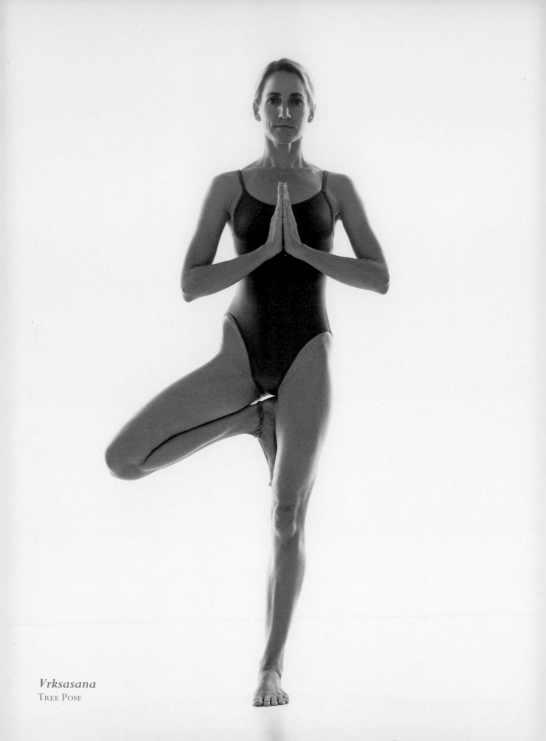

Vrksasana
TREE POSE

*Ardha Padmasana
in Vrksasana*
TREE POSE IN HALF LOTUS

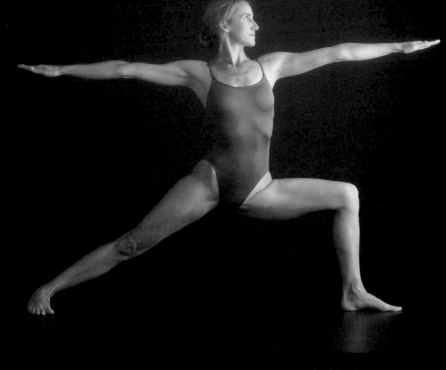

Virabhadrasana II
WARRIOR II

Virabhadrasana I
WARRIOR I

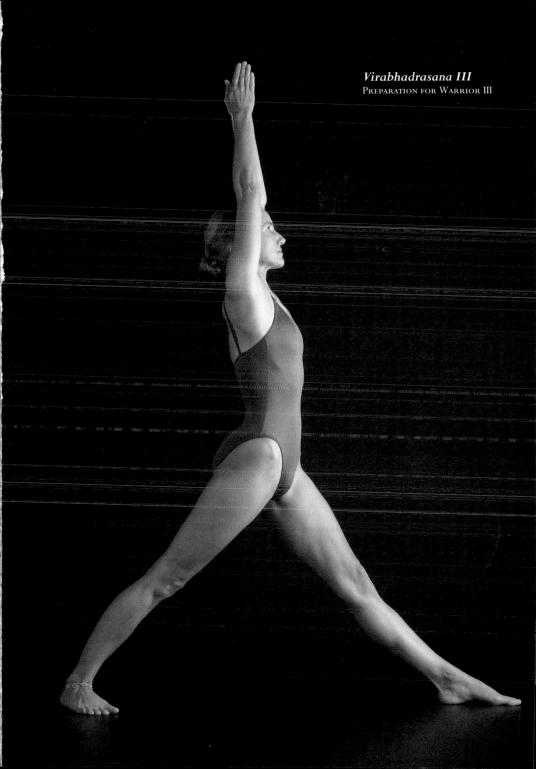

Virabhadrasana III
PREPARATION FOR WARRIOR III

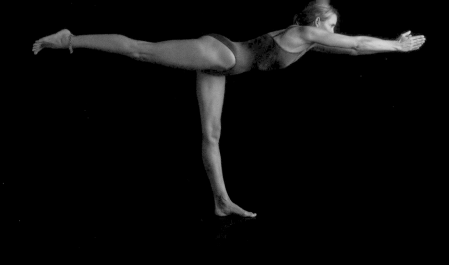

Virabhadrasana III
WARRIOR III

Tadasana Urdhva
Baddha Hastasana
Mountain Pose with
Bound Hands

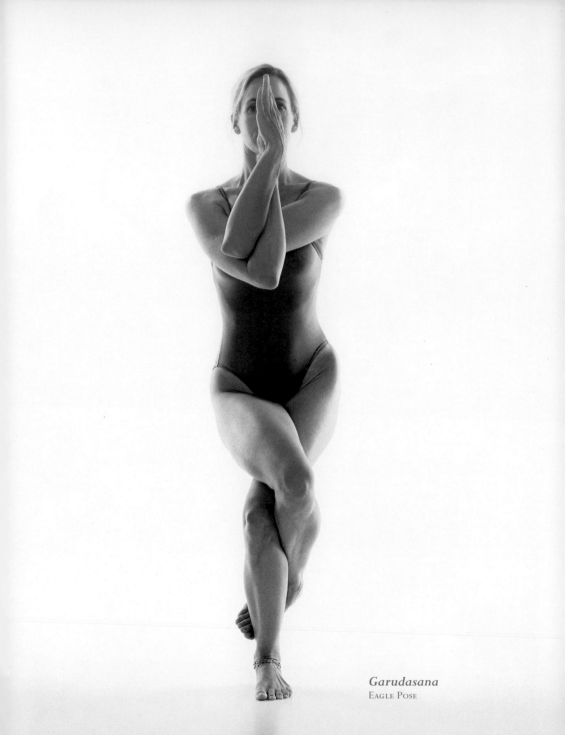

Garudasana
EAGLE POSE

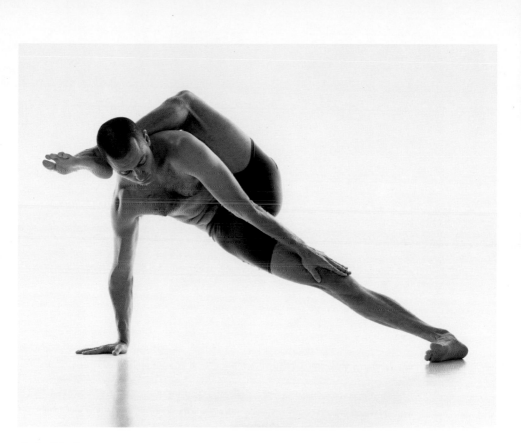

Kala Bhairavasana
POSE DEDICATED TO SHIVA
THE DESTROYER

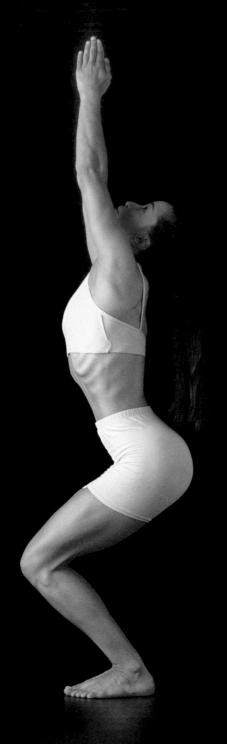

Utkatasana
CHAIR POSE

Natarajasana I
LORD OF THE DANCE POSE I

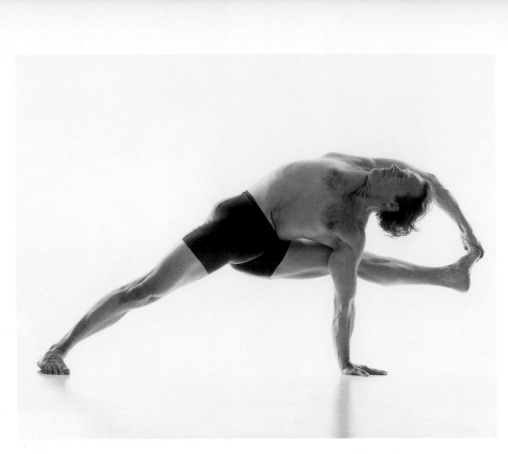

Visvamitrasana
Pose dedicated to Visvamitra

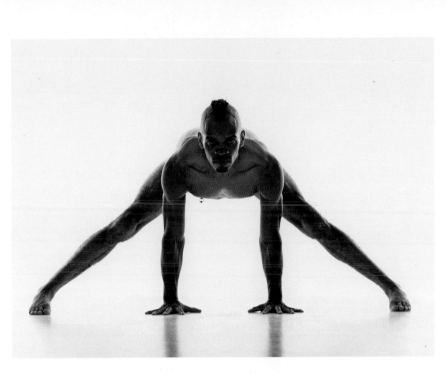

Prasarita Padottanasana I
WIDE ANGLE STANDING FORWARD BEND I (VAR.)

Prasarita Padottanasana IV
WIDE ANGLE STANDING FORWARD BEND IV

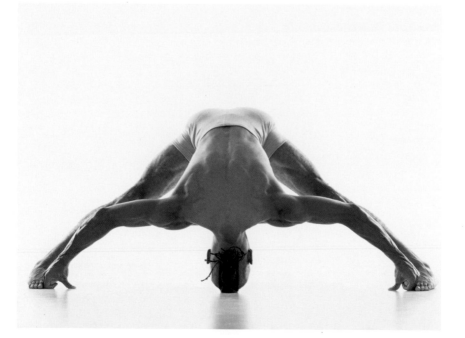

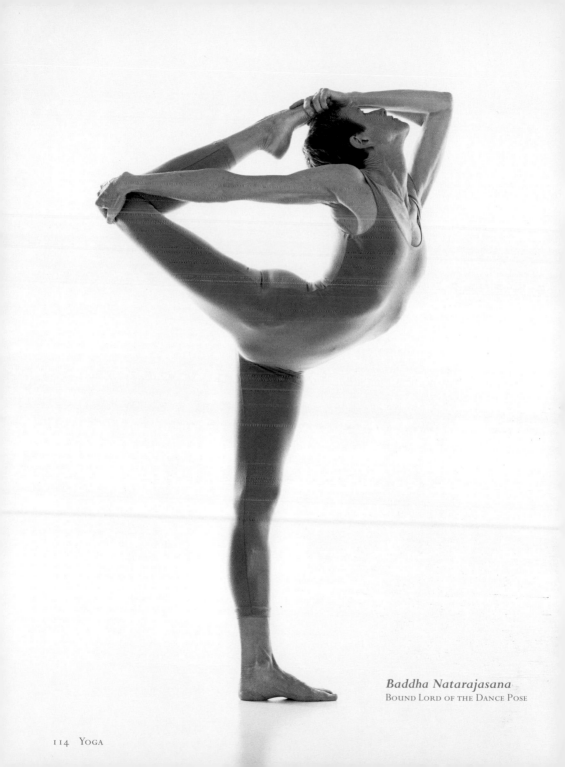

Baddha Natarajasana
Bound Lord of the Dance Pose

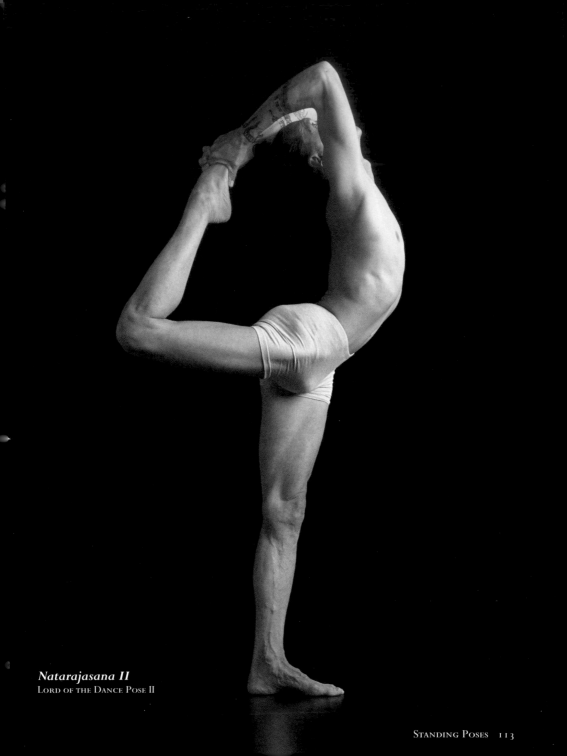

Natarajasana II
Lord of the Dance Pose II

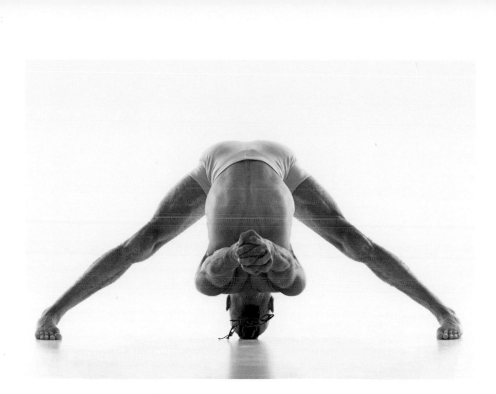

Prasarita Padottanasana III
WIDE ANGLE STANDING FORWARD BEND III

Parivrtta Prasarita Padottanasana
REVOLVED WIDE ANGLE FORWARD BEND

Prasarita Padottanasana I
WIDE ANGLE STANDING FORWARD BEND I

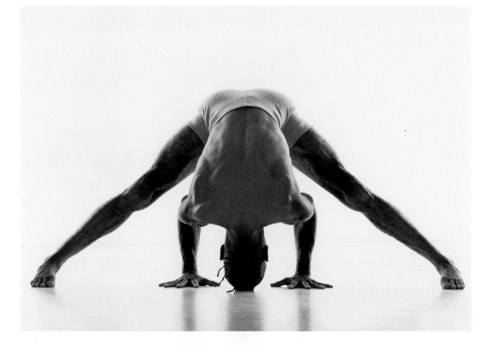

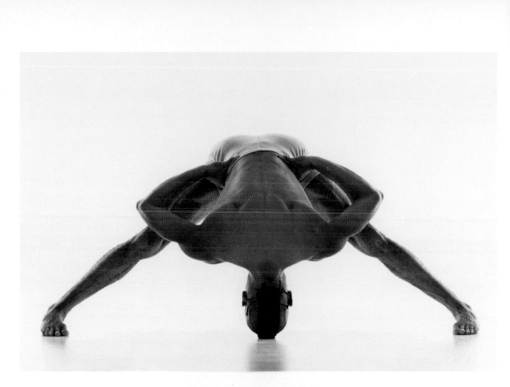

Prasarita Padottanasana II
WIDE ANGLE STANDING FORWARD BEND II

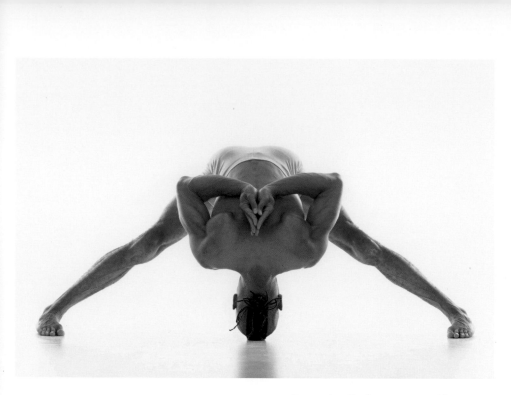

Prasarita Padottanasana II
WIDE ANGLE STANDING FORWARD BEND II (VAR.)

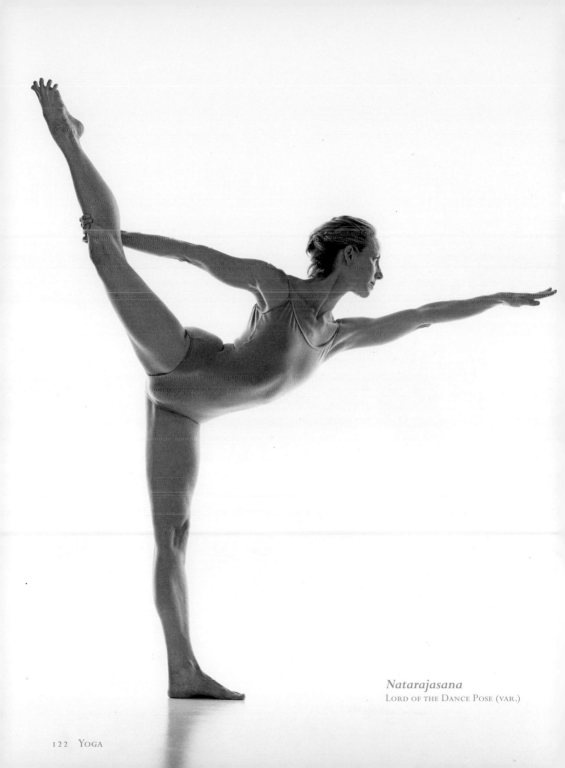

Natarajasana
LORD OF THE DANCE POSE (VAR.)

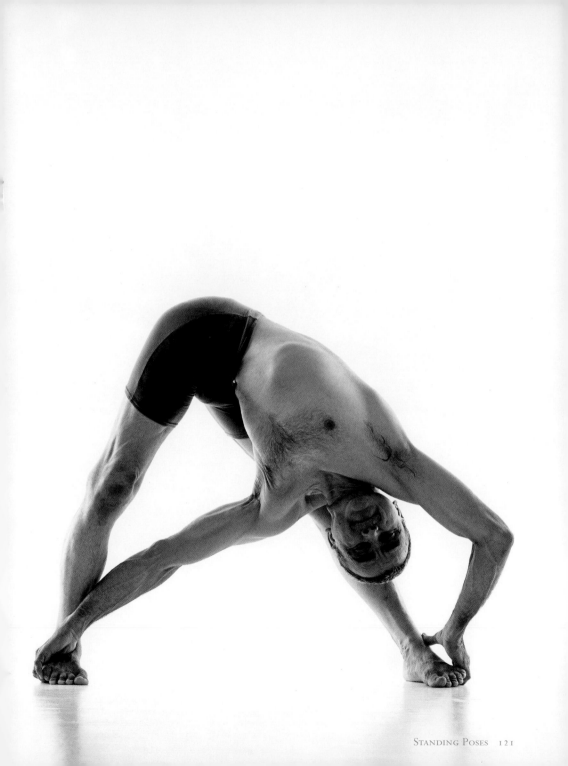

Uttanasana
Standing Forward Bend

Eka Pada Adho Mukha Svanasana
One-Legged Downward-Facing Dog Pose

Parivrtta Uttanasana
REVOLVED STANDING FORWARD BEND

Padahastasana
Feet-on-Hands Pose

Ardha Baddha Padmottanasana

Bound Half Lotus Standing Forward Bend

Balance Poses

To balance in the space between movement and stillness is to practice asana with complete present-moment focus. Physically, these poses strengthen the arms and legs, promote equilibrium and stamina, and bring freedom to the breath. Their weight-bearing action stimulates the bones in the legs, arms, and spine. On a deeper level, these poses teach us that a balanced body brings a steadier mind. By learning to stay balanced and focused in these poses, we bring that awareness into our everyday lives.

Balance Poses

Neither knowable, knowledge, nor
knower am I, formless is my form,
I dwell within the senses but they
are not my home;
Ever serenely balanced, I am neither
free nor bound—
Consciousness and joy am I,
and Bliss is where I am found.

—ATMA SATKAM *(Song of the Soul)*
by Shankara (ca. 800 C.E.)

Tittibhasana
FIREFLY POSE

Bakasana
CRANE POSE

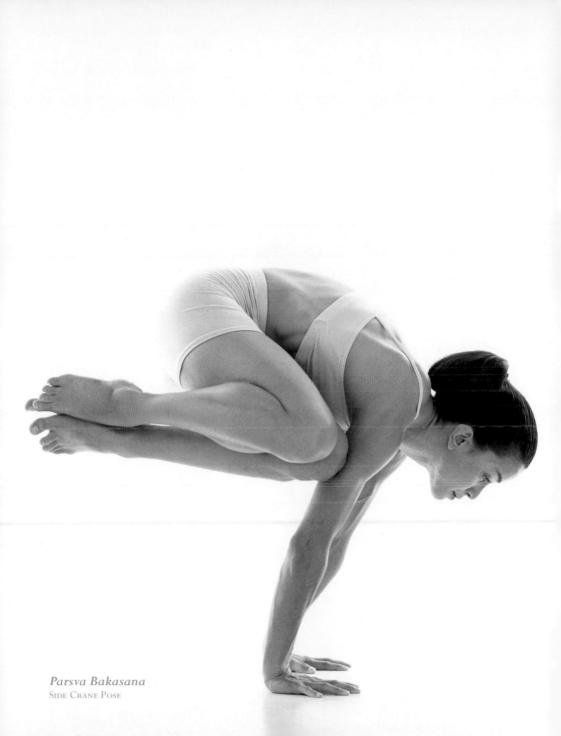

Parsva Bakasana
SIDE CRANE POSE

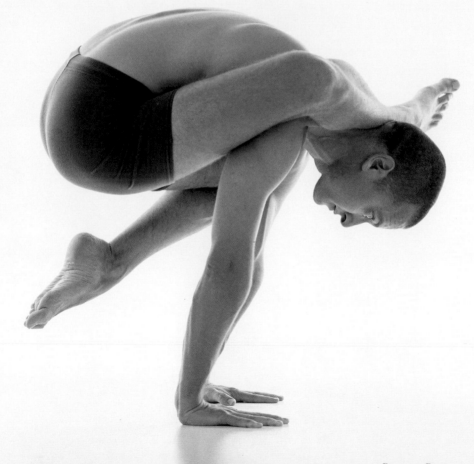

Eka Pada Sirsa Bakasana
ONE-FOOT-BEHIND-THE-HEAD
CRANE POSE

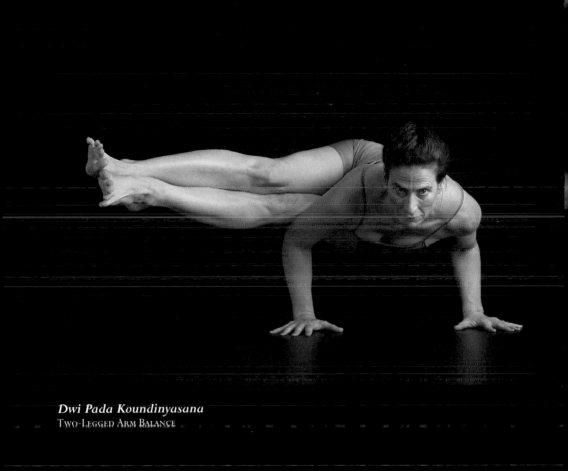

Dwi Pada Koundinyasana
TWO-LEGGED ARM BALANCE

Astavakrasana
BALANCE DEDICATED TO
ASTAVAKRA

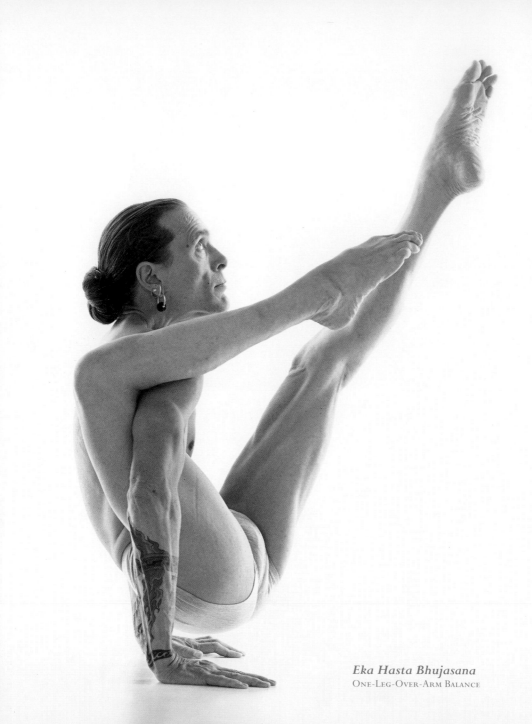

Eka Hasta Bhujasana
ONE-LEG-OVER-ARM BALANCE

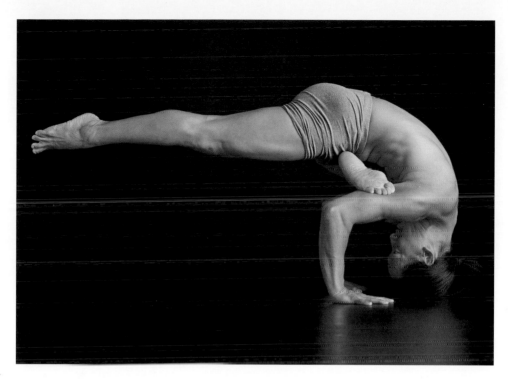

Eka Pada Galavasana
ONE-LEGGED BALANCE (PREP)

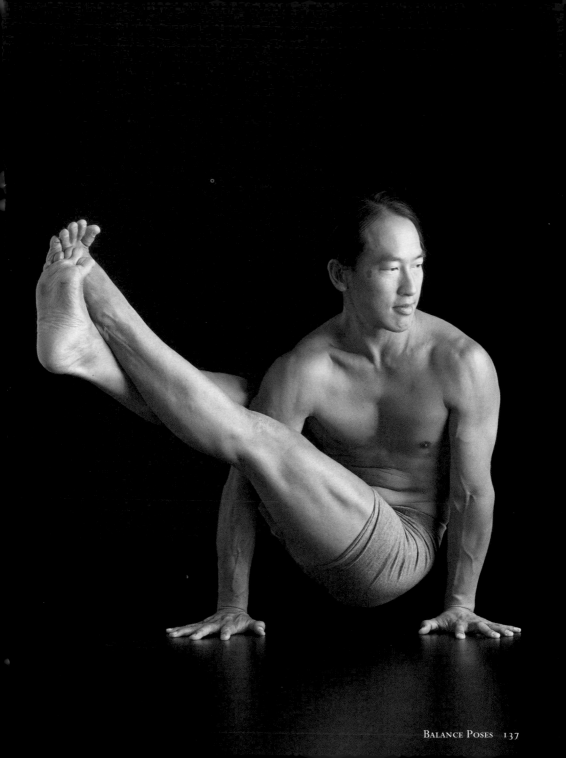

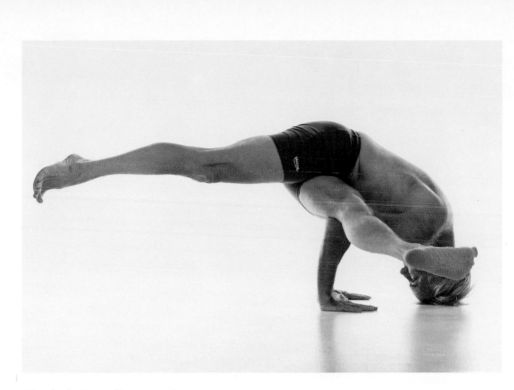

Eka Pada Koundinyasana I
ONE-LEGGED BALANCE POSE (PREP)

Eka Pada Galavasana
ONE-LEGGED ARM BALANCE FOR
KOUNDINYA (VAR.)

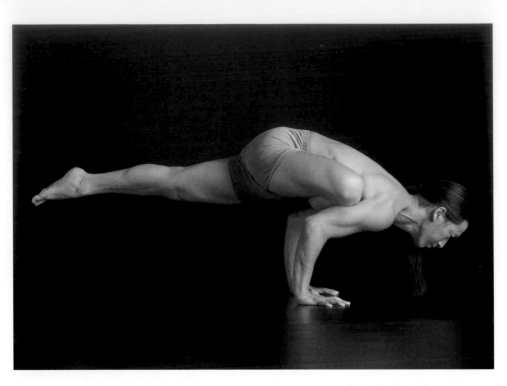

Eka Pada Galavasana
ONE-LEGGED BALANCE POSE

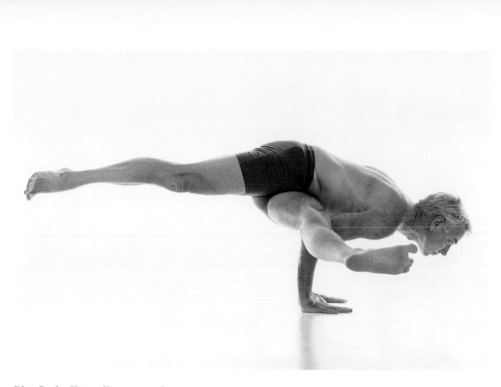

Eka Pada Koundinyasana I
ONE-LEGGED ARM BALANCE FOR
KOUNDINYA I

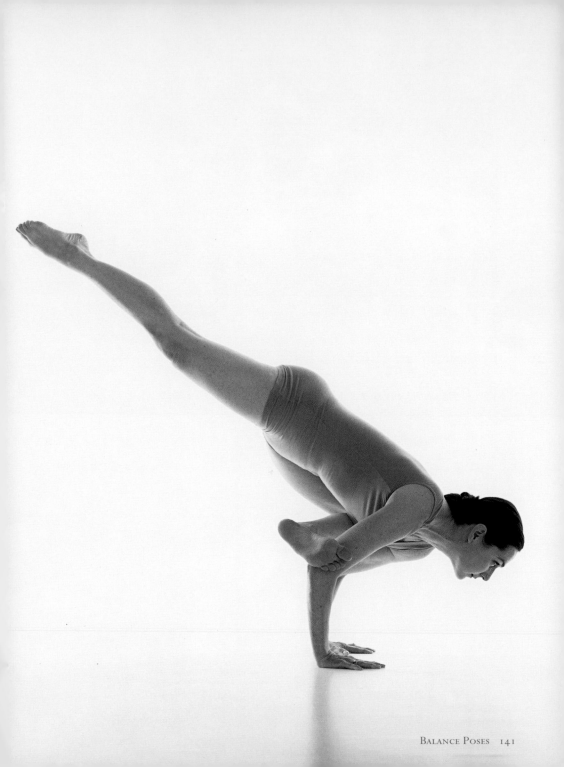

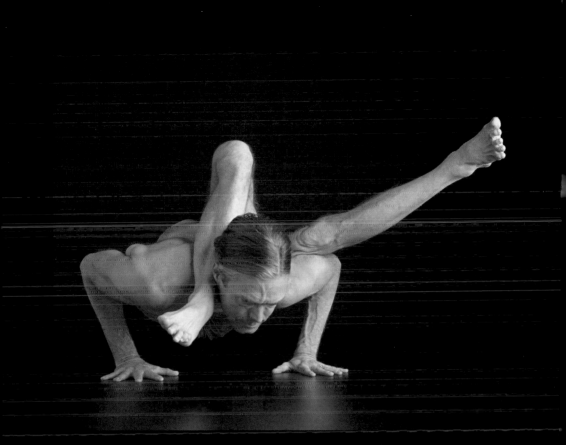

Parsva Dandasana
TWISTED STAFF POSE

Valgulasana
VISHNU BAT POSE

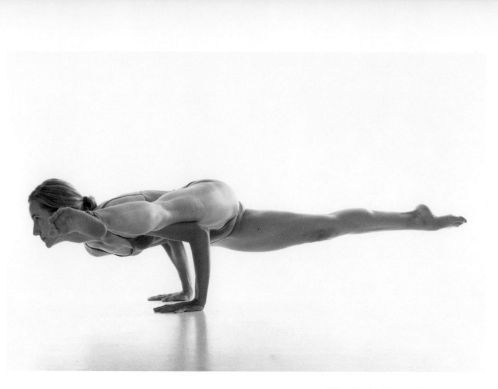

Eka Pada Koundinyasana II
ONE-LEGGED ARM BALANCE FOR
KOUNDINYA II

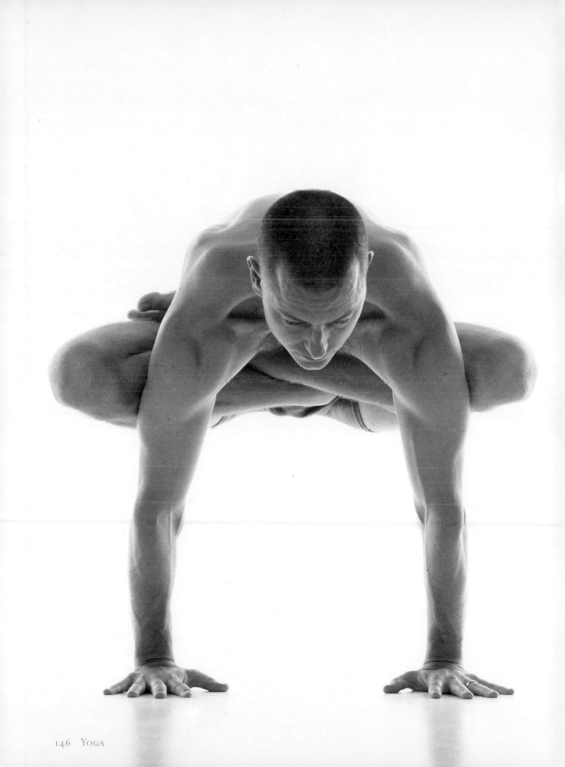

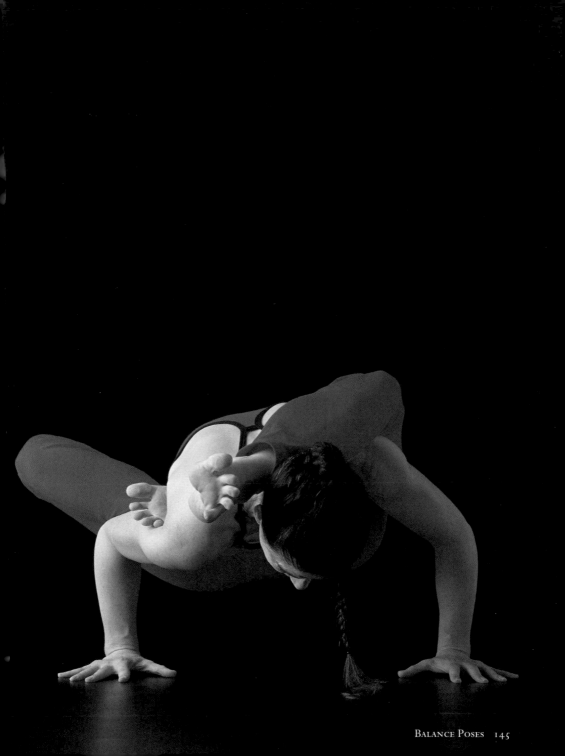

Mayurasana
PEACOCK POSE

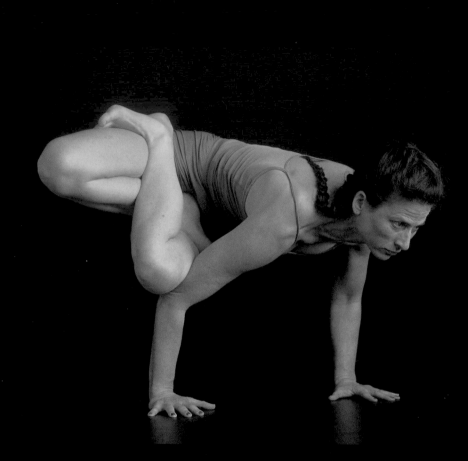

Parsva Kukkutasana
SIDE COCK POSE

Urdhva Kukkutasana
UPWARD COCK POSE

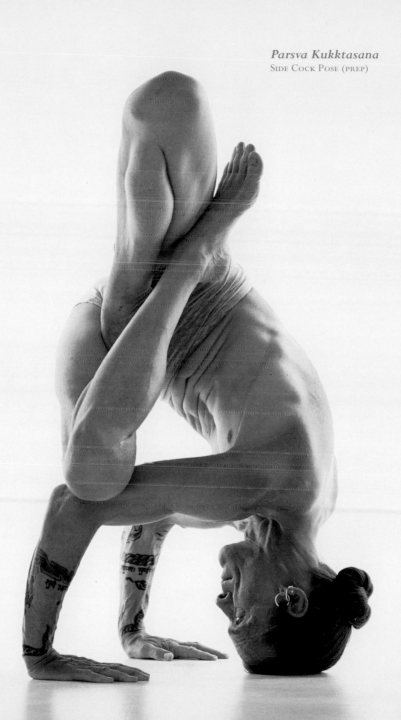

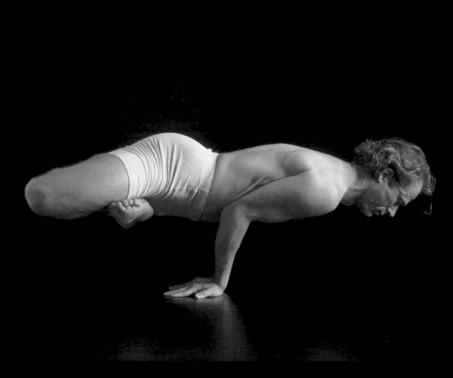

Padma Mayurasana
LOTUS PEACOCK POSE (PREP)

Urdhva Padma Mayurasana
INVERTED LOTUS PEACOCK POSE (PREP)

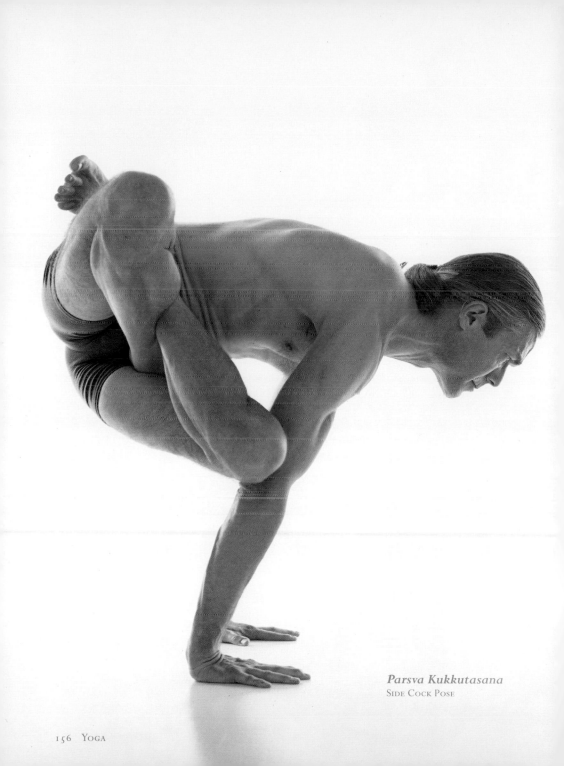

Parsva Kukkutasana
SIDE COCK POSE

Parsva Kukkutasana
Side Cock Pose

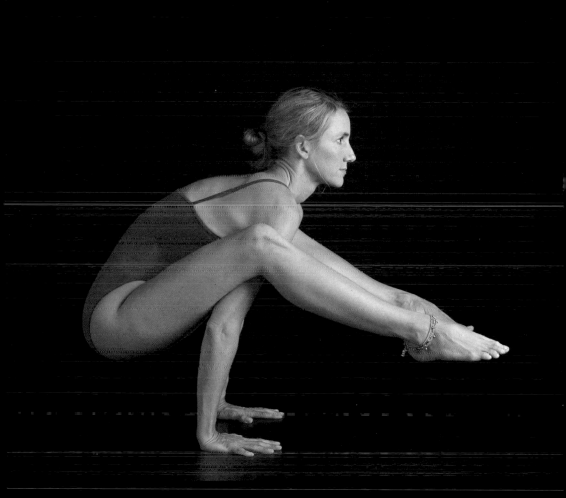

Dwi Hasta Bhujasana
Two-Handed Arm Balance

Bhujapidasana
Shoulder Pressing Arm Balance

Omkarasana
OM POSE

Bhujapidasana
SHOULDER PRESSING ARM BALANCE

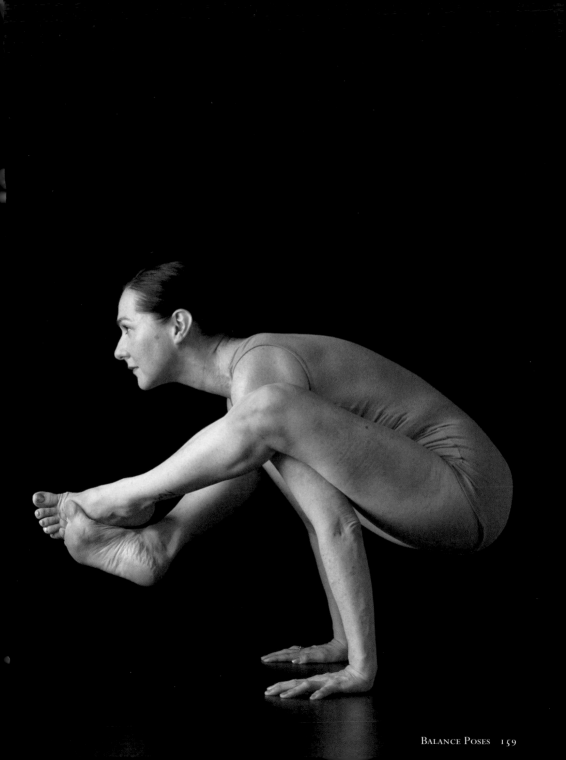

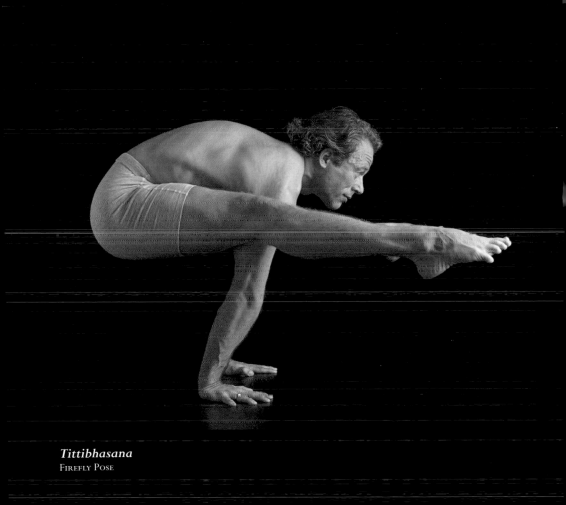

Tittibhasana
FIREFLY POSE

Tittibhasana
FIREFLY POSE

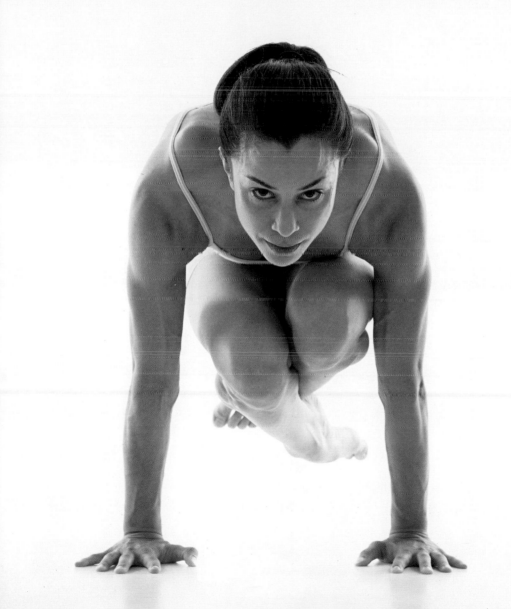

Lolasana
PENDANT POSE

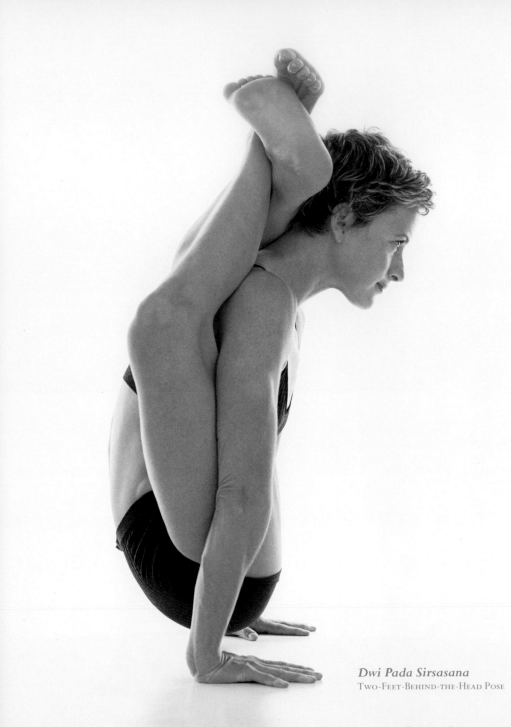

Dwi Pada Sirsasana
Two-Feet-Behind-the-Head Pose

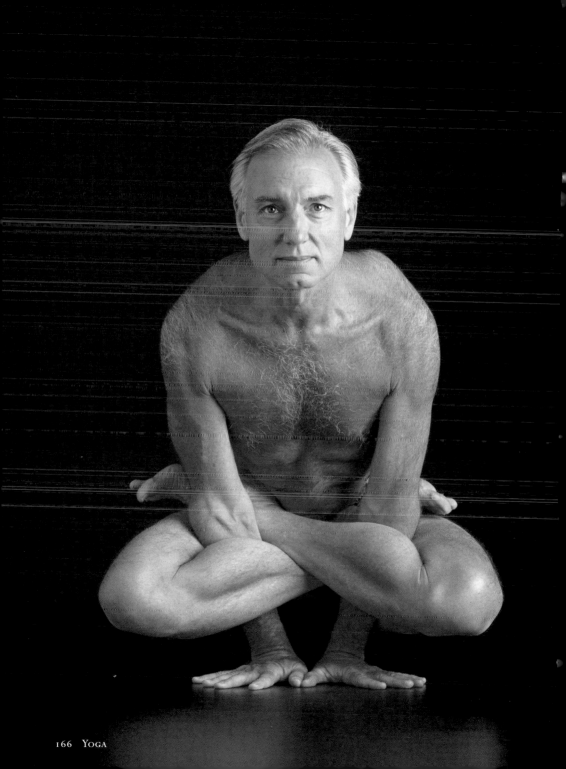

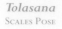

Tolasana
SCALES POSE

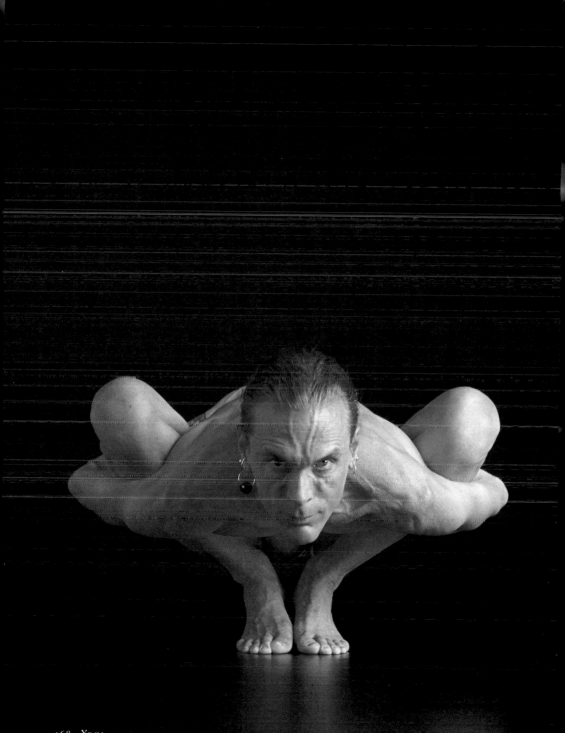

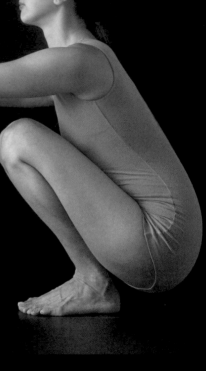

Malasana
GARLAND POSE (PREP)

Kukkutasana
COCK POSE

Ardha Baddha Padma Padangusthasana
BOUND HALF LOTUS TIP-TOE POSE
(VAR.)

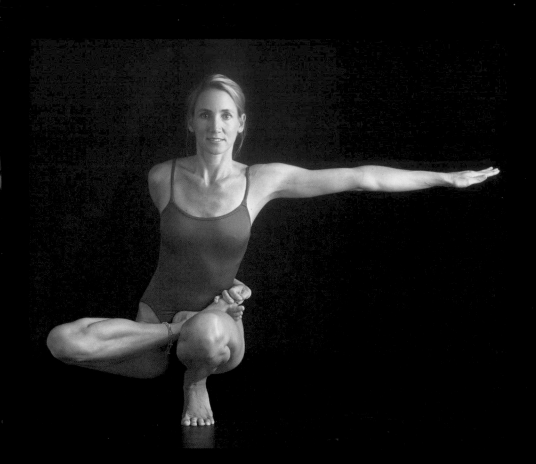

***Ardha Baddha Padma
Padangusthasana***
Bound Half Lotus Tip-Toe Pose

Malasana
Garland Pose

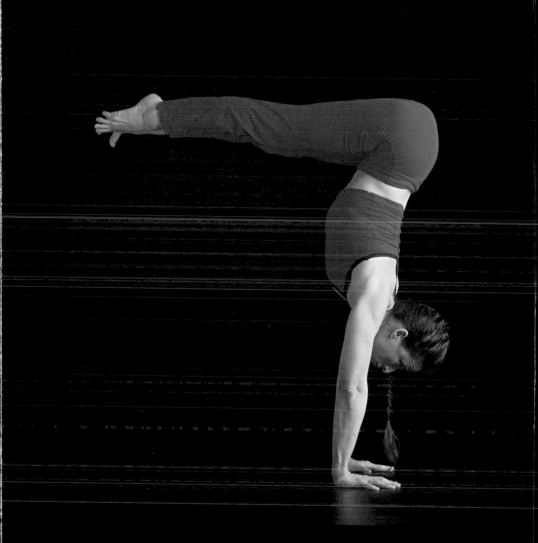

Urdhva Dandasana in
Adho Mukha Vrksasana
Upward Staff Pose in
Full Arm Balance

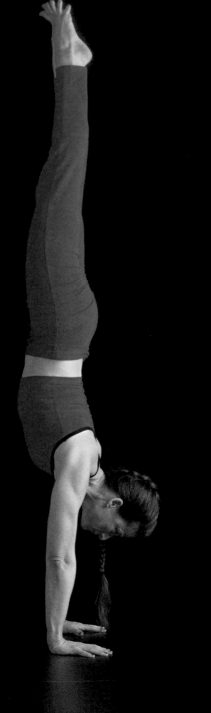

Garudasana in Adho Mukha Vrksasana
EAGLE POSE IN HANDSTAND

Adho Mukha Vrksasana
HANDSTAND (PREP)

*Baddha Konasana in
Adho Mukha Vrksasana*
Bound Angle Pose
in Handstand

Ardha Padma
Adho Mukha Vrksasana
Half Lotus in Handstand

Eka Pada Adho Mukha Vrksasana

ONE-LEGGED HANDSTAND

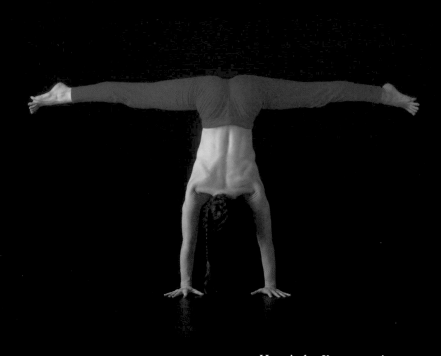

Upavistha Konasana in Adho Mukha Vrksasana
OPEN-ANGLE POSE IN HANDSTAND

Urdhva Padmasana in
Adho Mukha Vrksasana
INVERTED LOTUS IN
HANDSTAND

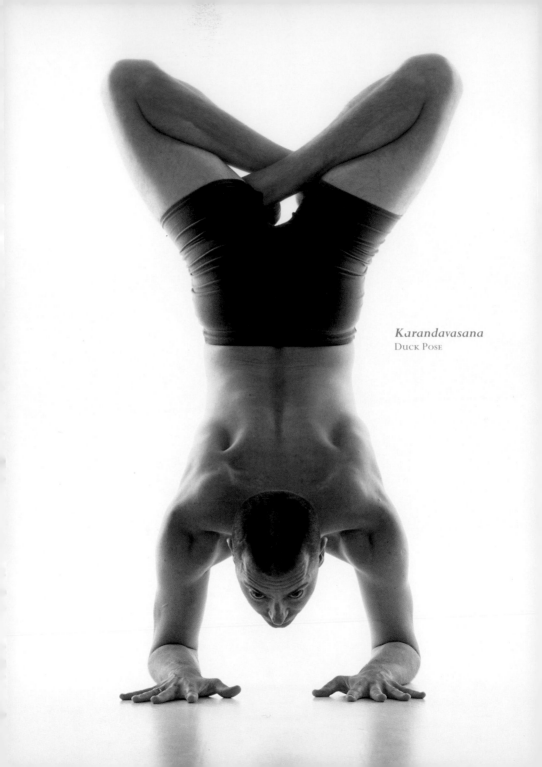

Karandavasana
DUCK POSE

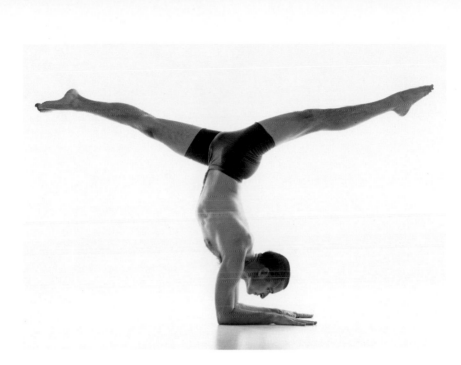

Hanumanasana in Pincha
Mayurasana
SPILT LEGS IN PEACOCK FEATHER POSE

Pincha Mayurasana
Peacock Feather Pose

Eka Pada Vrschikasana II
ONE-LEGGED SCORPION POSE

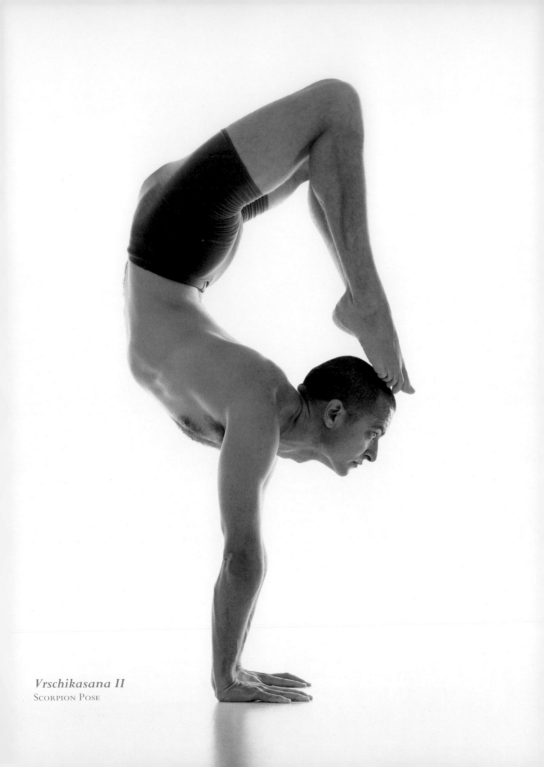

Vrschikasana II
SCORPION POSE

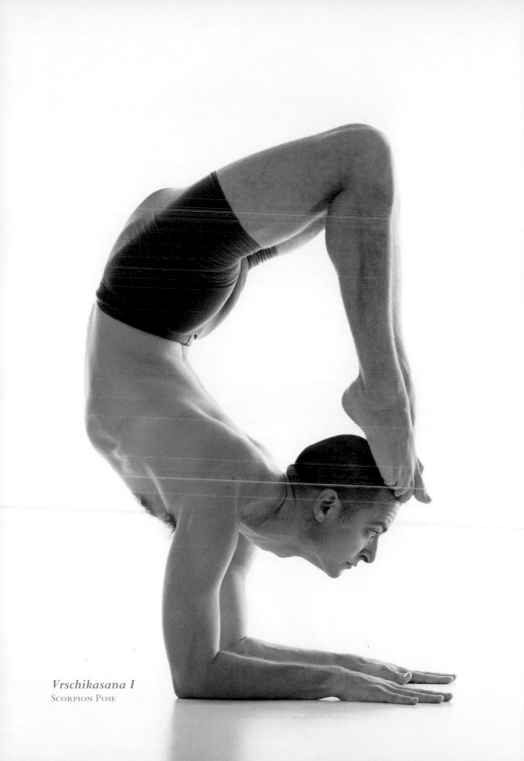

Vrschikasana I
Scorpion Pose

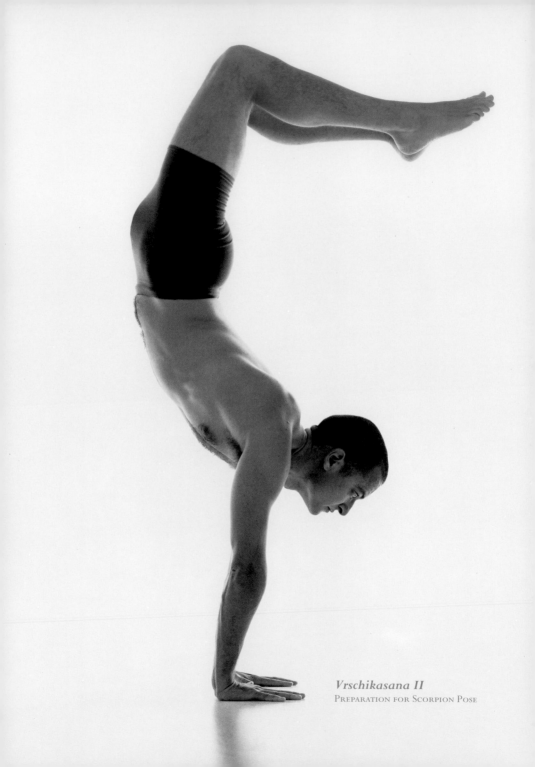

Vrschikasana II
PREPARATION FOR SCORPION POSE

Sayanasana
COUCH POSE

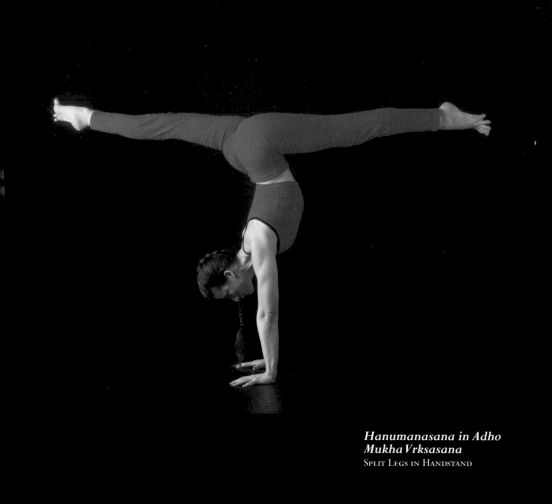

Hanumanasana in Adho Mukha Vrksasana
SPLIT LEGS IN HANDSTAND

*Eka Pada Sirsa
Padangusthasana*
FOOT-BEHIND-THE-HEAD
TIP-TOE POSE

Padma Sayanasana
LOTUS COUCH POSE

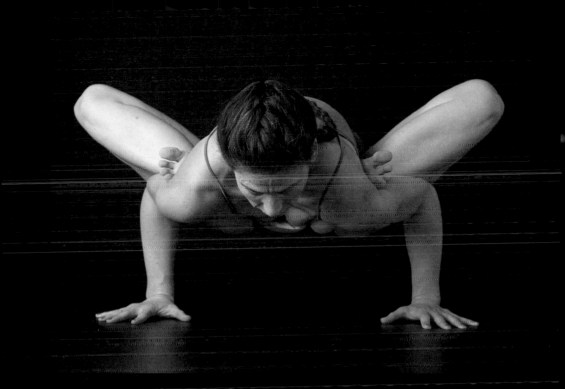

Dwi Pada Yogadandasana
Two-Legged Yogi Staff Balance

Padma Viparita Salabhasana
Inverted Locust Pose with Lotus Legs

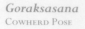

Goraksasana
COWHERD POSE

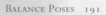

Vasisthasana

BALANCE DEDICATED TO THE
SAGE VASISTHA (VAR.)

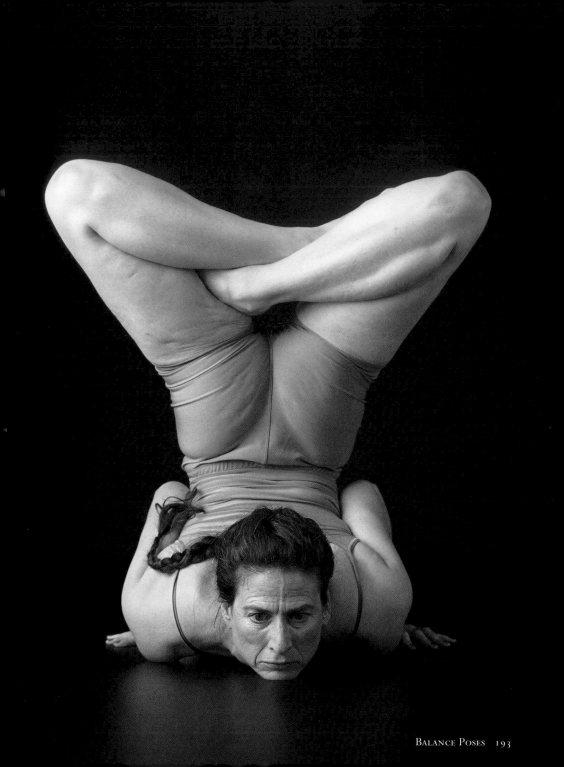

Vasisthasana
BALANCE DEDICATED TO THE
SAGE VASISTHA (VAR.)

Kala Bhairavasana
BALANCE DEDICATED TO THE
UNIVERSAL DESTROYER

Vasisthasana
Balance dedicated to the
Sage Vasistha (var.)

Vasisthasana

BALANCE DEDICATED TO THE
SAGE VASISTHA

Kasyapasana
BALANCE DEDICATED TO KASYAPA

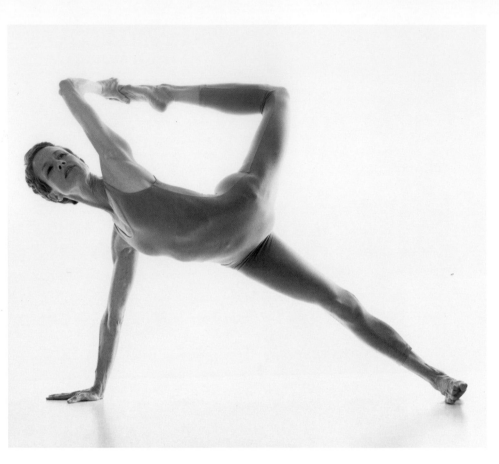

Kapinjalasana
PARTRIDGE POSE

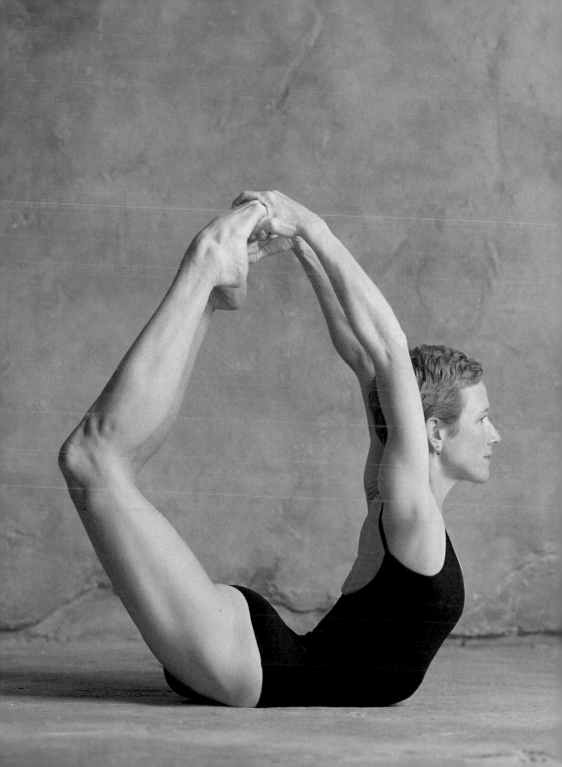

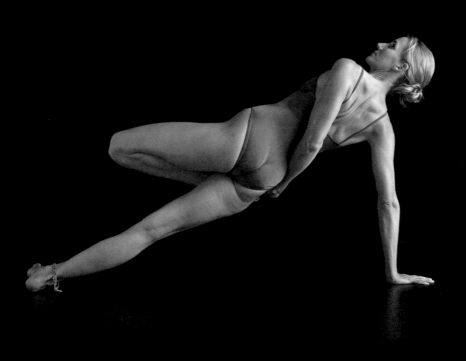

Kasyapasana
BALANCE DEDICATED TO KASYAPA

Backbend Poses

Backbends allow us to open our hearts fully to whatever the universe has in store for us, while remaining rooted in Earth, strong and capable of action. Physiologically, backbends stimulate the central nervous system and energize the whole body, alleviating headaches, hypertension, and nervous exhaustion. They tone the adrenal glands, liver, kidneys, and pancreas. Energetically, backbends create space for the breath to move more freely, creating a lighter mind.

Backbend Poses

When the senses are stilled,
the mind is at rest,
and the intellect waivers not—
then, say the wise, is reached
the highest stage.
This steady control of the senses and
the mind has been defined as Yoga.
He who attains it is free from delusion.

—KATHOPANISHAD

Padangusthasana Dhanurasana
BIG TOE BOW POSE

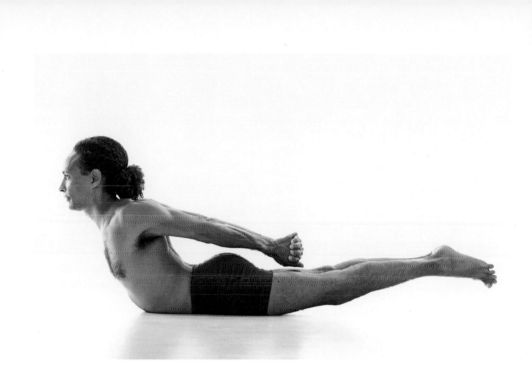

Salabhasana
LOCUST POSE (VAR.)

Salabhasana
LOCUST POSE (VAR.)

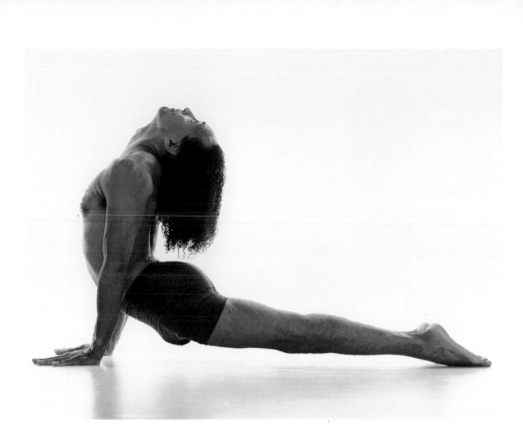

Urdhva Mukha Svanasana
UPWARD-FACING DOG POSE

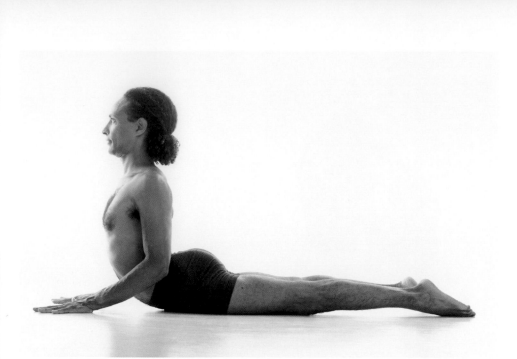

Bhujangasana I
COBRA POSE (VAR.)

Rajakapotasana
King Pigeon Pose (var.)

Bhujangasana
Cobra Pose (var.)

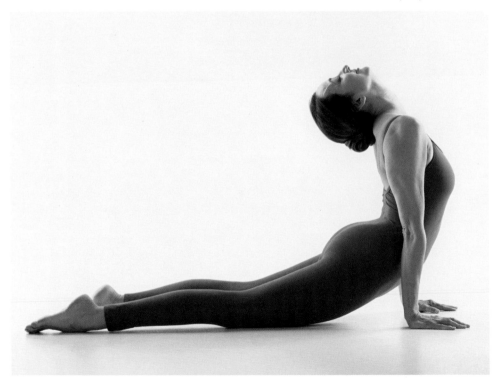

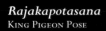

Rajakapotasana
KING PIGEON POSE

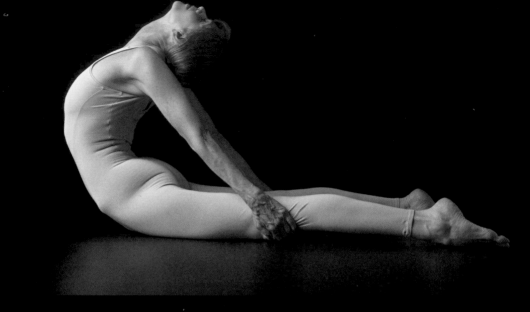

Bhujangasana II
COBRA POSE

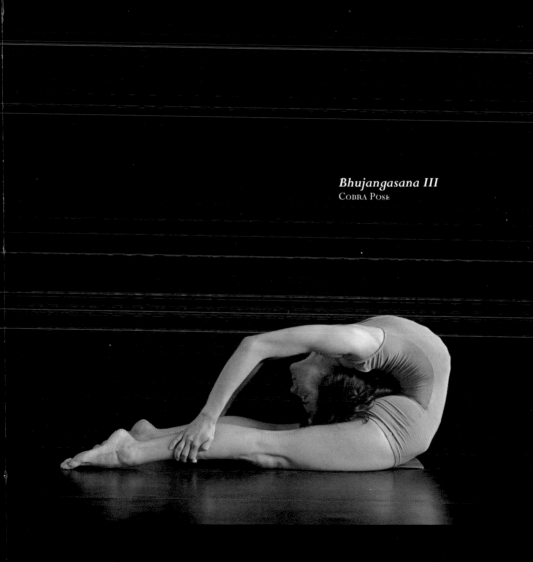

Bhujangasana III
COBRA POSE

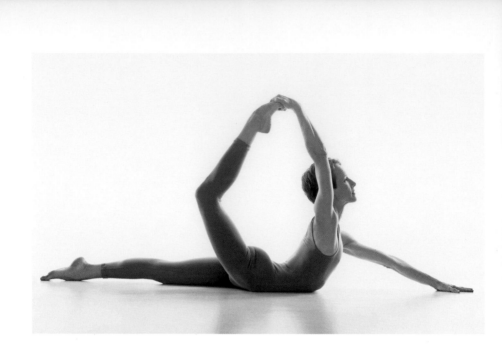

*Eka Pada Padangustha
Dhanurasana*
ONE-LEGGED BIG-TOE BOW POSE

Dhanurasana
BOW POSE

Gherandasana
Pose Dedicated to the
Sage Gheranda (var.)

Padangustha Dhanurasana

Big Toe Bow Pose (var.)

Padangustha Dhanurasana
Big Toe Bow Pose (prep.)

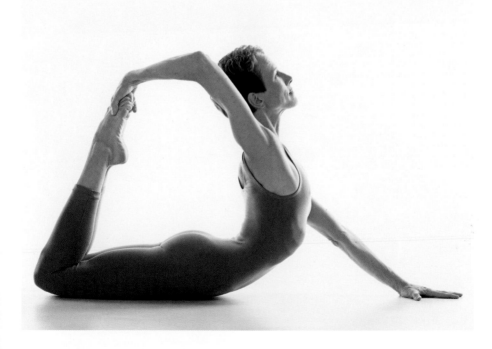

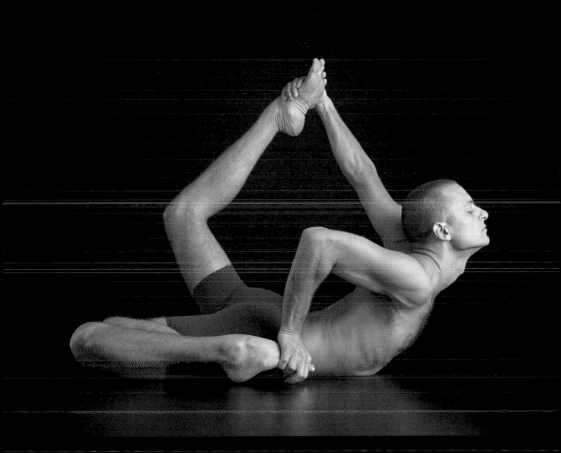

Gherandasana I
POSE DEDICATED TO THE
SAGE GHERANDA I

Gherandasana II
POSE DEDICATED TO THE
SAGE GHERANDA II

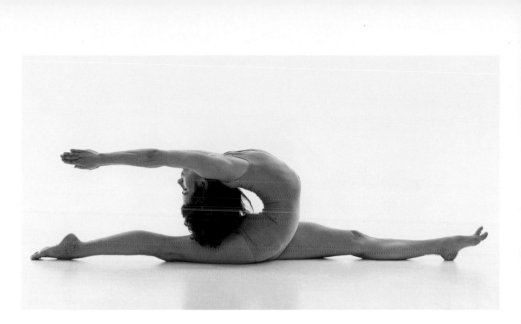

Hanumanasana
MONKEY POSE (VAR.)

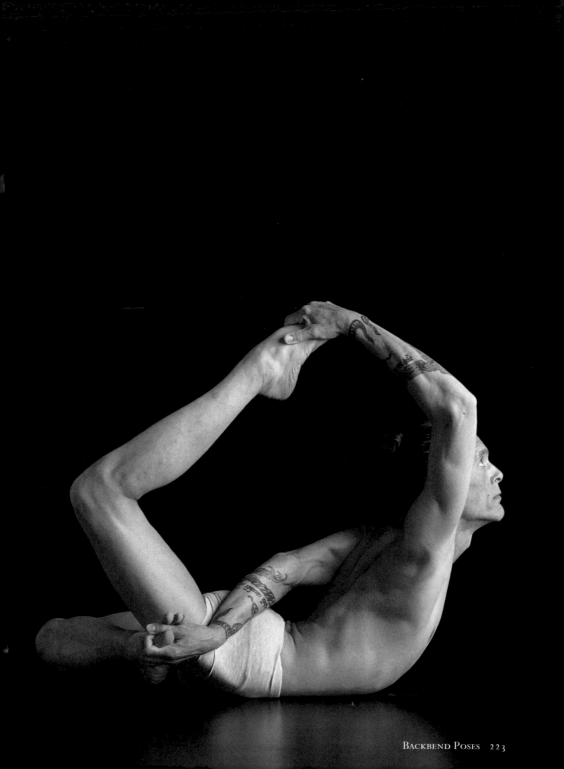

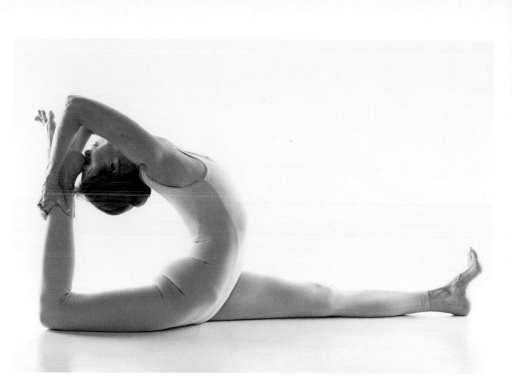

Eka Pada Rajakapotasana
ONE-LEGGED KING PIGEON POSE

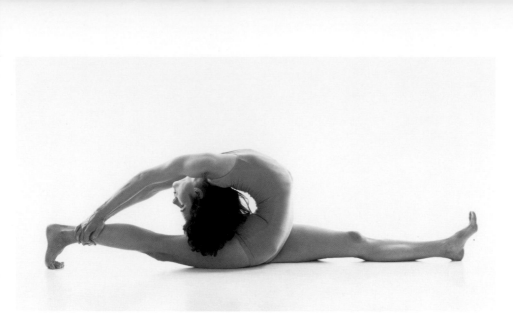

Hanumanasana
MONKEY POSE (VAR.)

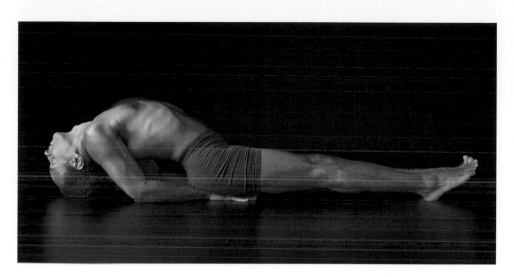

Matsyasana
FISH POSE (VAR.)

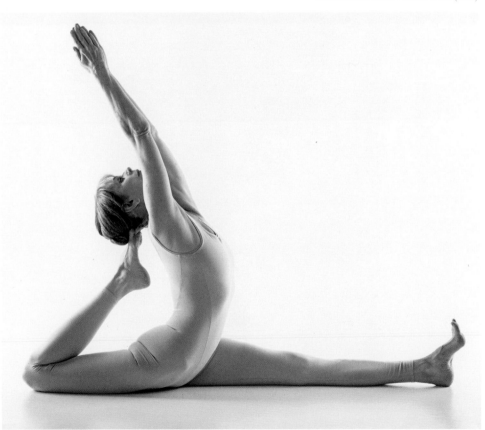

Eka Pada Rajakapotasana
ONE-LEGGED KING PIGEON POSE (VAR.)

Uttana Padasana
INTENSE LEG STRETCH (VAR.)

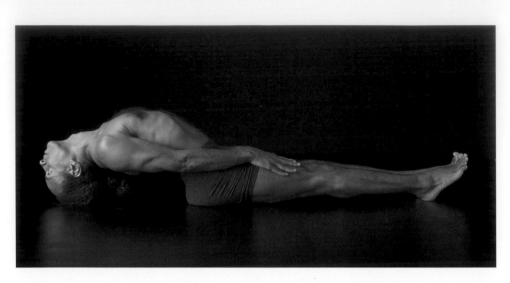

Matsyasana
FISH POSE (VAR.)

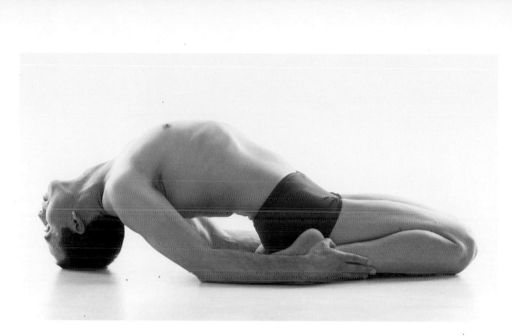

Paryankasana
BED POSE (PREP)

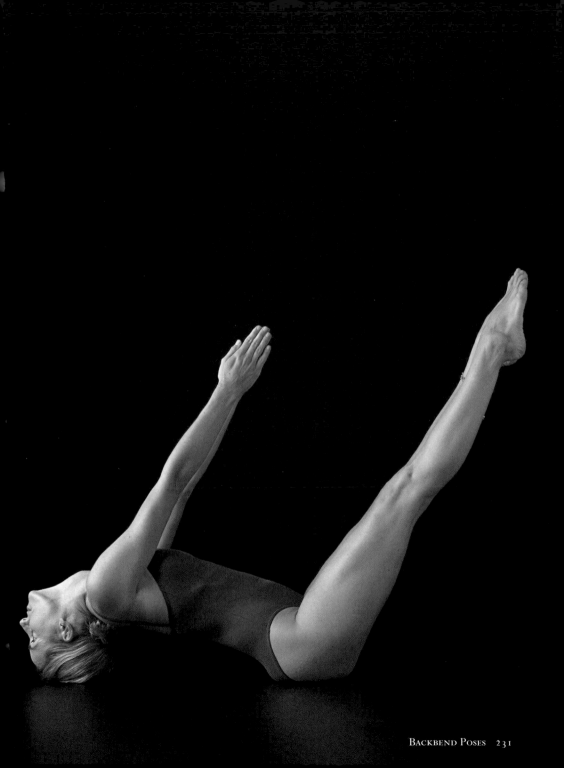

Supta Bhekasana
RECLINING FROG POSE

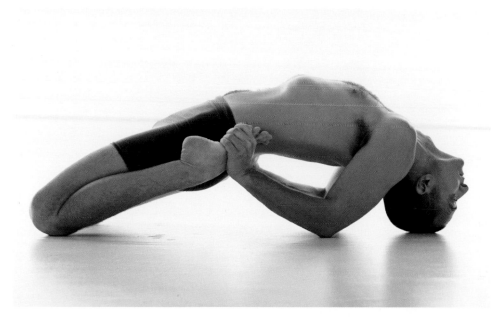

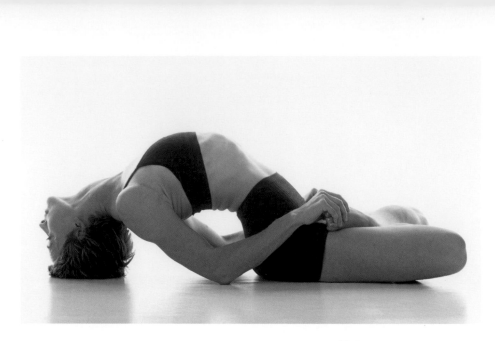

Matsyasana
FISH POSE

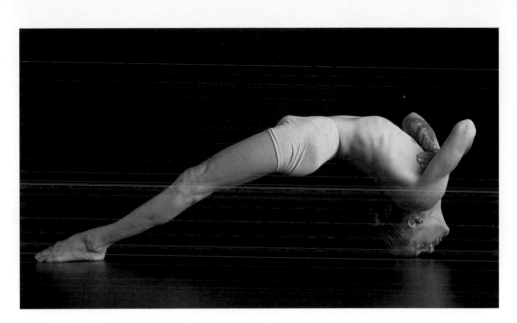

Setu Bandhasana
BRIDGE POSE

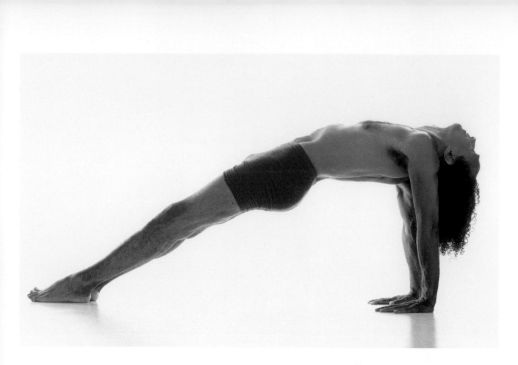

Purvottanasana
INTENSE FRONT BODY STRETCH

Eka Pada Setu
Bandhasana
One-Legged Bridge Pose

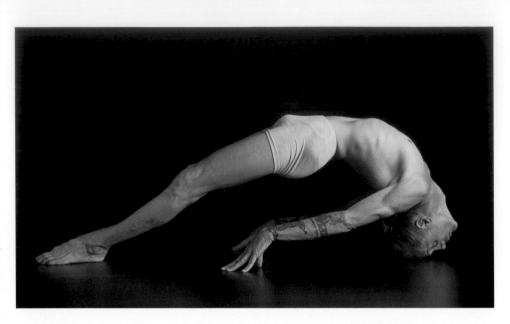

Setu Bandhasana
BRIDGE POSE (VAR.)

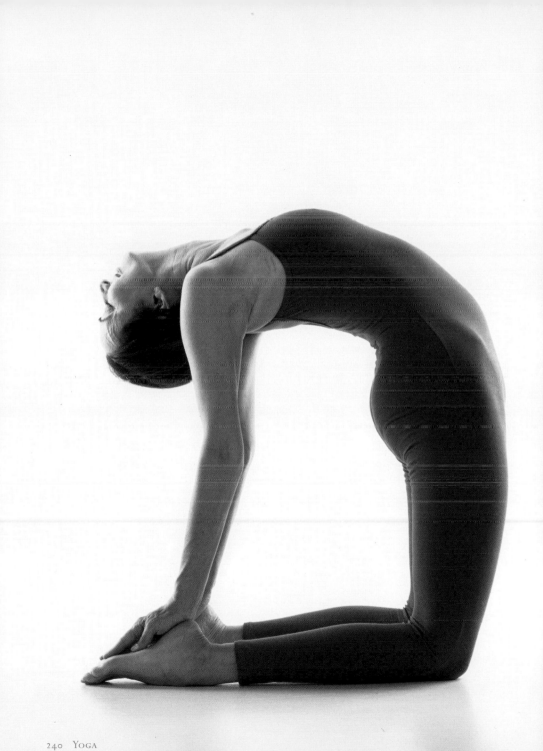

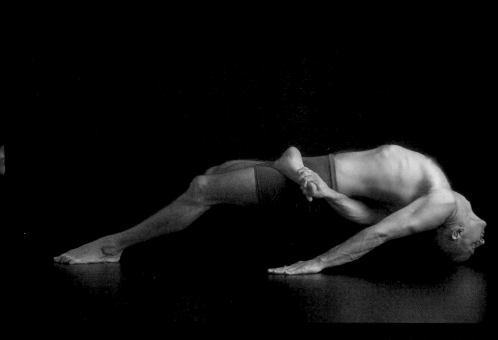

***Ardha Baddha Padma
Setu Bandhasana***
Bound Half Lotus Bridge Pose

Kapotasana
PIGEON POSE

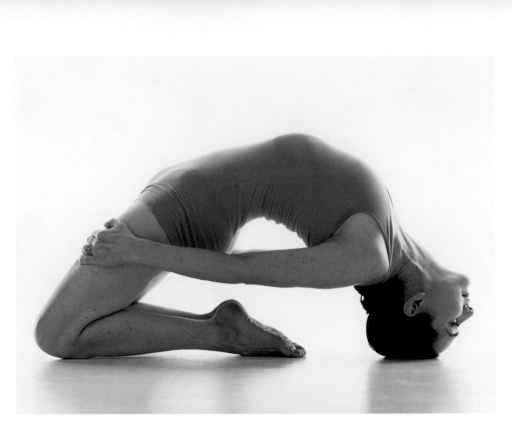

Laghu Vajrasana
LITTLE THUNDERBOLT POSE (VAR.)

Ustrasana
CAMEL POSE

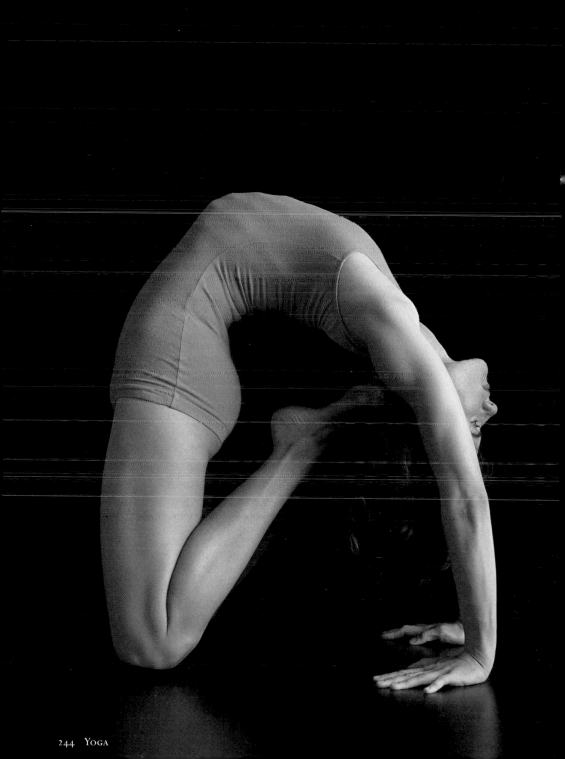

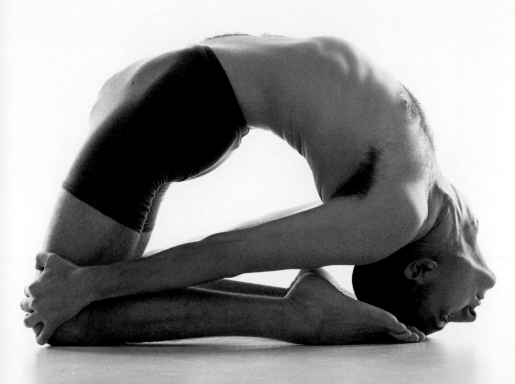

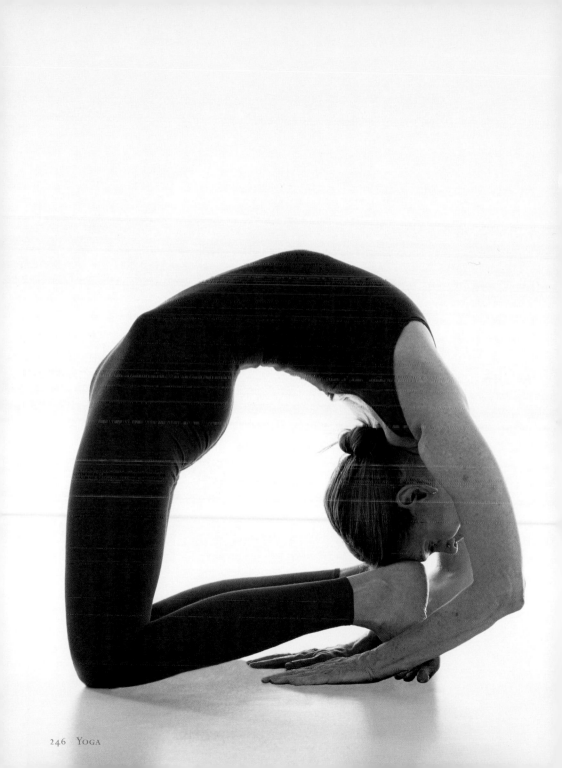

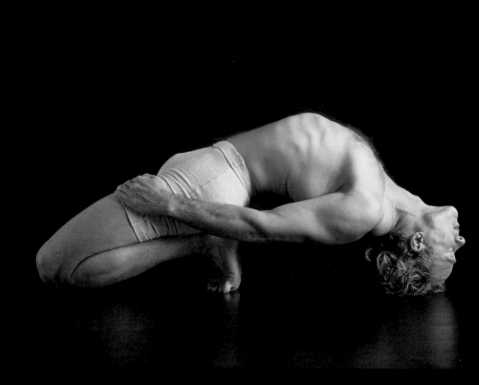

Padangustha Setu Bandhasana
TIP-TOE BRIDGE POSE

Kapotasana
PIGEON POSE (VAR.)

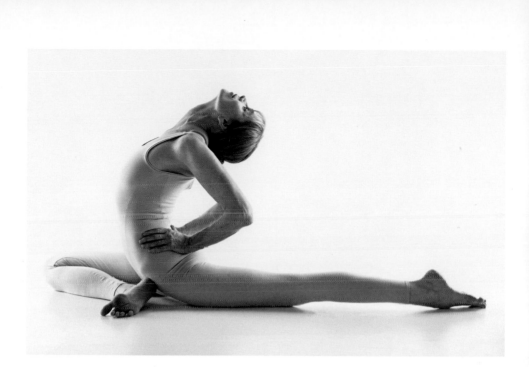

Eka Pada Rajakapotasana I
ONE-LEGGED KING PIGEON POSE I (PREP)

Eka Pada Rajakapotasana I
ONE-LEGGED KING PIGEON POSE I

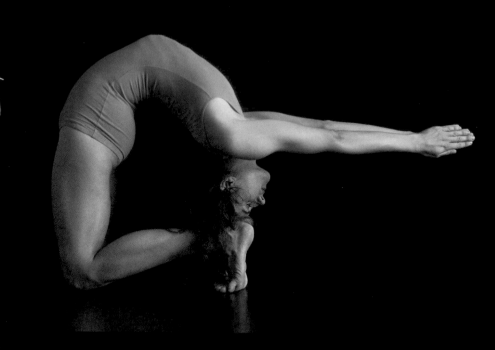

Padangustha Kapotasana
TIP-TOE PIGEON POSE (VAR.)

Padangustha Kapotasana
TIP TOE PIGEON POSE (VAR.)

Eka Pada Rajakapotasana II
ONE-LEGGED KING PIGEON POSE II

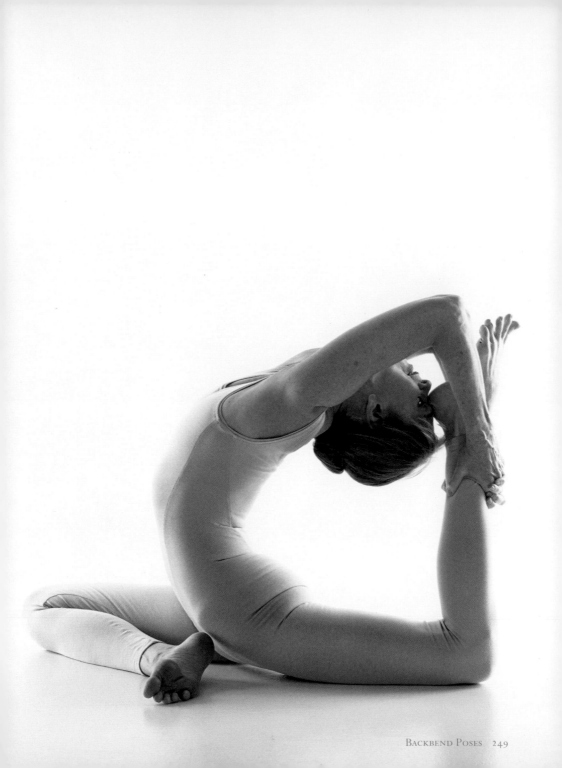

Dwi Pada Viparita
Dandasana
Two-Legged Inverted Staff Pose

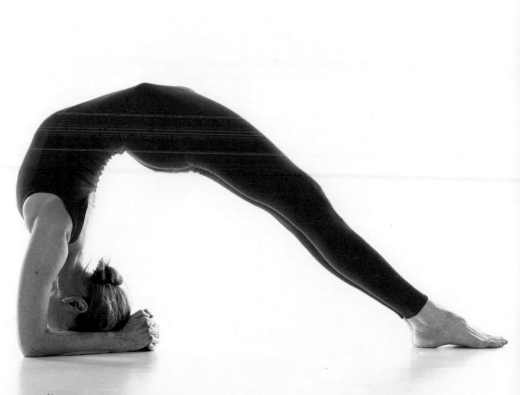

Eka Pada Rajakapotasana I

One-Legged King Pigeon Pose I (var.)

Eka Pada Viparita
Dandasana I
ONE-LEGGED INVERTED STAFF POSE I (PREP)

Eka Pada Viparita
Dandasana I
One-Legged Inverted Staff Pose I

Eka Pada Viparita Dandasana II

ONE-LEGGED INVERTED STAFF POSE II

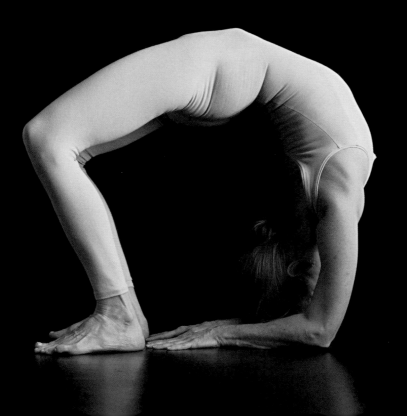

Chakra Bandhasana
BOUND WHEEL POSE (VAR.)

Eka Pada Viparita
Dandasana II
One-Legged Inverted Staff Pose II

Chakra Bandhasana
Bound Wheel Pose

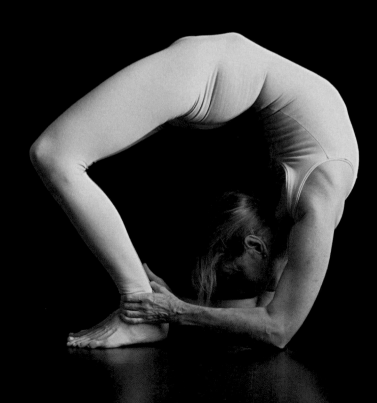

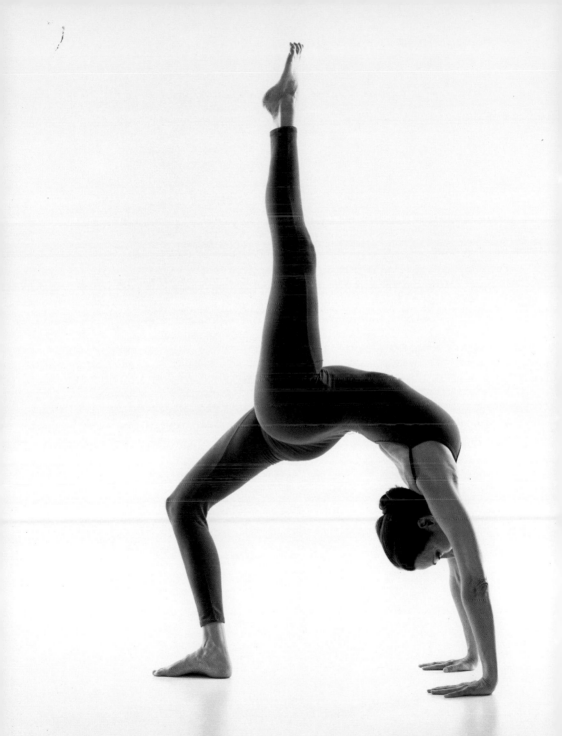

Urdhva Dhanurasana
Inverted Bow Pose

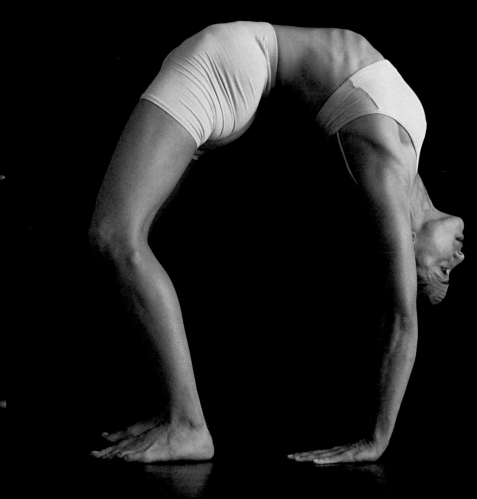

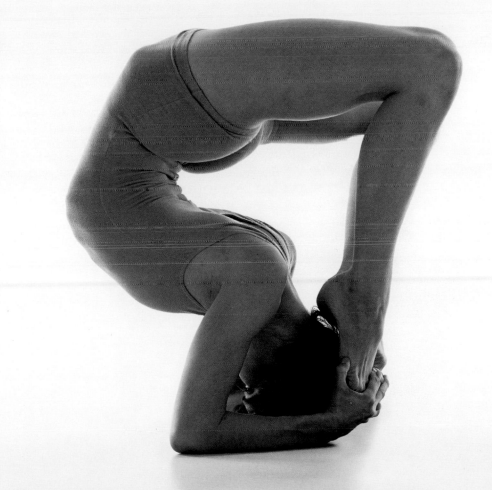

Eka Pada Urdhva Dhanurasana
ONE-LEGGED INVERTED BOW POSE

Sirsa Padasana
FEET-TO-HEAD POSE (PREP)

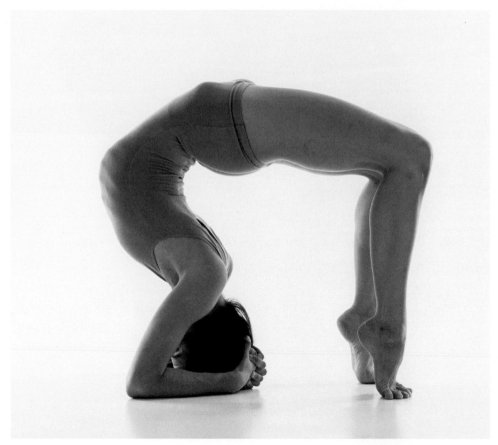

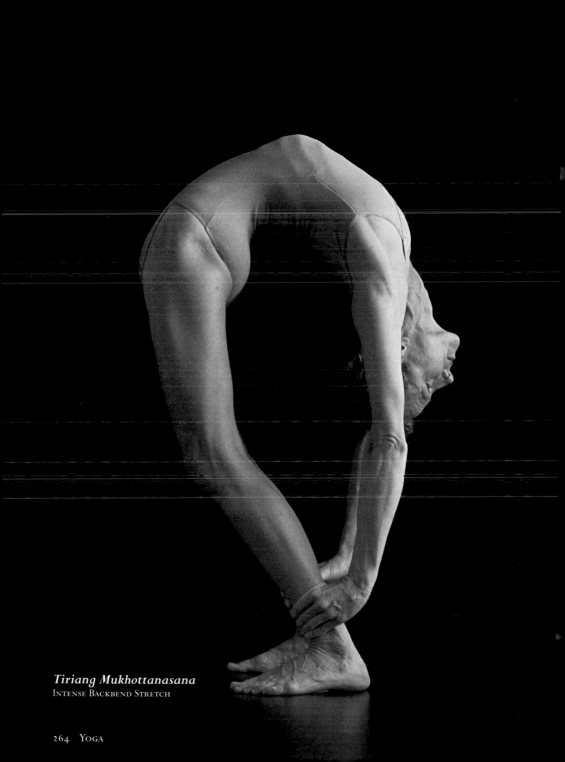

Tiriang Mukhottanasana
INTENSE BACKBEND STRETCH

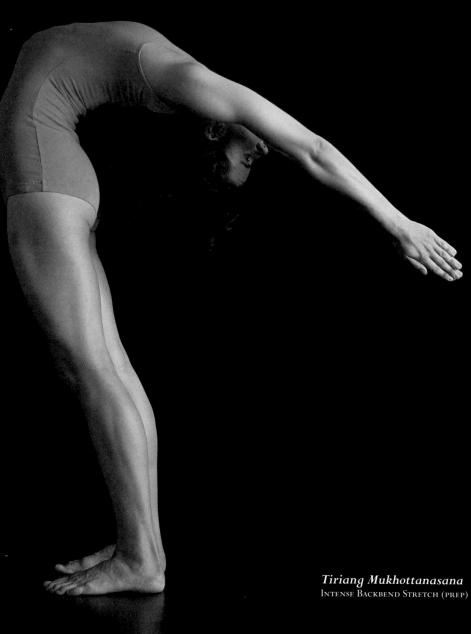

Tiriang Mukhottanasana
INTENSE BACKBEND STRETCH (PREP)

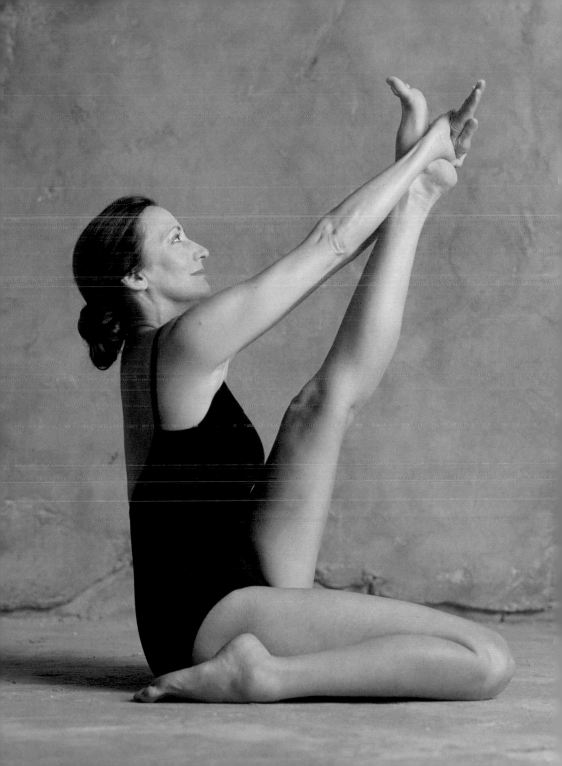

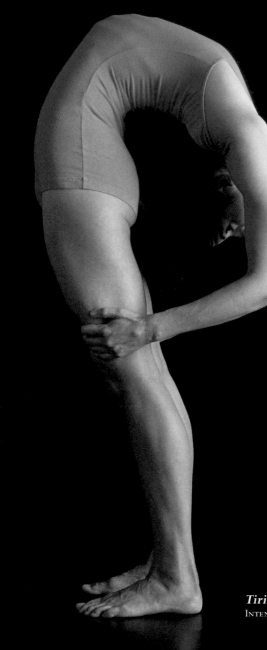

Tiriang Mukhottanasana
Intense Backbend Stretch (var.)

Seated Poses

To master the art of yoga asana is to sit in meditation with a firm body, a steady mind, and an open heart. As the lower body connects with Earth, the upper body is free to extend and release upward. Physically, these poses elongate the spine, alleviate stiffness in the knees and ankles, and release the hips and groins, giving the body the strength and flexibility it needs to sit quietly for long stretches of time. On a deeper level, seated poses quiet the mind and help control the senses, leading us to the next level of spiritual awareness.

Seated Poses

Not only the flower of the lotus,
but the posture itself
appears so glamorous that its
achievement seems worthwhile,
regardless of its difficulty.
It is as if one assumes, with the lotus
posture, the beauty, the grace,
and the divinity of the flower.

—SWAMI SIVANANDA RADHA

Krounchasana
HERON POSE

Urdhva Mukha
Paschimottanasana
Upward-Facing Forward Bend (var.)

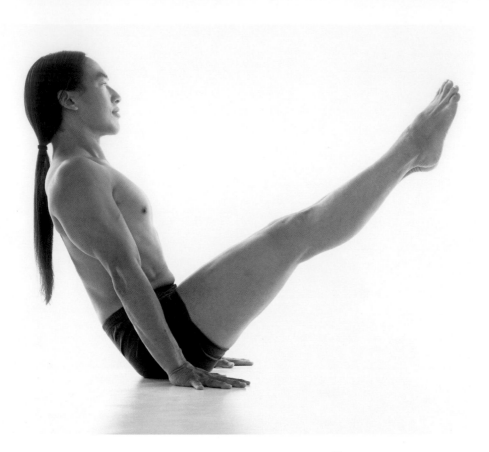

Navasana
BOAT POSE (VAR.)

Urdhva Ardha Padma
Paschimottanasana
Upward Half Lotus Forward Bend

Ubhaya Padangusthasana
BIG TOE POSE

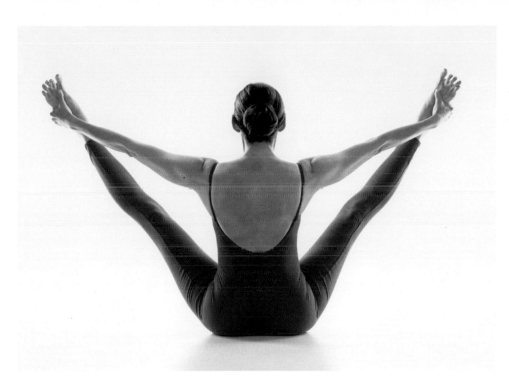

Urdhva Upavistha
Konasana
UPWARD-FACING OPEN ANGLE POSE

Urdhva Ardha Padma
Paschimottanasana
UPWARD HALF LOTUS FORWARD BEND

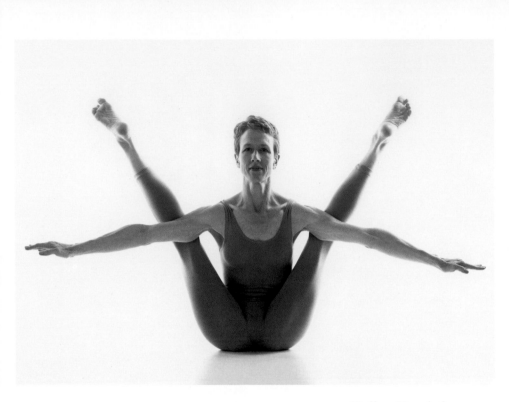

**Urdhva Upavistha
Konasana**
UPWARD-FACING OPEN ANGLE POSE
(VAR.)

Akarna Dhanurasana I
ARCHER POSE 1

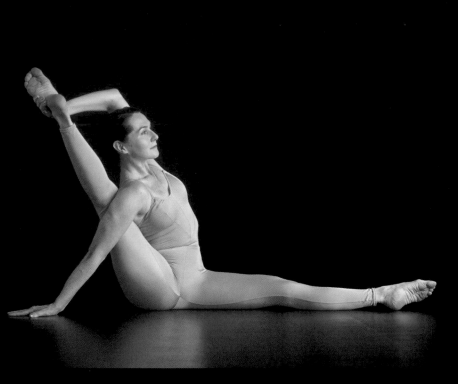

Akarna Dhanurasana II
ARCHER POSE II (VAR.)

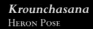

Krounchasana
HERON POSE

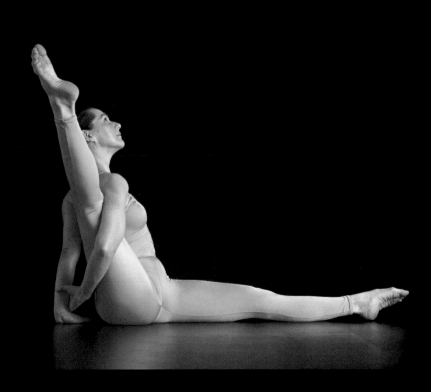

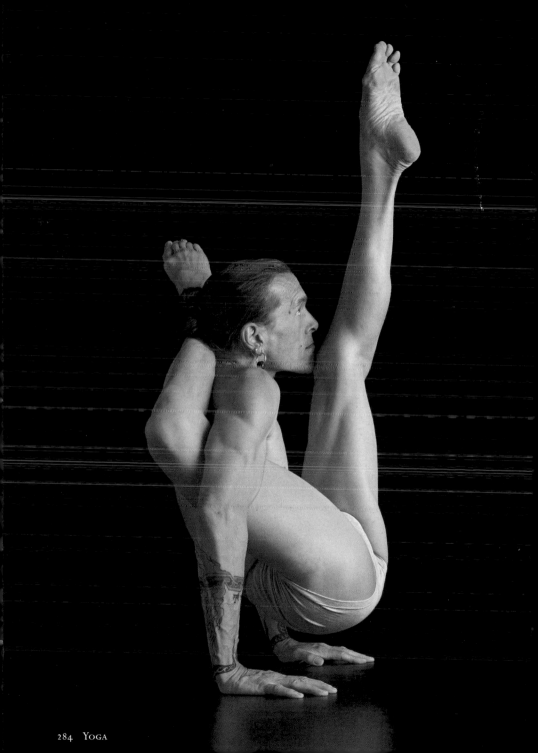

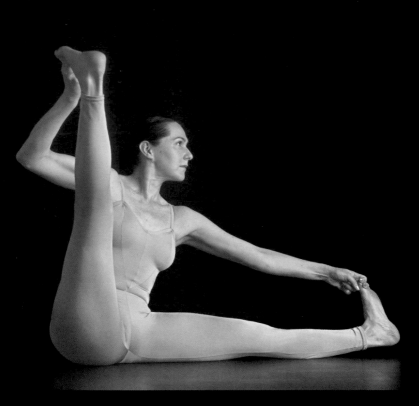

Akarna Dhanurasana II
ARCHER POSE II

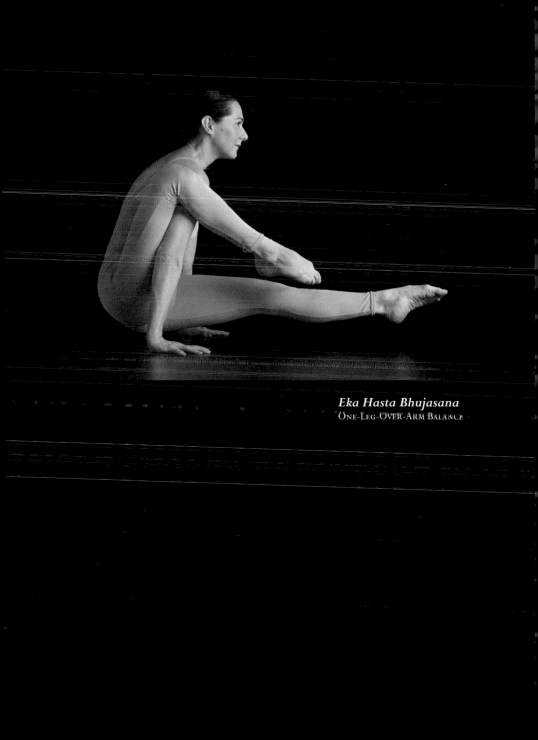

Eka Hasta Bhujasana
ONE-LEG-OVER-ARM BALANCE

Akarna Dhanurasana II
ARCHER POSE II (VAR.)

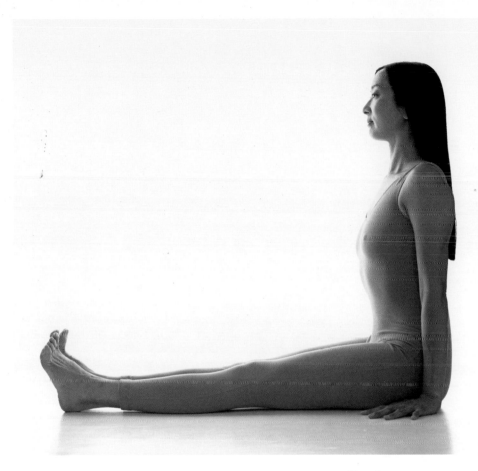

Dandasana
STAFF POSE

Chakorasana
MOONBIRD POSE

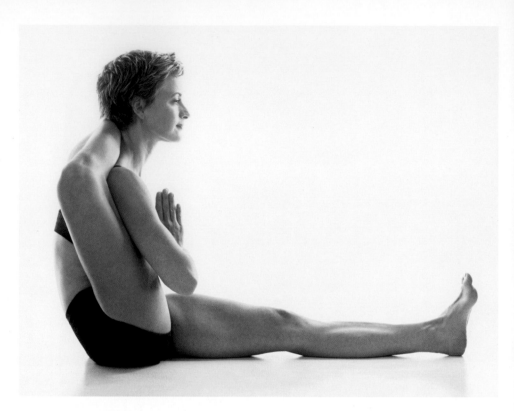

Eka Pada Sirsasana
Foot-Behind-the-Head Pose

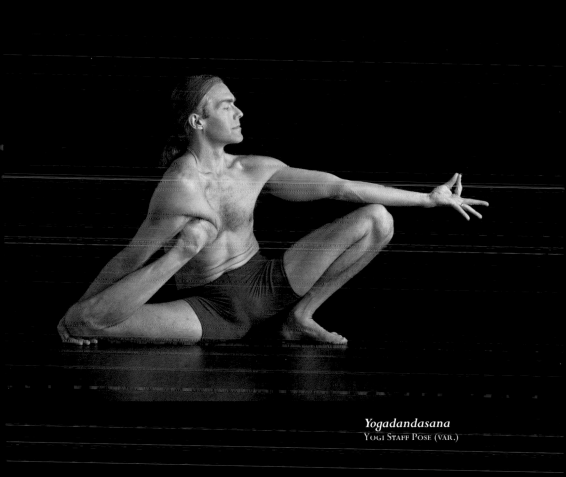

Yogadandasana
YOGI STAFF POSE (VAR.)

Viranchyasana I
POSE DEDICATED TO VIRANCHI
(BRAHMA)

Garbha Pindasana
EMBRYO POSE

Viranchyasana I
POSE DEDICATED TO VIRANCHI
(BRAHMA)

Dwi Pada Sirsasana
FEET-BEHIND-HEAD POSE

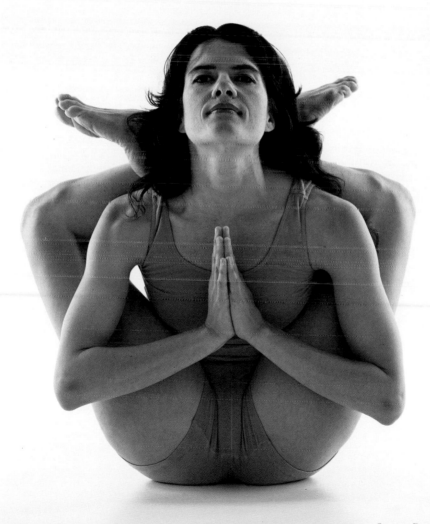

Gomukhasana

Cow Face Pose (var.)

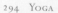

Gomukhasana
COW FACE POSE

Malasana
GARLAND (VAR.)

Gomukhasana
COW FACE POSE

Simhasana
Lion Pose (var.)

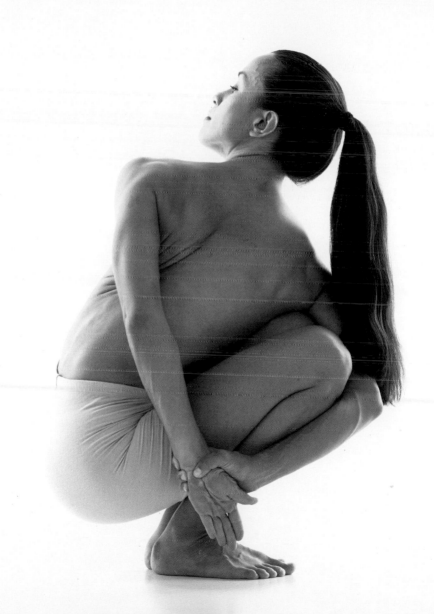

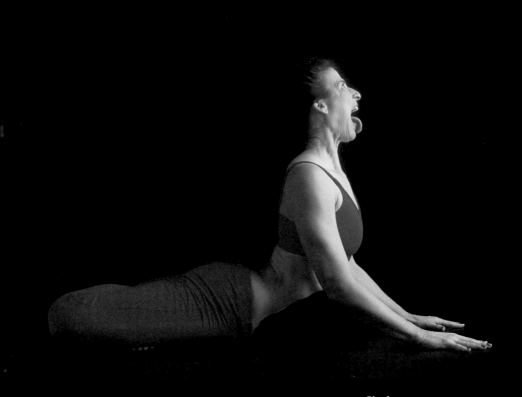

Simhasana
Lion Pose (var.)

Ardha Matsyendrasana
HALF LORD OF THE FISHES POSE

Ardha Matsyendrasana
HALF LORD OF THE FISHES POSE (VAR.)

Marichyasana IV
Twist Dedicated to the Sage Marichi

Bharadvajasana II
TWIST DEDICATED TO THE
SAGE BHARADVAJA

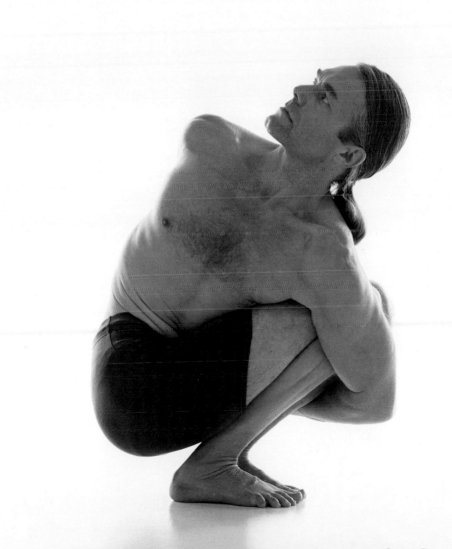

Bharadvajasana I
Twist Dedicated to the
Sage Bharadvaja

Marichyasana II
TWIST DEDICATED TO THE
SAGE MARICHI (PREP)

Marichyasana II
TWIST DEDICATED TO THE
SAGE MARICHI (PREP)

Marichyasana II
TWIST DEDICATED TO THE
SAGE MARICHI

Marichyasana II
Twist Dedicated to the Sage Marichi (var.)

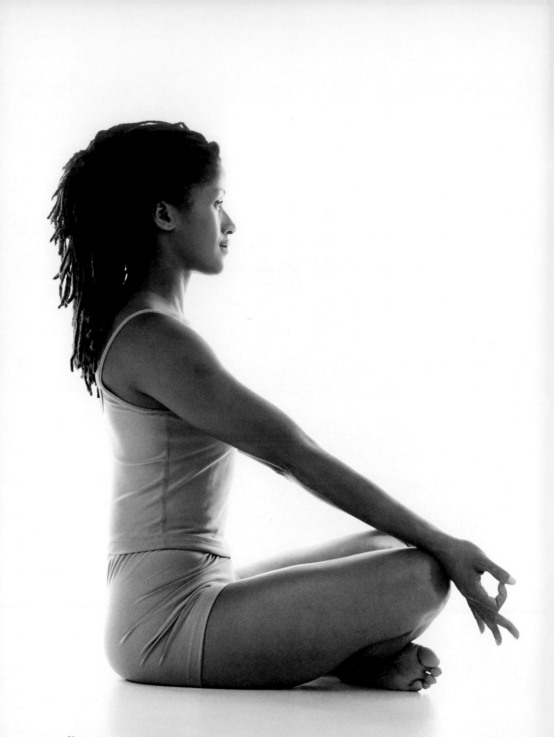

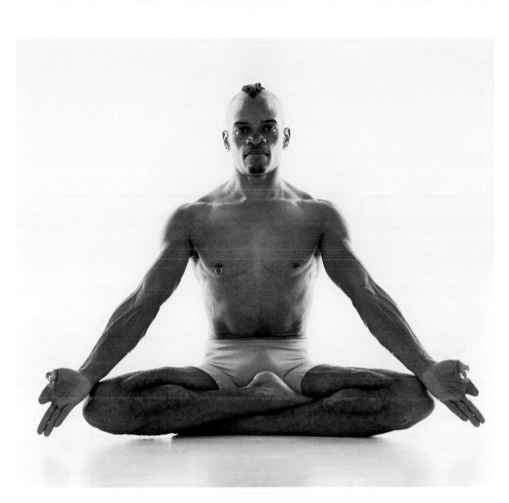

Siddhasana
ADEPT'S POSE

Sukhasana
EASY SEATED POSE

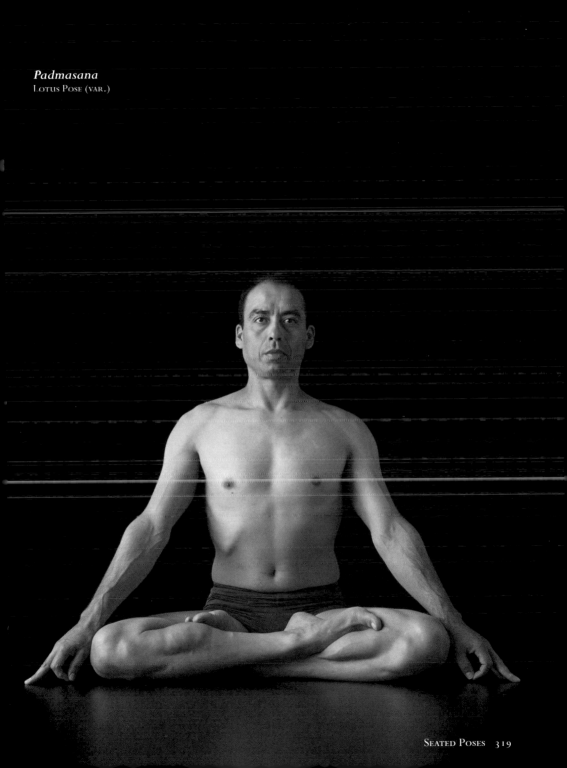

Padmasana
Lotus Pose (var.)

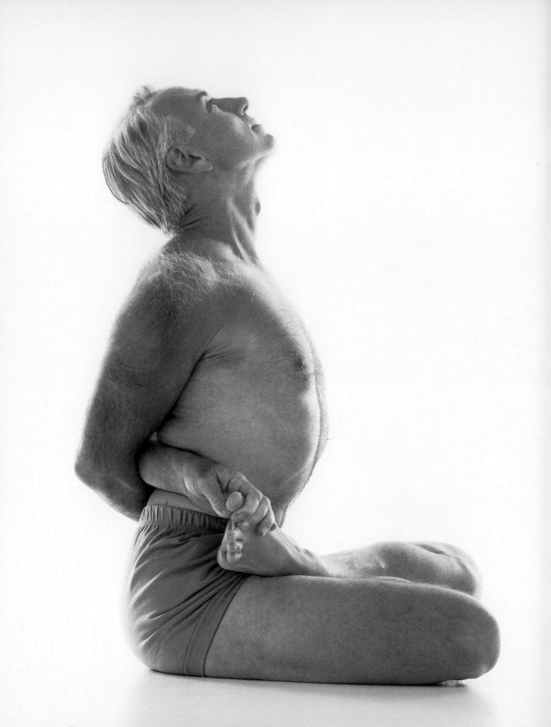

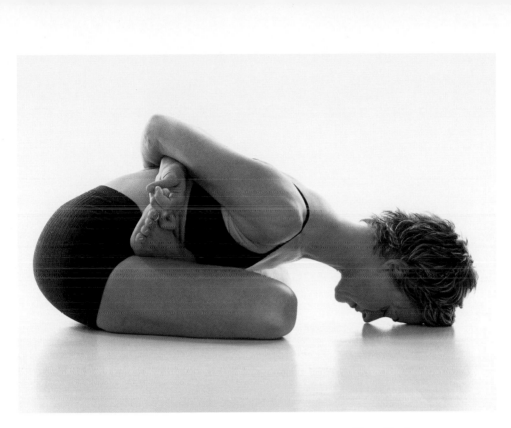

Yoga Mudrasana
YOGIC SEAL

Baddha Padmasana
BOUND LOTUS POSE

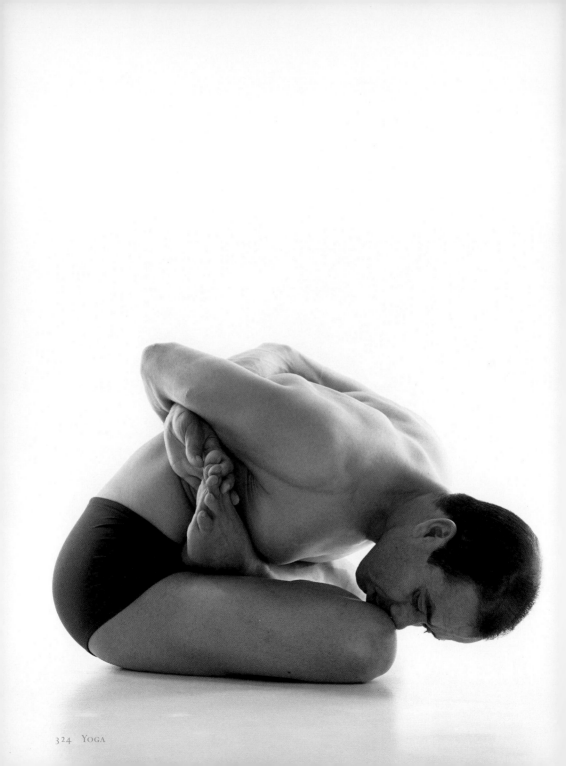

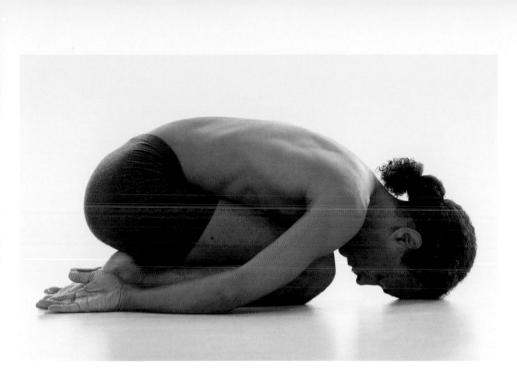

Balasana
CHILD'S POSE

Parsva Yoga Mudrasana
SIDE-BENDING YOGIC SEAL

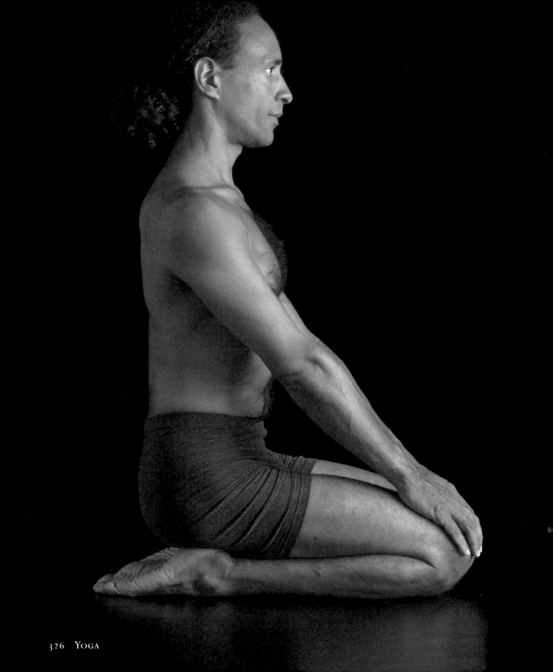

Buddhasana
ENLIGHTENED POSE (VAR.)

Vajrasana
THUNDERBOLT POSE

Padmasana
LOTUS POSE (VAR.)

Baddha Konasana
BOUND ANGLE POSE (VAR.)

<div align="right">

Baddha Konasana
BOUND ANGLE POSE

</div>

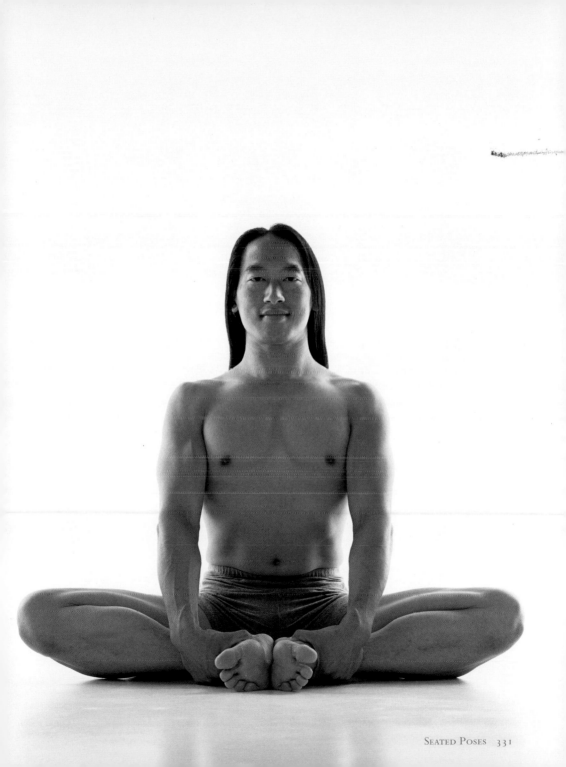

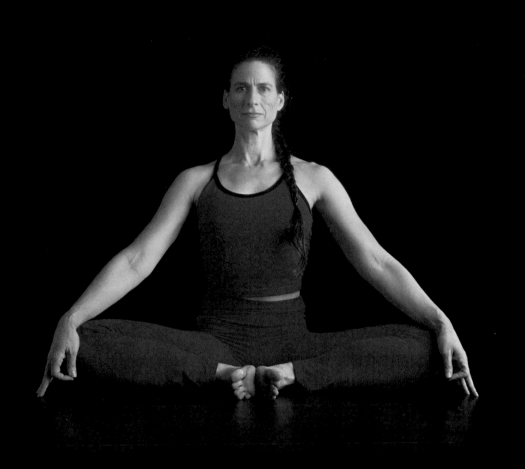

Baddha Konasana
BOUND ANGLE POSE (VAR.)

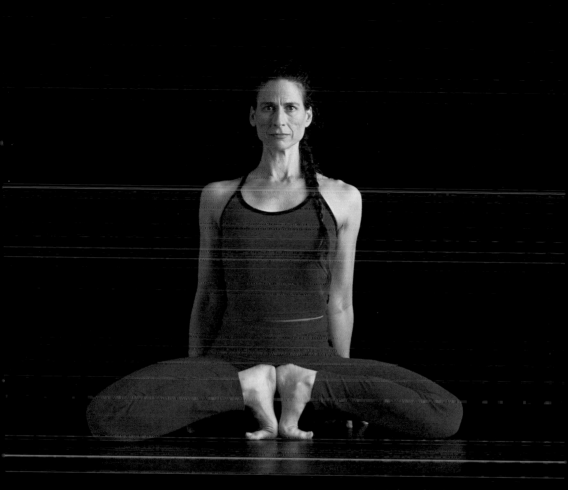

Mulabandhasana
Root Chakra Pose (var.)

Mulabandhasana
ROOT CHAKRA POSE (VAR.)

Mulabandhasana

Root Chakra Pose (var.)

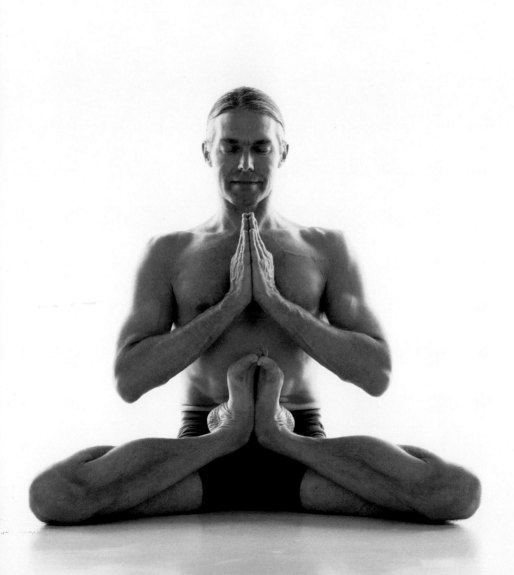

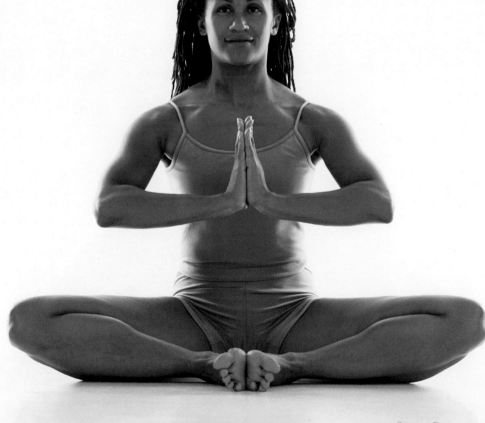

Baddha Konasana
Bound Angle Pose (var.)

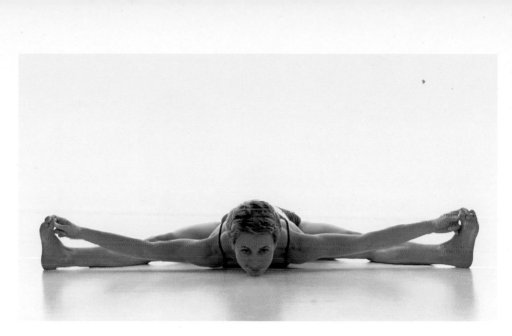

Upavistha Konasana II
OPEN ANGLE SEATED FORWARD
BEND

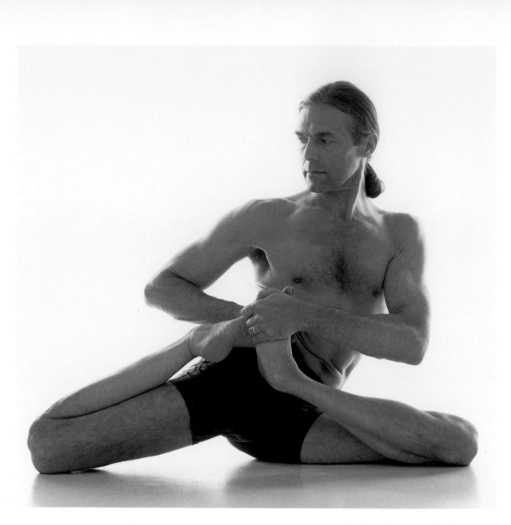

Vamadevasana II
POSE DEDICATED TO THE
SAGE VAMADEVA

Parivrtta Janu Sirsasana
REVOLVED HEAD-TO-KNEE POSE

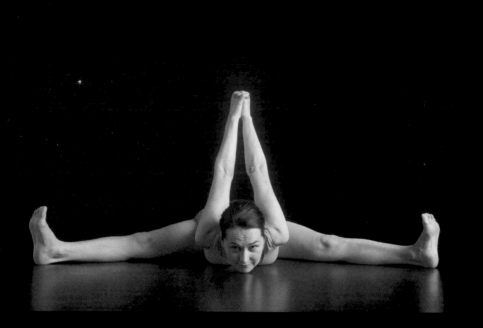

Upavistha Konasana

OPEN ANGLE SEATED FORWARD
BEND (VAR.)

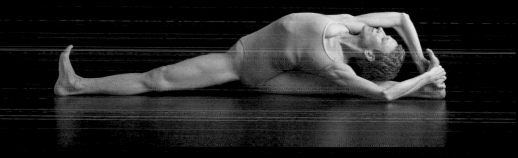

*Parivrtta Upavistha
Konasana*
REVOLVED OPEN ANGLE SEATED
FORWARD BEND

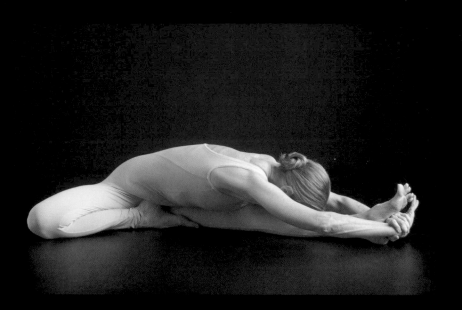

Janu Sirsasana
HEAD-TO-KNEE POSE

Paschimottanasana
SEATED FORWARD BEND (VAR.)

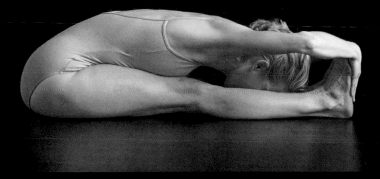

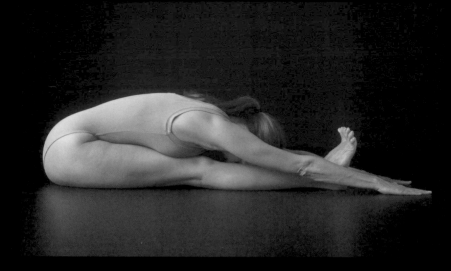

Paschimottanasana
SEATED FORWARD BEND

Parivrtta Paschimottanasana

REVOLVED SEATED FORWARD BEND

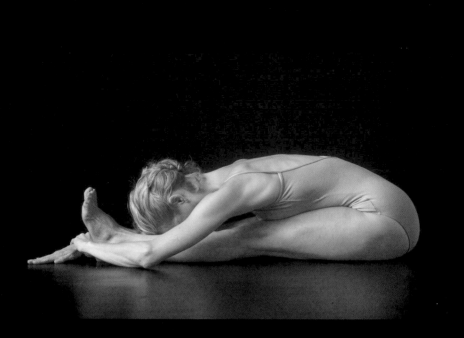

Paschimottanasana
SEATED FORWARD BEND (VAR.)

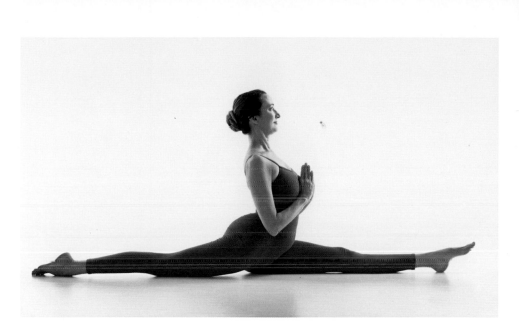

Hanumanasana
MONKEY POSE (VAR.)

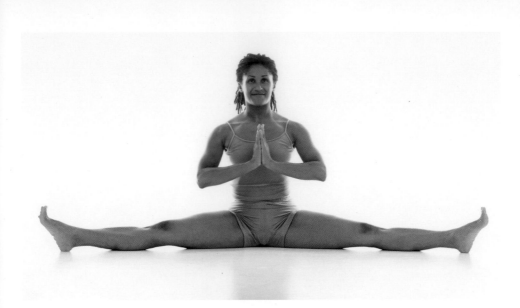

Samakonasana
FULL SIDEWAYS SPLIT

Kurmasana
TORTOISE POSE

Supta Kurmasana
RECLINING TORTOISE POSE

Supta Kurmasana
TORTOISE POSE (PREP)

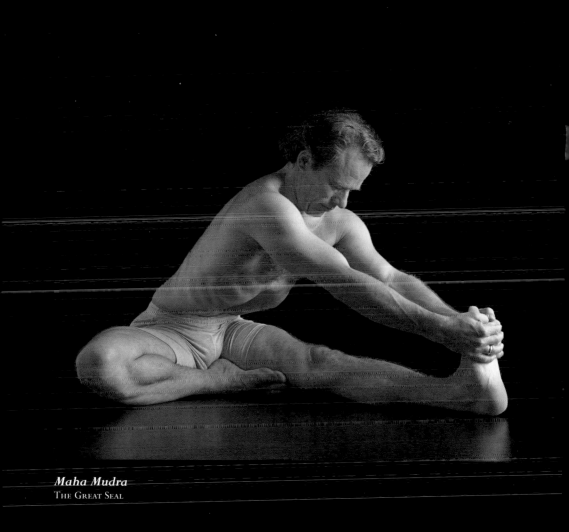

Maha Mudra
THE GREAT SEAL

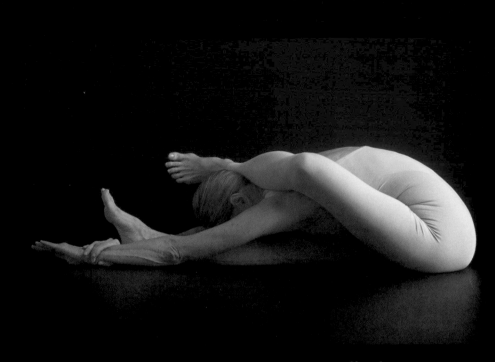

Skandasana
POSE DEDICATED TO THE GOD OF WAR

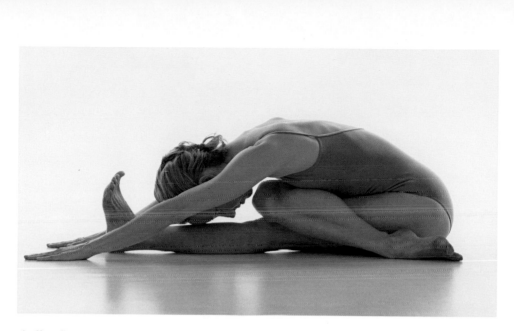

Ardha Gomukha
Paschimottanasana
HALF COW FACE FORWARD BEND

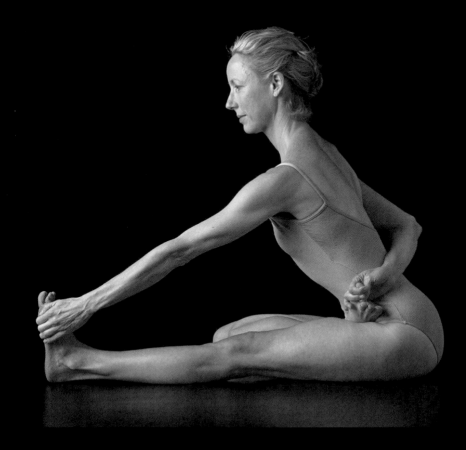

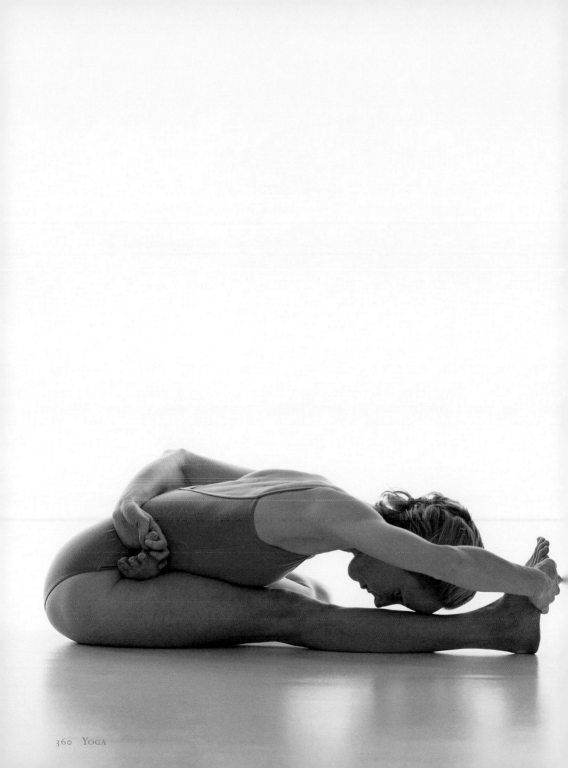

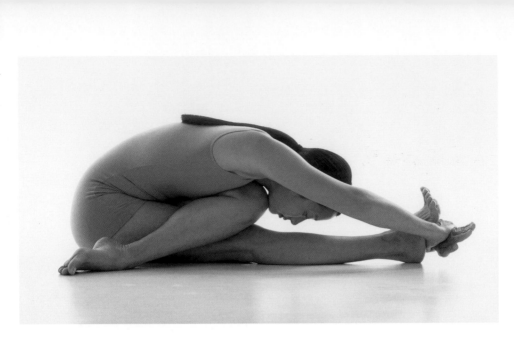

Ardha Gomukha
Paschimottanasana
Half Cow Face Forward Bend (var.)

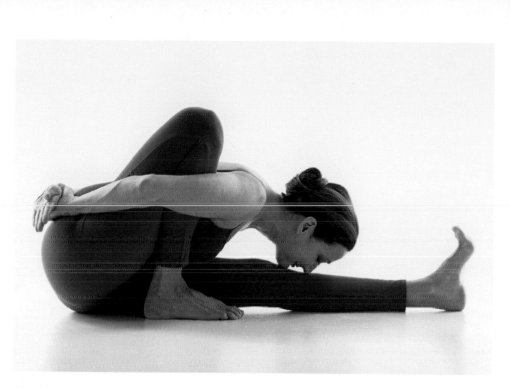

Marichyasana I

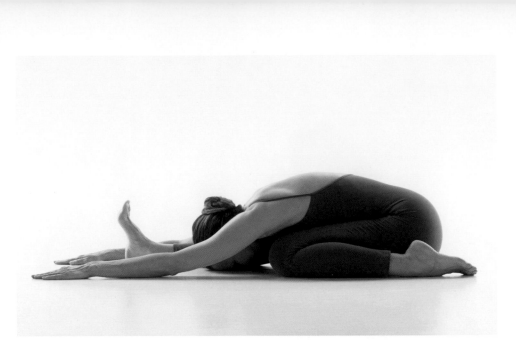

Triang Mukhaikapada
Paschimottanasana
THREE-LIMBED FORWARD BEND

Ardha Baddha Padma
Paschimottanasana
BOUND HALF LOTUS FORWARD BEND

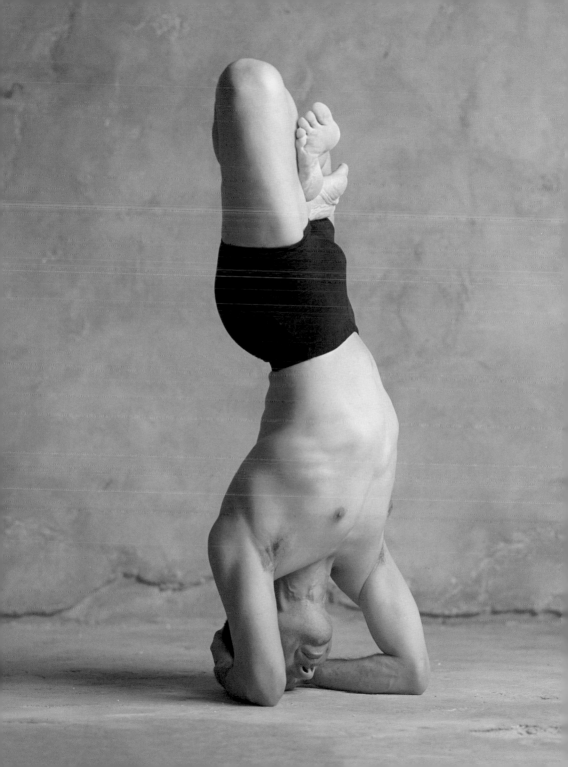

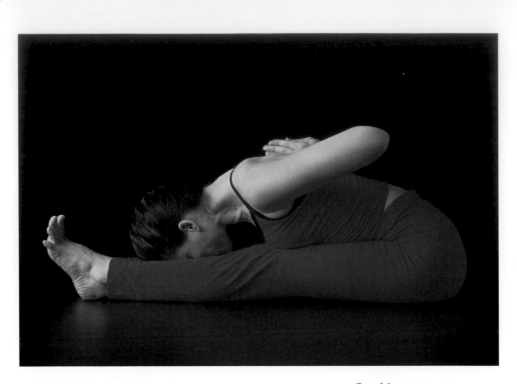

Paschimottanasana
Namaskar
FORWARD BEND WITH HANDS IN
PRAYER POSE

Inversions

Inversions teach us to stay
focused and present even as
our world turns "upside down."
Reversing our relationship to
gravity, the yogis believe, energizes
and stabilizes the whole body.
Physiologically, inversions are
yoga's gift to the body's circulation
system, allowing freshly
oxygenated blood to circulate more
freely and bringing balance to the
endocrine system. Psychologically,
inversions clear the mind and
re-energize the spirit, and give
us a renewed sense of balance
and stability.

Inversions

The yogi conquers the body by the practice of asanas and makes it a fit vehicle for the spirit. The yogi knows that it is a necessary vehicle for the spirit, for a soul without a body is like a bird deprived of its power to fly.

—B.K.S. IYENGAR

Parsva Urdhva Padma Sirsasana
SIDEWAYS UPWARD LOTUS IN HEADSTAND

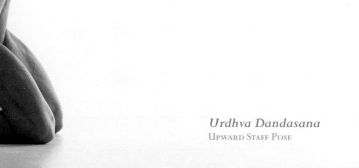

Urdhva Dandasana
UPWARD STAFF POSE

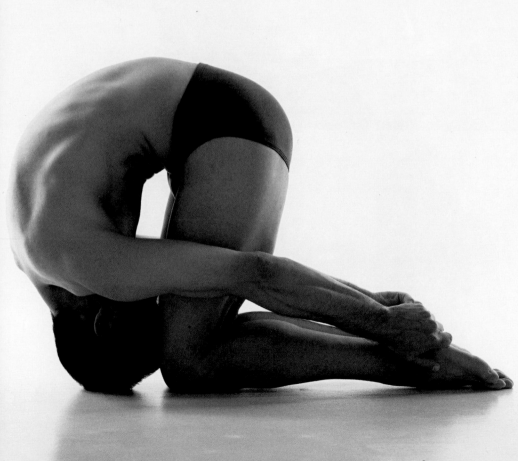

Parsva Sirsasana I

SIDEWAYS HEADSTAND

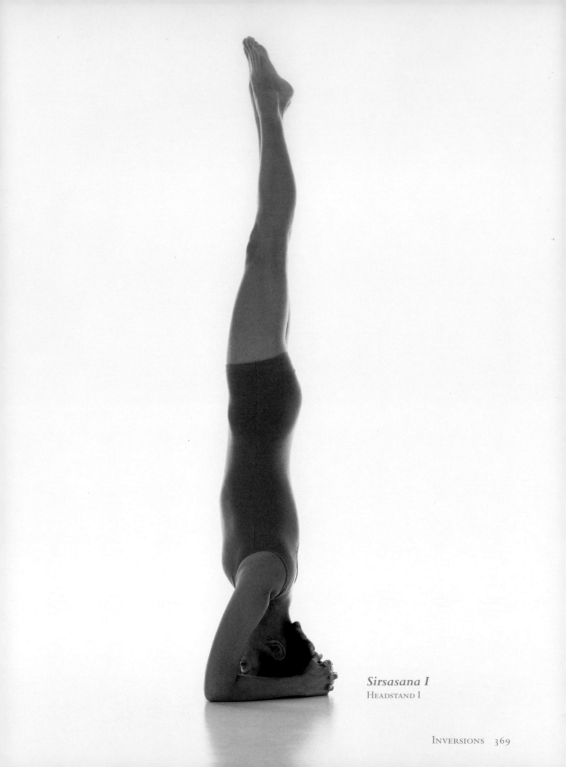

Sirsasana I
HEADSTAND I

Baddha Konasana in Sirsasana I
Bound Angle Headstand I

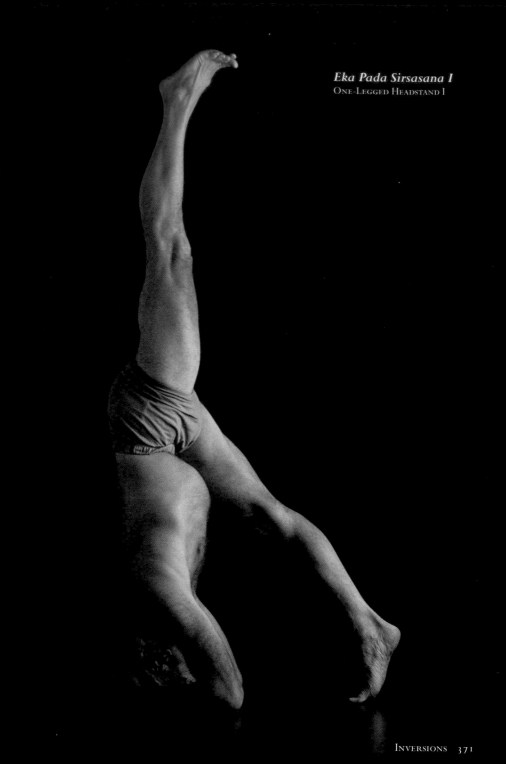

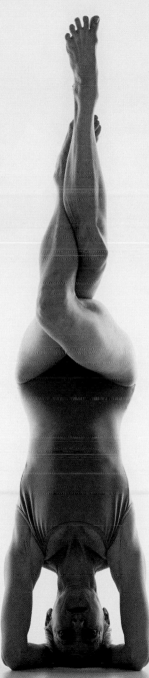

Garudasana in Sirsasana I
HEADSTAND WITH EAGLE LEGS I

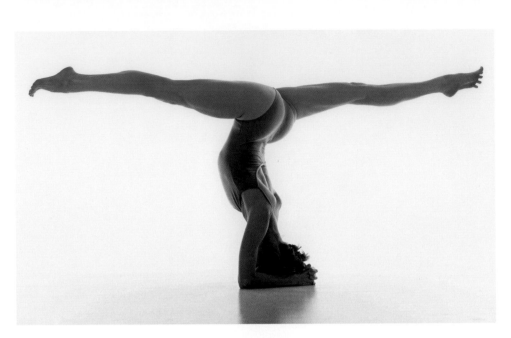

***Hanumanasana in
Sirsasana I***
Headstand with Front Splits I

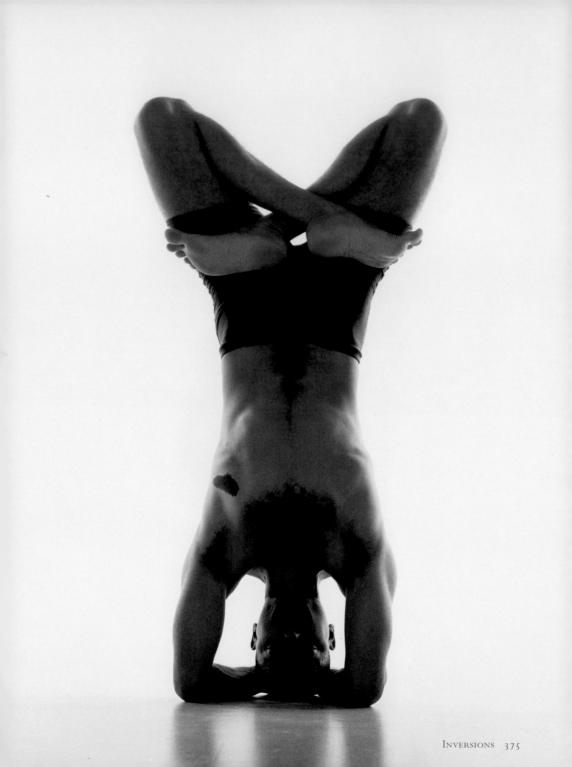

Pindasana in Sirsasana I
EMBRYO POSE IN HEADSTAND I
(PREP)

Parsva Urdhva
Padmasana in Sirsasana I
SIDEWAYS UPWARD LOTUS
IN HEADSTAND I

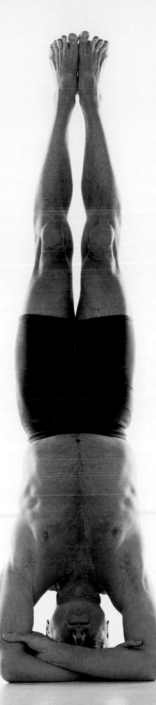

Baddha Hasta Sirsasana
BOUND HAND HEADSTAND

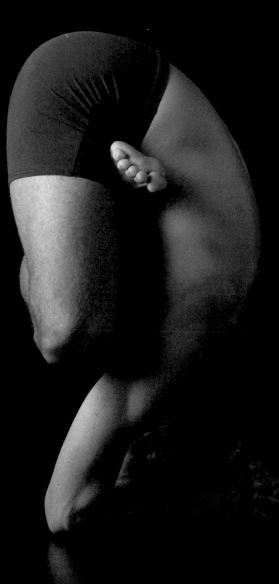

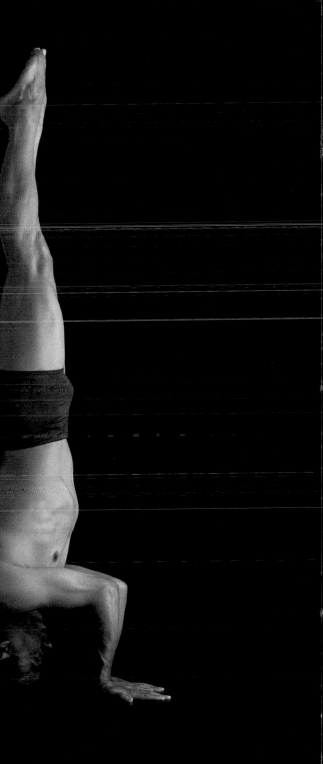

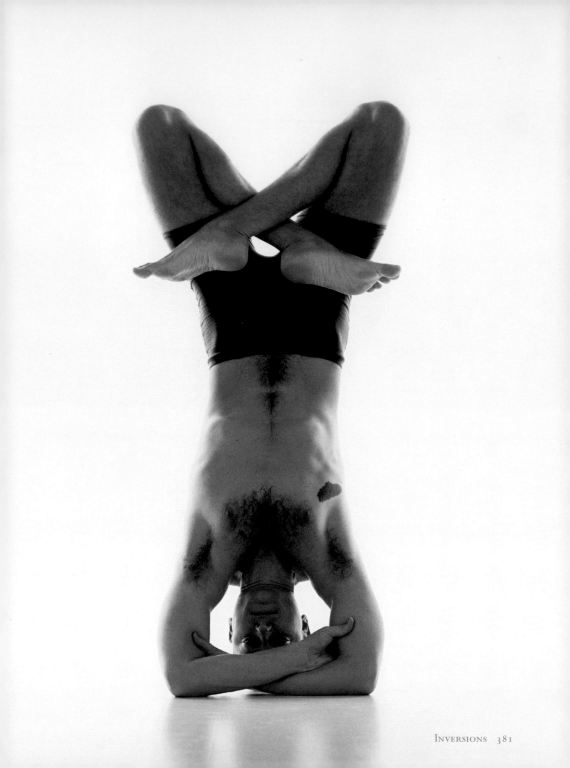

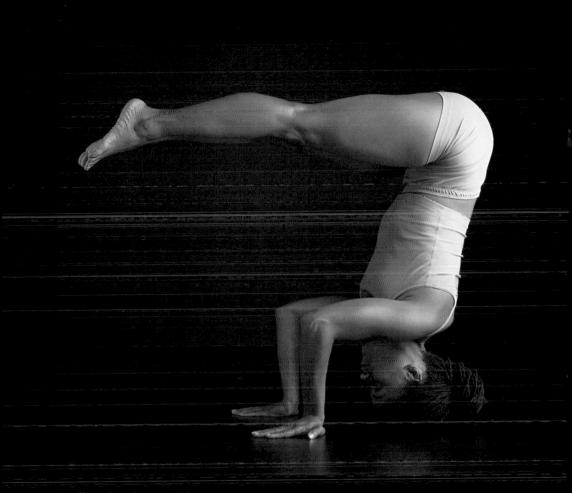

Urdhva Dandasana III
UPWARD STAFF POSE III

Parsva Sirsasana II
SIDEWAYS HEADSTAND II

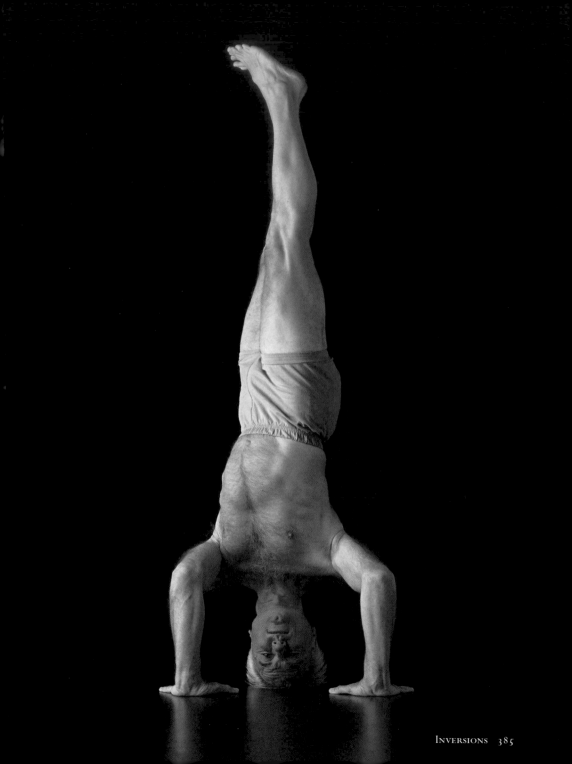

Niralamba Sirsasana
UNSUPPORTED HEADSTAND

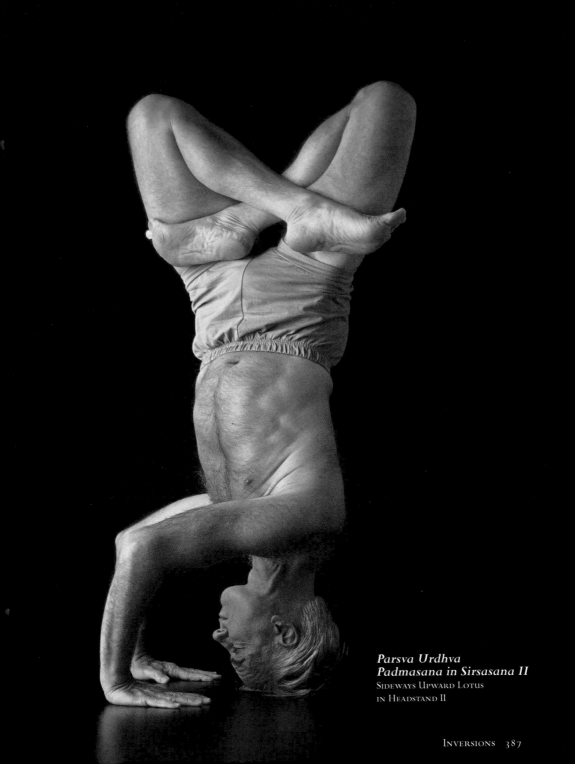

Parsva Urdhva
Padmasana in Sirsasana II
SIDEWAYS UPWARD LOTUS
IN HEADSTAND II

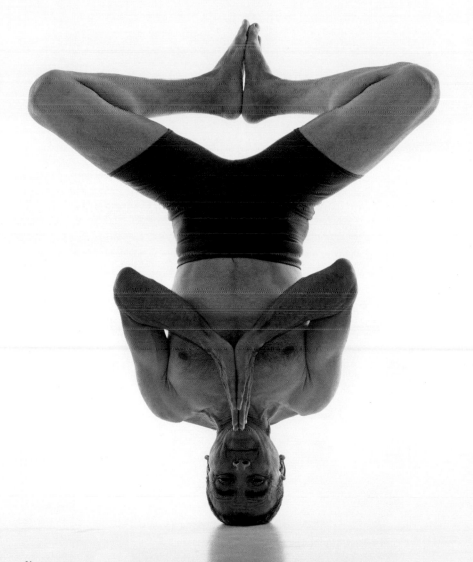

Baddha Konasana in
Niralamba Sirsasana
BOUND ANGLE UNSUPPORTED
HEADSTAND

Niralamba Sirsasana
UNSUPPORTED HEADSTAND

Mukta Hasta Sirsasana
Free-Hand Headstand (var.)

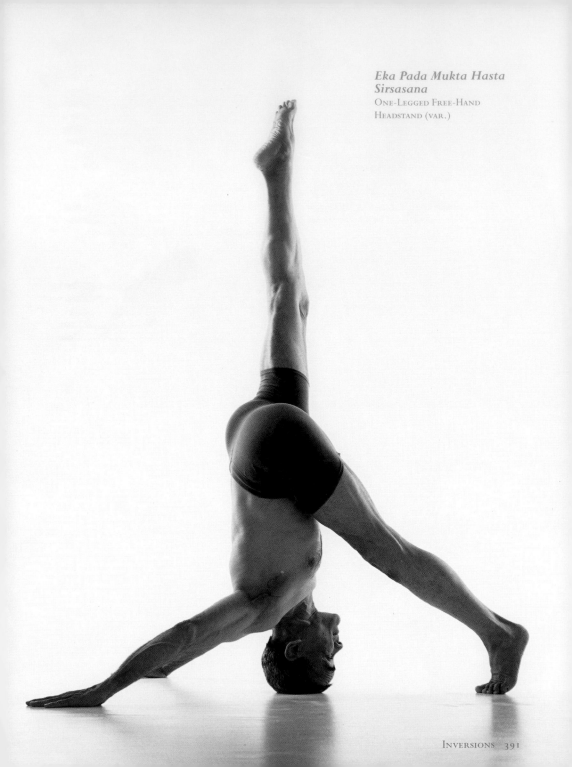

Eka Pada Mukta Hasta Sirsasana
ONE-LEGGED FREE-HAND
HEADSTAND (VAR.)

Urdhva Padmasana in Mukta Hasta Sirsasana
UPWARD LOTUS IN FREE-HAND HEADSTAND

Mukta Hasta Sirsasana
Free-Hand Headstand

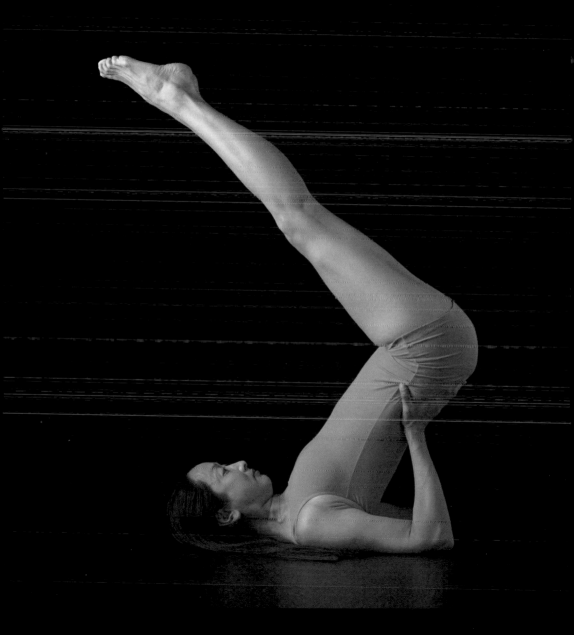

Urdhva Padmasana in Mukta Hasta Sirsasana
UPWARD LOTUS IN FREE-HAND
HEADSTAND (VAR.)

Salamba Sarvangasana I
SUPPORTED SHOULDERSTAND I

Garudasana in Sarvangasana I

SHOULDERSTAND WITH
EAGLE LEGS I

Baddha Konasana in Sarvangasana I
BOUND ANGLE SHOULDERSTAND I

*Urdhva Padmasana in
Sarvangasana I*
UPWARD LOTUS IN
SHOULDERSTAND I

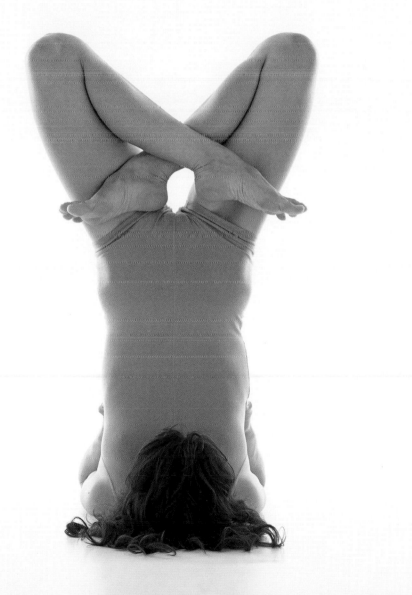

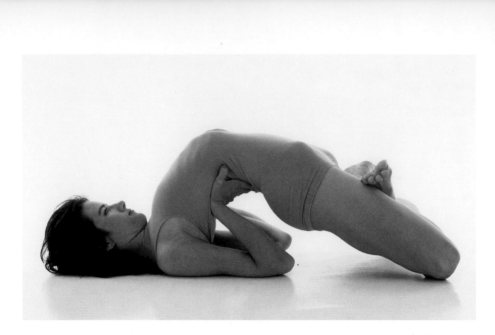

**Uttana Padma
Mayurasana**
INTENSE LOTUS PEACOCK POSE

**Parsvaika Pada
Sarvangasana I**
ONE-LEGGED SIDEWAYS
SHOULDERSTAND I

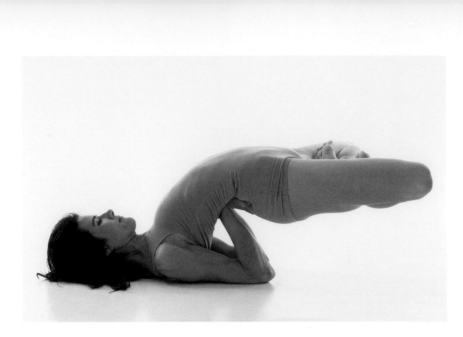

Uttana Padma
Mayurasana
INTENSE LOTUS PEACOCK (PREP)

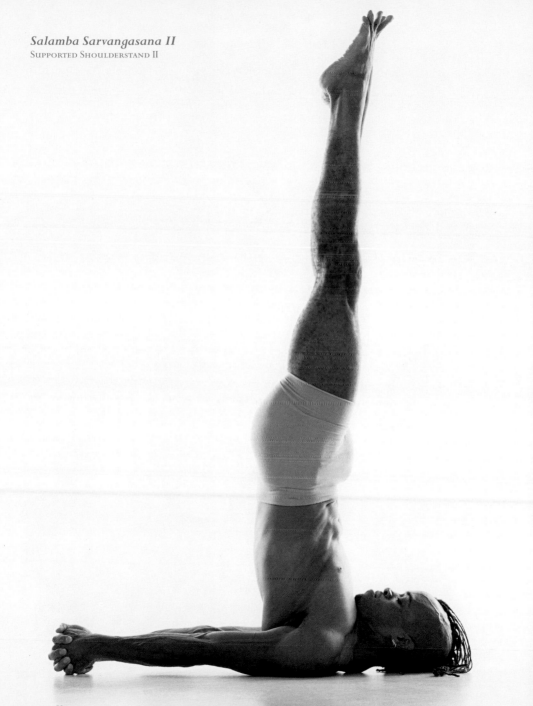

Salamba Sarvangasana II
SUPPORTED SHOULDERSTAND II

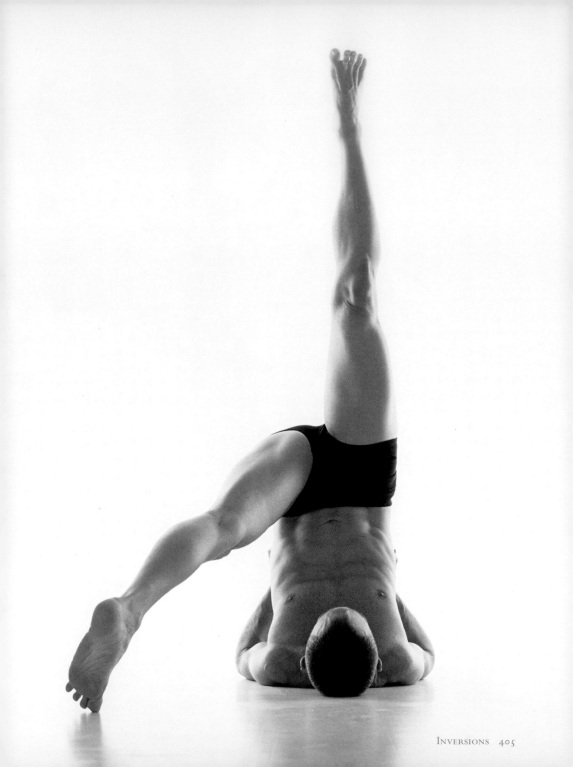

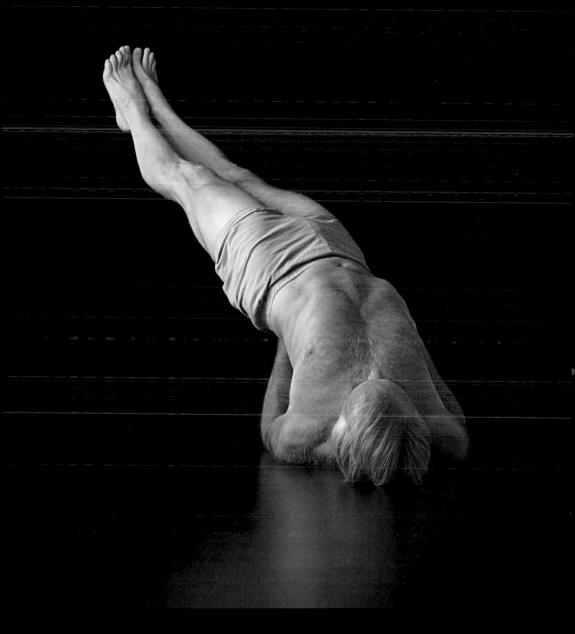

Niralamba Sarvangasana
Unsupported Shoulderstand

Setu Bandha Sarvangasana
Bridge Pose

Setu Bandha
Sarvangasana
BRIDGE POSE (PREP)

Halasana
PLOW POSE (VAR.)

Parsva Halasana
SIDEWAYS PLOW POSE

Halasana
PLOW POSE

Halasana
PLOW POSE (PREP)

Halasana
PLOW POSE (VAR.)

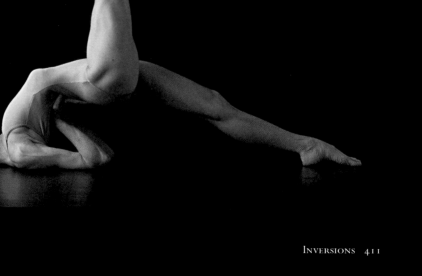

Eka Pada Setu Bandha Sarvangasana
ONE-LEGGED BRIDGE POSE

Parsva Pindasana in Halasana

SIDEWAYS EMBRYO PLOW POSE

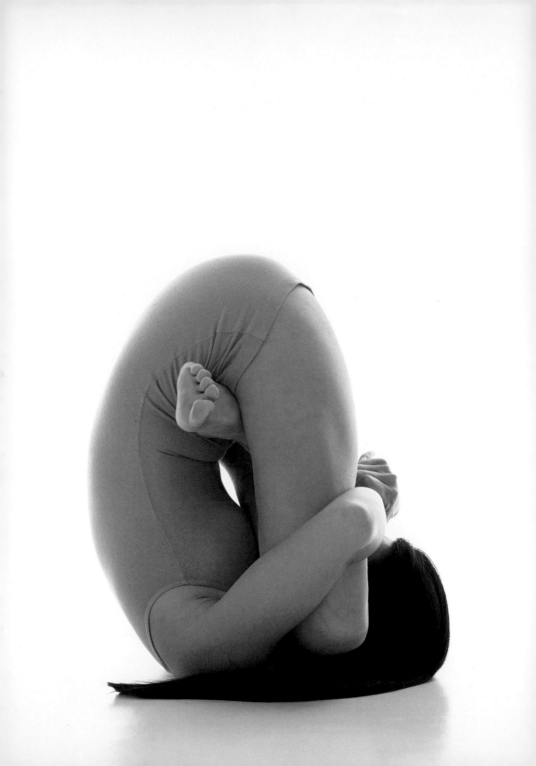

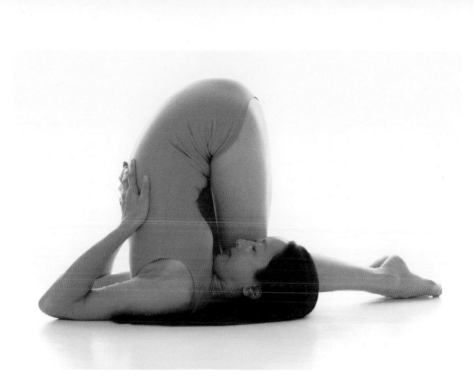

Parsva Karnapidasana
SIDEWAYS KNEE-TO-EAR POSE

Pindasana in Halasana
EMBRYO PLOW POSE

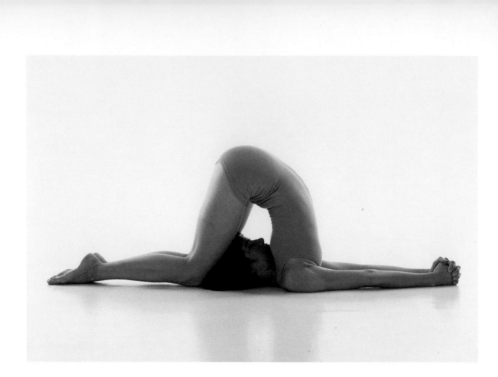

Karnapidasana
Knee-to-Ear Pose

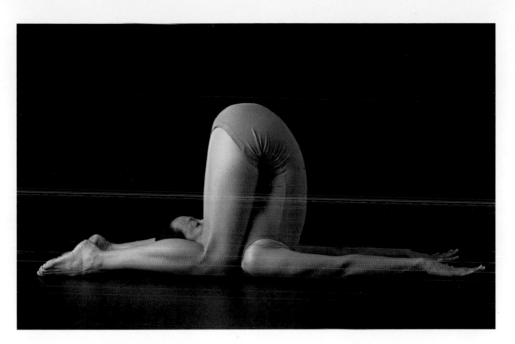

Karnapidasana
KNEE-TO-EAR POSE

Ganda Bherundasana
Formidable Face Pose (prep)

Ganda Bherundasana
Formidable Face Pose (prep)

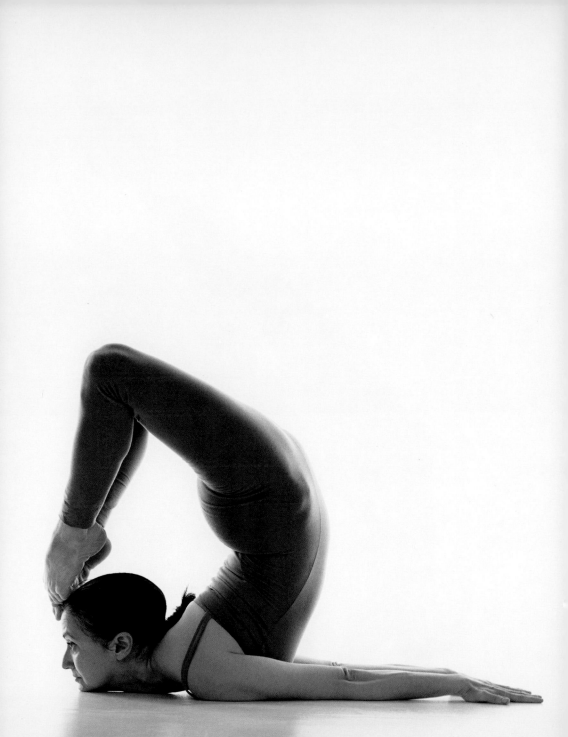

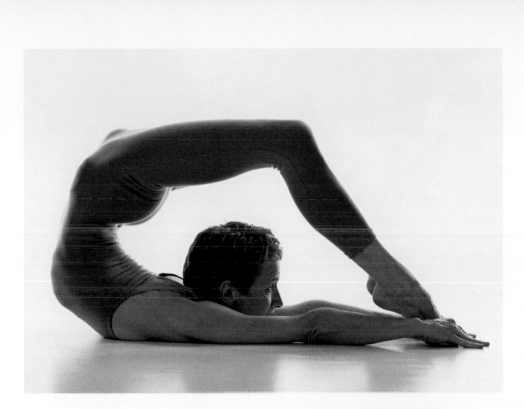

Utthita Ganda Bherundasana
EXTENDED FORMIDABLE FACE POSE

Viparita Salabhasana
INVERTED LOCUST POSE

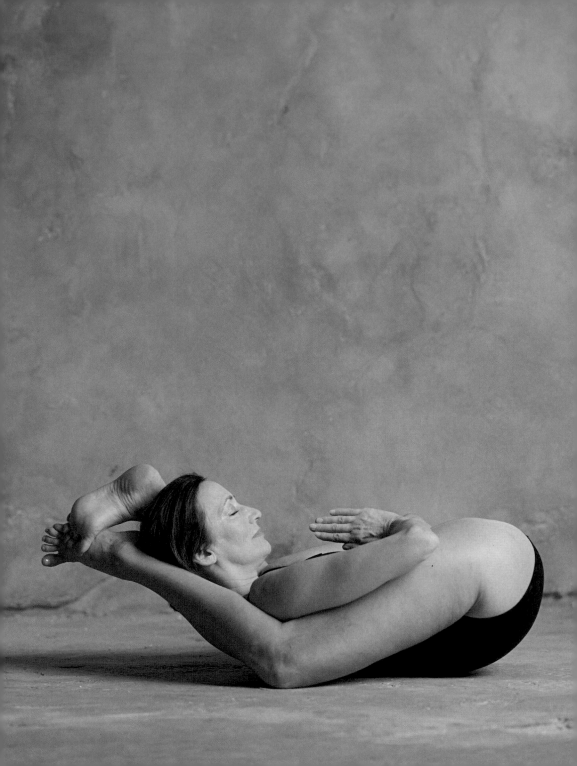

Supine Poses

When your mind has become serene
by the practice of meditation,
you see the Self through the self
and rest in the Self, rejoicing.
You know the infinite joy
that is reached by the understanding
beyond the senses; steadfast,
you do not fall back from the truth.

—THE BHAGAVAD GITA 6.20–21

Yoganidrasana
YOGIC SLEEP

Supine Poses

In the supine position, the body moves serenely through its full range of motion, safely cradled and completely supported by Earth. Physically, the variety of reclining poses allows us to stretch forward and release back, move up and down and side to side, lubricating the joints and opening the chest as we move toward Savasana, the ultimate resting pose, in which we can experience true stillness, the merging of body, mind, and spirit.

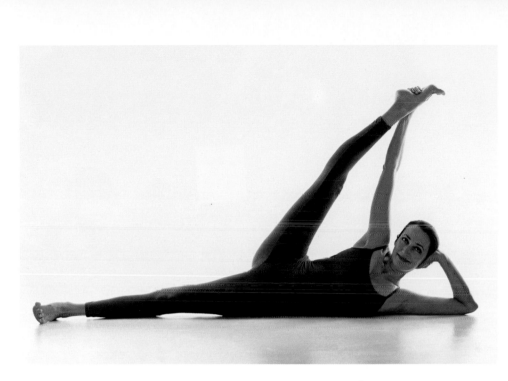

Anantasana
RECLINING POSE DEDICATED
TO VISHNU

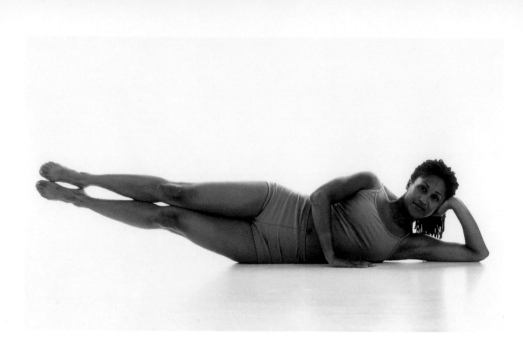

Anantasana
RECLINING POSE DEDICATED
TO VISHNU (VAR.)

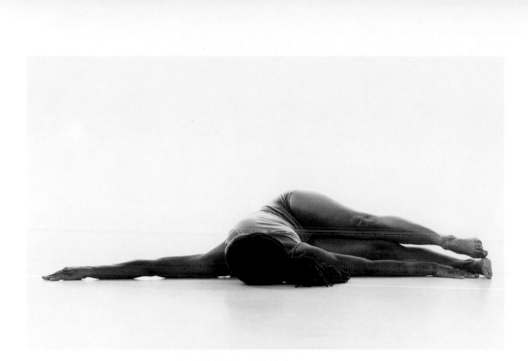

Jathara Parivartanasana
Twisted Stomach Pose

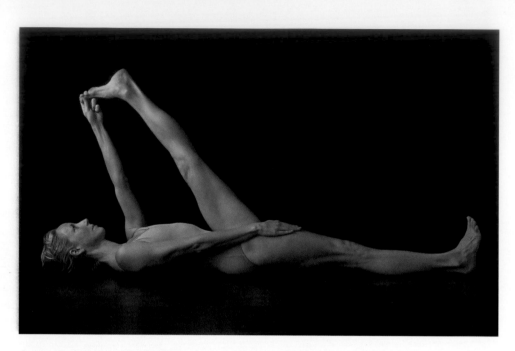

Supta Padangusthasana I
RECLINING BIG TOE POSE I

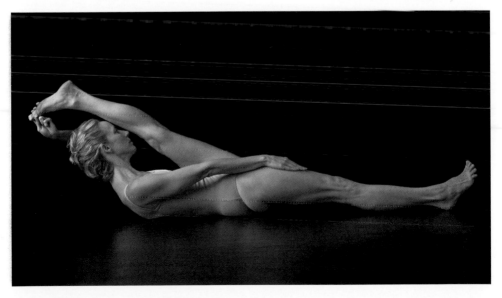

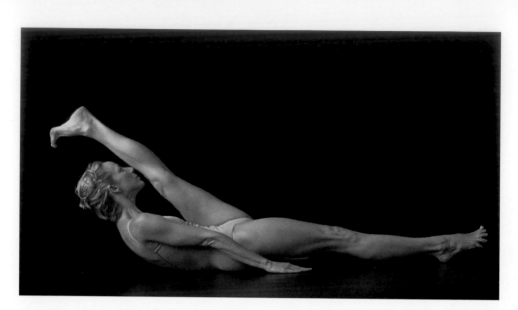

Supta Padangusthasana I
RECLINING BIG TOE POSE I

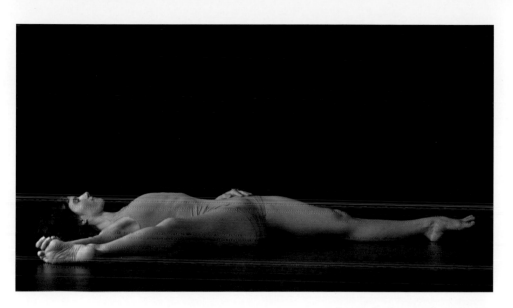

Supta Padangusthasana II
RECLINING BIG TOE POSE II

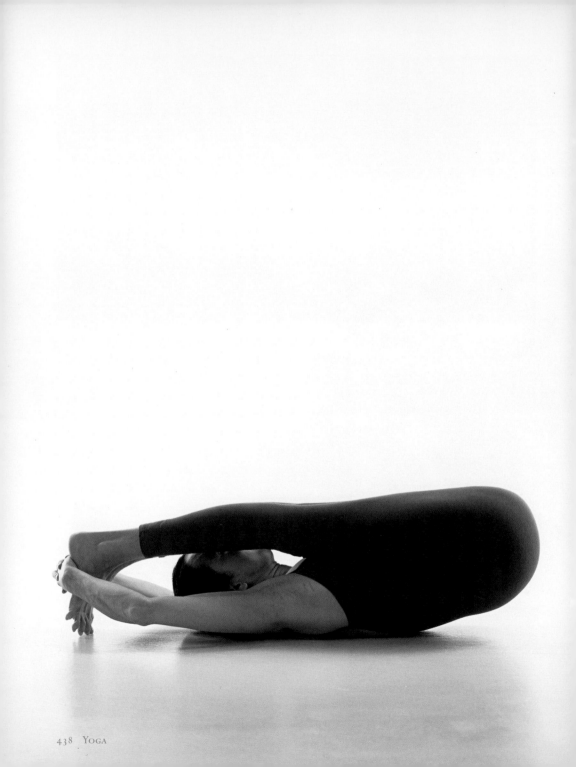

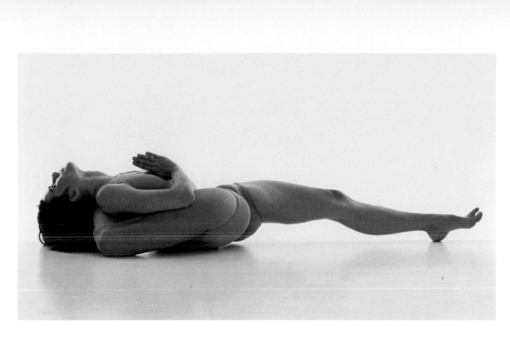

Bhairavasana
RECLINING FORMIDABLE POSE

Urdhva Mukha
Paschimottanasana II
UPWARD-FACING FORWARD BEND II

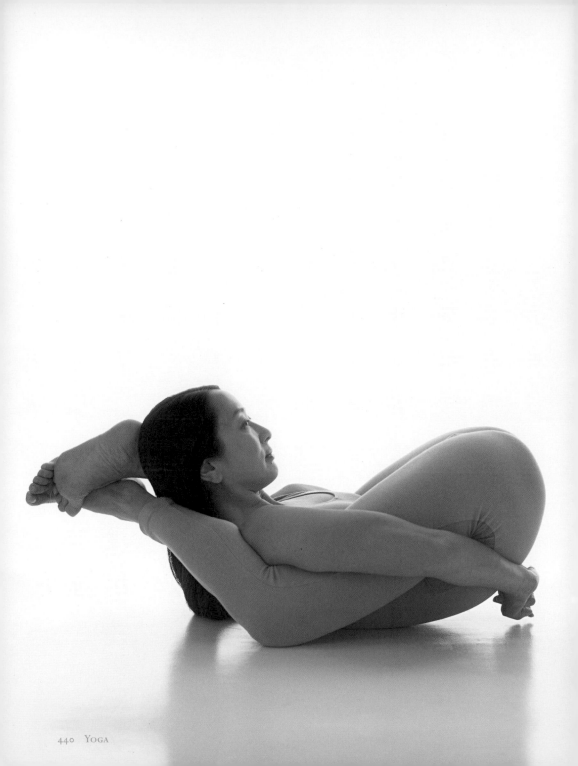

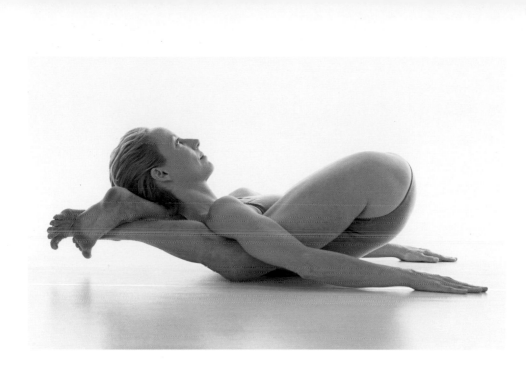

Yoganidrasana
YOGIC SLEEP (VAR.)

Yoganidrasana
YOGIC SLEEP

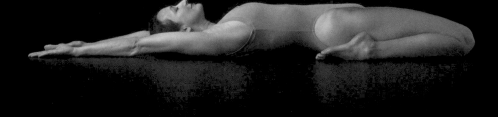

Supta Virasana
Reclining Hero Pose

Matsyasana
FISH POSE (VAR.)

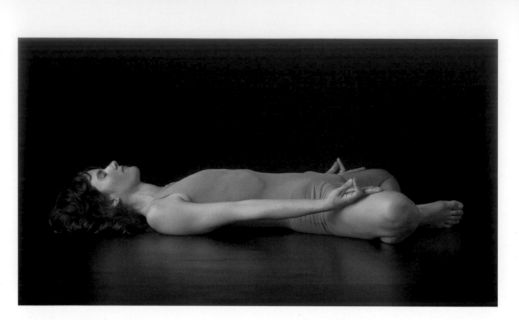

Supta Baddha Konasana
RECLINING BOUND ANGLE POSE

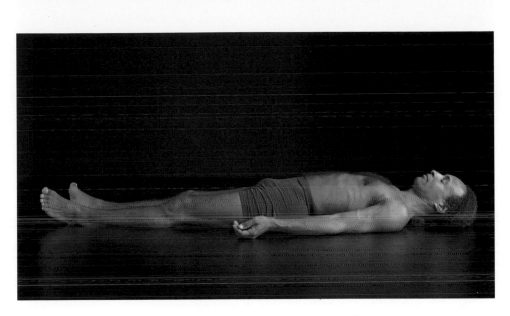

Savasana
CORPSE POSE

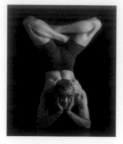

Dharma Mittra has spent more than half of his life teaching yoga in New York City. A devote disciple of Swami Kailashananda (also known as Swami Gupta), Dharma created, as a selfless offering to his guru, the 908-pose poster that hangs in yoga studios all over the world. He has touched hundreds of thousands of lives over his past years of service and at sixty-four years young, continues to give classes at Dharma Yoga Center on East 23rd Street in Manhattan.

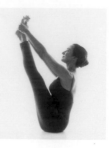

Catherine De Los Santos began her practice of yoga in 1969 with her performing dance group in college. The constant pain in her back (due to scoliosis) began to disappear and so began her love of yoga. Catherine has studied in India several times with B.K.S. Iyengar and is a graduate of the Iyengar Yoga Institute in San Francisco. Catherine is co-owner of The Yoga Center of Palo Alto, where she has taught since 1979. Her style is flowing and energetic.

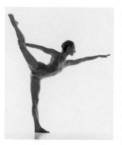

Annie Carpenter has studied both the Iyengar method and the Ashtanga system of yoga for over twenty years, including studies in India with Sri Pattabhi Jois. Previously a professional dancer, she performed and taught for the Martha Graham Company in New York, and at leading studios in Europe and Asia. Annie has a strong interest in anatomy, physiology, and kinesiology, and believes that alignment begins in the body, but ultimately leads us to the divine within. She currently teaches at Yoga Works in Santa Monica, California.

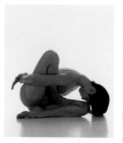

Donna Fone is the co-director of the Piedmont Yoga Studio in Oakland, California. Her eighteen-year yoga practice has seen her through three pregnancies, childbirth, the raising of three children, and life in general. She has taught intermittently over the years and is just now taking on more regular teaching engagements. Her beautiful poses have graced the pages of *Yoga Journal* as well as several of its calendars.

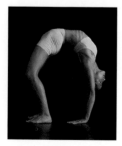

Simi Cruz is a practitioner of the Ashtanga yoga system. Guided and inspired by her teachers Maty Ezraty and Chuck Miller, she completed her teacher training at Yoga Works in Los Angeles in 1999 and has been teaching there since 2000. Through her own practice, Simi explores the ideas of peace and stillness. As a teacher she recognizes that inner peace in her students, guiding them to it, and helping them to understand that it is that peace, that stillness, that is the same within all of us.

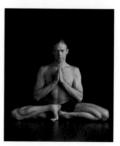

Richard Freeman, a student of yoga since 1968, has spent nearly nine years in Asia studying various traditions, which he incorporates into the Ashtanga practice taught by his principal teacher, Sri Pattabhi Jois of India. Richard's background includes Zen and Vipassana Buddhist practice, bhakti and traditional hatha yoga, Sufism, and an in-depth study of Iyengar yoga. His ability to juxtapose various viewpoints, without losing the depth and integrity of each, has helped Richard develop a unique, metaphorical teaching style. He directs the Yoga Workshop in Boulder, Colorado.

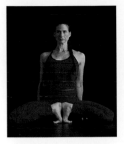

Ana Forrest, founder of the Forrest Yoga Circle, celebrates the beauty of life and the power of spirit in her yoga. In "hunting her own spirit," Ana's own life trauma and experiences compelled her to create "Forrest Yoga," an intensely mindful practice that teaches students how to awaken, heal, and strengthen their bodies and how to discover and nourish their spirit. Ana teaches her students to infuse their spirit into all parts of their lives. She calls this "Embodying Spirit."

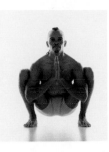

Chris Hoskins began yoga in 1975, training in the Desikachar, Sri Pattabhi Jois, and Iyengar styles. He graduated from the Deep 99 and the Advanced Studies programs at Piedmont Yoga Studio. Chris danced with Oakland Ballet, Cleveland Ballet, and Elliot Feld Ballet in New York City. Yoga is a unifier of spirit, heart, psyche, body, and mind for Chris. He uses his unique perception and understanding of movement to help students explore the subtle rhythm of the body-mind, and the inner dialogues that arise with yoga practice.

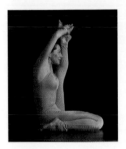

Sharon Gannon is a disciple of Sri Brahmananda Saraswati, Sri Swami Nirmalananda, and Sri Pattabhi Jois. She is the co-founder and co-director of Jivamukti Yoga Center and the author of *Cats and Dogs are People Too!*, a look into the insensitive attitudes that result in speciesism, with optimistic measures on improving our relationship to animals. She teaches yoga as a spiritual practice, relating the ancient teachings of yoga to the modern world. Sharon brings a highly disciplined asana and meditation practice to her teaching.

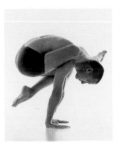

Brent Kessel has been a dedicated yoga practitioner since 1989, and has studied with Sri Pattabhi Jois in India three times. When not practicing yoga at Yoga Works in Santa Monica, California, Brent counsels clients for his company, Abacus Wealth Management, Inc. He also writes and leads workshops on the integration of money and spiritual practice. Brent's incredible yoga poses can often be seen in the pages of *Yoga Journal*, as well as in its calendars.

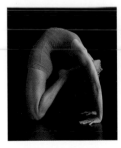

Maia Heiss is an advanced Ashtanga yoga student of Sri Pattabhi Jois in Mysore, India. Having begun a hatha yoga practice in 1994, in 1996 she dedicated herself to the formal study of Ashtanga yoga, under the guidance of Chuck Miller. She studied dance and music since early childhood, has earned degrees in both, and has danced professionally. She now continues her artworks with their form and theme being influenced by her yoga practice. Maia teaches Ashtanga yoga throughout the U.S. and abroad, with a blessing from her guru.

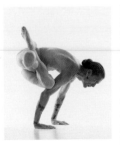

David Life is a disciple of Sri Brahmananda Saraswati, Sri Swami Nirmalananda and Sri Pattabhi Jois. With Sharon Gannon he developed the Jivamukti yoga method, co-directs the Jivamukti Yoga Center in New York City, and has written two books, *Jivamukti Yoga: Practices for Liberating Body & Soul* and *The Art of Yoga*. He imbues his classes with metaphor, musicality and spirituality, spiced with humor, vigor, and spontaneity. A respected and popular teacher all over the world, David is in demand wherever he goes.

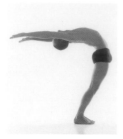

James Murphy pursued a ten-year career in dance, touring worldwide with the Nikolais Dance Theater, when he became interested in yoga. He helped found the Iyengar Yoga Institute of New York in 1992 and has been teaching classes there ever since. He has taken extended trips to India to study with the Iyengar family. James's keen perception and observation skills combine with a natural talent for teaching to make his classes rich and exhilarating.

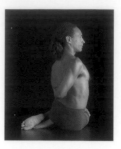

Ty Powers has been practicing yoga for fifteen years and leading yoga retreats for the past ten years. He is currently in a Dharma leader-training program at Spirit Rock Meditation Center, under the guidance of Jack Kornfield and James Baraz. Ty makes his home in Marin County, California, with his wife Sarah and their daughter Imani Jade. He also manages and assists in the classes, workshops, and retreats Sarah teaches throughout the world.

Lauren Peterson is a well-respected yoga teacher living with her son, Sashi, in Malibu, California. She is a student of Iyengar yoga, and an advanced Ashtanga yoga practitioner. Lauren has been featured in the television series "Healing Quest," for the yoga program she started for women with eating disorders. Lauren is also the creator of "The Yogi's Companion," a yoga practice CD. She counts among her clients Cher, Olympic gold medallist Greg Louganis, and Nick Nolte.

Natasha Rizopoulos has been teaching Ashtanga yoga at Yoga Works in Santa Monica, California, since 1997, under the guidance of Chuck Miller and Maty Ezraty. A former ballet student, Natasha is both flexible and strong. She has a daily Ashtanga practice and has been fortunate to study in India with her guru, Sri Pattabhi Jois. She feels she benefits daily from the wisdom of her guru's oft-repeated refrain, "Do your yoga, all is coming."

Sarah Powers has been teaching yoga for fifteen years. Her classes incorporate both a yin style of holding poses and a vinyasa style of moving with the breath, blending the essential aspects of the Iyengar, Ashtanga, and Viniyoga traditions. Pranayama is also included in her work. Sarah has been a student of Buddhism in Asia and the U.S., inspired by such luminaries as Jack Kornfield (Vipassana), Toni Packer, whose roots stem from the Zen tradition, and Tsoknyi Rinpoche, her Tibetan teacher.

Tony Sanchez began his practice of hatha yoga in 1976 and was certified in 1979 by Ghosh's College of Physical Education in Calcutta, India. He is from the lineage established around the 10th century C.E. by Yogi Matsyendranath, founder of the Nath sect. The foundation of Tony's practice is a system of eighty-four classic asanas passed from teacher to student in a traditional three-year apprenticeship. In 1984, Tony founded the United States Yoga Association to teach the benefits of hatha yoga to people of all ages.

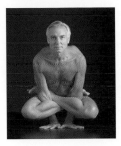

John Schumacher, founder and director of Unity Woods, has practiced yoga for over thirty years and has taught in Washington D.C. since 1973. John has studied in India with B.K.S. Iyengar and is a certified senior Iyengar yoga teacher. Cited by *Yoga Journal* as one of "25 American originals who are shaping yoga today," John is one of the country's leading yoga teachers. He travels throughout the world, including Europe, Asia, and the Caribbean, to conduct workshops for students and teachers of all levels.

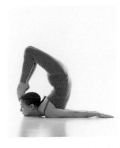

Eva Grubler-Vargas (Ismrittee Devi-Eva) has been a student of Dharma Mittra in New York City since 1985. There she found peace in the beautiful teachings, the amazing posture series, and especially in hearing the words of the scriptures singing in her ears. Eva started teaching yoga sixteen years ago to private individuals as well as instructing seniors and beginner students at the YWCA on 61st Street and Lexington Avenue in New York City. Some of those friends are still with her today at the Dharma Yoga Center.

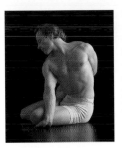

Rod Stryker holds the title of Yogiraj and has taught tantra, hatha, and Yogananda's kriya yoga for more than twenty years. He specializes in the art of personalizing yoga and meditation practices, known as Anava-Upaya-Yoga. He is a student of Pundit Rajmani Tigunait and is an initiate in the lineage of Swami Rama of the Himalayas. In the mid-1990s, Rod teamed with famed fitness star Kathy Smith to co-produce a series of yoga videos, all of which have been honored with a variety of awards.

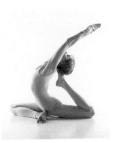

Patricia Walden is a classical Iyengar yoga teacher. She teaches yoga asana and pranayama as methods to explore the nature of self and to see the body as a gateway to the mind. She is a student of Yogacharya B.K.S. Iyengar, whom she first met in 1976. She travels annually to India where she continues her studies with him. Patricia holds a senior advanced certificate and is the founder of the B.K.S. Iyengar Center of Cambridge, Massachusetts. She teaches workshops internationally and has a special interest in yoga for women.

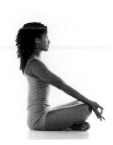

Bahni Turpin began to study yoga in earnest when she discovered it filled a void that was left when she gave up dancing years earlier. For this young girl from Potomac, Michigan, yoga also held the promise of inte-grating the physical with the spiritual, making the body open up to the fullness of the spirit. Bahni currently practices Ashtanga yoga and teaches early morning "flow" classes at Yoga Works in Santa Monica, California, while also pursuing an acting career.

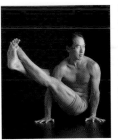

Rodney Yee is the co-director of the Piedmont Yoga Studio in Oakland, California. One of the most visible yoga teachers in the country, Rodney has been a guest on "Oprah" and profiled in *People* magazine. He is best known for his yoga videos and the workshops and teacher training programs he offers worldwide. He is the co-author of a book entitled *Yoga: The Poetry of the Body.* Yoga, as well as his children, is Rodney's source of exploration and inspiration.

INDEX

PHOTO CREDITS

Page 8, © Giraudon/Art Resource, N.Y.; 10, Thomas L. Kelly; 11, (TOP) © Borromeo/Art Resource, N.Y., (BOTTOM) © David Samuel Robbins/CORBIS; 12, © Abbie Enock, Travel Ink/CORBIS; 13, © Giraudon/Art Resource, N.Y, 14, © Getty Images/Digital Image Copyright © 2002 Getty Images; 15, © Réunion des Musées Nationaux/Art Resource, N.Y.; 16, © Borromeo/Art Resource, N.Y.; 17, © Scala/Art Resource, N.Y.; 18, Erich Lessing/Art Resource, N.Y.; 19, © Scala/Art Resource, N.Y.; 20, Thomas L. Kelly; 23, courtesy Krishnamacharya Yoga Mandiram; 24, Thomas L. Kelly; 27, Victoria and Albert Museum, London/Art Resource, N.Y.; 28, Victoria and Albert Museum, London/Art Resource, N.Y.; 29, © Lindsay Hebberd/CORBIS; 31, © Réunion des Musées Nationaux/Art Resource, N.Y., 33, Thomas Laird; 34, Victoria and Albert Museum, London/Art Resource, N.Y.; 37, © 2002 Yoga Research and Education Center, www.yrec.org; 39, © Réunion des Musées Nationaux/Art Resource, N.Y.; 40, Werner Forman Archive/Art Resource, N.Y.; 41, Victoria and Albert Museum, London/Art Resource, N.Y.; 42, © Giraudon/Art Resource, N.Y.; 44, 45, Victoria and Albert Museum, London/Art Resource, N.Y.; 46, © Christie's Images Limited 2002; 47, Victoria and Albert Museum, London/Art Resource, 49, © Archivo Iconografico, S.A./CORBIS; 51, 52, courtesy Krishnamacharya Yoga Mandiram; 54, courtesy Jivamukti Yoga Center; 55, courtesy Pablo Bartholomew; 56, courtesy Krishnamacharya Yoga Mandiram; 57, © Abilio Lope/CORBIS; 58, © Joseph Sohm, ChromoSohm Inc./CORBIS; 61, Thomas L. Kelly.